C. Mattheck

Springer

*Berlin
Heidelberg
New York
Barcelona
Budapest
Hong Kong
London
Milan
Paris
Santa Clara
Singapore
Tokyo*

Claus Mattheck

Design in Nature

Learning from Trees

With 205 Figures, 117 in Color

Springer

Prof. Dr. Claus Mattheck
Research Center Karlsruhe
Institute for Material Research II
P.O. Box 36 40
D-76021 Karlsruhe
Germany

Translated by:
Dr. William Linnard
7, Ffordd Las
Radyr
Cardiff CF4 8EP
UK

Title of the original German edition: „Design in der Natur: Der Baum als Lehrmeister", published by Rombach Verlag 1997

ISBN 3-540-62937-8 Springer-Verlag Berlin Heidelberg New York

Library of Congress Cataloging-in-Publication Data
Mattheck C. (Claus), 1947-
[Design in der Natur. English]
Design in nature : learning from trees / Claus Mattheck.
 p. cm.
Includes bibliographical references (p.) and index.
ISBN 3-540-62937-8 (softcover)
1. Biomechanics. 2. Trees–Mechanical properties I. Title.
QH513.M3813 1998
571.4' 3–dc21 97-34438

This work is subject to copyright. All rights are reserved, whether the whole or part of the material is concerned, specifically the rights of translation, reprinting, reuse of illustrations, recitation, broadcasting, reproduction on microfilm or in any other way, and storage in data banks. Duplication of this publication or parts thereof is permitted only under the provisions of the German Copyright Law of September 9, 1965, in its current version, and permissions for use must always be obtained from Springer-Verlag. Violations are liable for prosecution under the German Copyright Law.

© Springer-Verlag Berlin Heidelberg 1998
Printed in Germany

The use of general descriptive names, registered names, trademarks, etc. in this publication does not imply, even in the absence of a specific statement, that such names are exempt from the relevant protective laws and regulations and therefore free for general use.
Cover design: design & production GmbH, Heidelberg
Cover illustration: C. Mattheck and J. Schäfer
Typesetting: Camera ready by D. Gräbe, Karlsruhe
SPIN 10573021 31/3137 5 4 3 2 1 0 - Printed on acid free paper

To my teachers –
the silent giants in green freedom
whose mechanical body language
proclaims a mute truth
which knows no lie.
To the silent giants in green freedom –
my friends.

Preface

The chicken bone you nibbled yesterday and threw away was a high-tech product! Not only that: it was a superlative light-weight design, functionally adapted to its mechanical requirements. No engineer in the world has, as yet, been able to copy this structural member, which is excellently optimized in its external shape and its internal architecture as regards minimum weight and maximum strength.

The tree stem on which you recently carved your initials has also, by life-long care for its body, steadily improved its internal and external structure and adapted optimally to new loads. In the course of its biomechanical self-optimization it will heal up the notch you cut as speedily as possible, in order to repair even the smallest weak point, which might otherwise cost it its life in the next storm.

This book is dedicated to the understanding of this biomechanical optimization of shape. It is the synthesis of many years of extensive research using the latest computer methods at the Karlsruhe Research Centre to help understand the mechanism of biological self-optimization (adaptive growth) and to simulate it by computer. The method newly developed for this purpose was called CAO (Computer-Aided Optimization). With this method, it is possible to predict the growth of trees, bones and other biological structures from the tiger's claw to the sea urchin's skeleton. As these are recognized as such perfect structures, it was tempting to use the CAO technique for the improvement of mechanical structural members as well. *An apparently crazy idea: trees as design instructors for designers!* However, this approach was incredibly successful in the shortest imaginable time, and the CAO method has immediately gained wide acceptance in German industry. The reason: this method is simple and brutally successful like nature itself, *as computer-simulated mechanical components grow like trees.*

In repeated-stress tests under laboratory conditions, prototypes of optimized shape exhibited a working life sometimes more than 100 times greater than non-optimized ones, without visible crack formation, as was expected.

Biological shape optimization, which has evolved in an incredibly and cruelly consistent way over millions of years, has already proved itself in nature in the best possible way. The most fascinating result from all previous studies is that there is probably only one single design rule, which defines wide areas of biological design throughout nature: *the axiom of uniform stress.* This states that on average, over time, stress acts uniformly over the surface of components, i.e. the load is 'fairly' distributed. This is demonstrated with numerous examples of trees, bones, claws etc. in this book. A machine component which is dimensioned by 'growth' into a shape having uniform stress distribution has neither breaking

points (locally excessive stresses) nor wasted material (zones not fully loaded). It is in the true sense a 'biological' design – ultra light and very strong.

This concept of mechanical designing is beginning to close the gap which yawns between technology and nature, and which exists in the mechanical field with over-dimensioned and excessively heavy components having an extremely uneven load distribution. To this extent, this book seeks to show a path towards the *unity of technology and nature*, which has the possibility of energy- and resource-saving by light-weight construction, analogous to that found in animals and plants. *An ecological design of mechanical components*, which are exposed to the growth laws of nature and yet satisfy the functional demands of man, is no utopian dream but a real goal which has become more attainable for the practising designer by the availability of the CAO method. Conversely, the method also allows shape adaptation in nature to be evaluated, and growth reactions (e.g. the reaction of a bone to the application of a prosthesis) to be predicted by computer simulation. In this way, animal experiments can also be at least partially replaced by CAO application. Accordingly, CAO makes it possible to *understand biological shaping as consistent with the axiom of uniform stress.*

It is the author's wish to make this information on *design in nature and following nature* understandable and credible to a wide readership by means of a simple and yet scientifically precise presentation. For this it has been necessary to use language which is simple and yet not absolutely precise, either biologically or mechanically. A precise presentation would be incomprehensible both to biologists and to engineers, let alone the general reader. So indulgence is requested for any loose phraseology or terminology which, technical considerations apart, were intended to make the book entertaining for the shattered reader after a stressful day at work.

The reader will come across many quotations from the author's own published work. These are not for self-glorification, but will help the interested reader to gain access to further and more detailed literature.

Finally, I wish to thank all those who trusted us from the start and believed in the success of the new methods. In particular I should like to mention my friend Professor Dr. Hans Kübler (Department of Forestry, University of Madison, Wisconsin) whose work on mechanical stresses in trees has given rise not only to many stimulating ideas but also to valuable and encouraging personal discussions. I am therefore especially pleased that the first German edition of this book appeared in the year of his 70th birthday.

The management of the Karlsruhe Research Centre are thanked for their courage in tolerating, with benevolence, research which certainly seemed crazy initially, and for backing it with supportive interest to a successful conclusion. My very special thanks go to my industrious colleagues and the students recruited from my biomechanics lectures at Karlsruhe University, whose enthusiasm, interest and will to work helped the computer methods developing around the *axiom of uniform stress* achieve such brilliant success. Dagmar Gräbe and Jürgen Schäfer deserve a thankyou for their patience of Job in making the illustrations for

the computer simulations. Dagmar Gräbe also prepared the camera-ready manuscript with care and accuracy. Grateful thanks are also due to Dipl.-Ing. H. Moldenhauer for assistance in adapting the method to the FEM ABAQUS program as well as to Dr. Klaus Bethge for carefully proof reading of the manuscript. I thank Springer's publishing house, and especially Dr. Andrea Schlitzberger, Dr. Dieter Czeschlik and Mrs. Claudia Seelinger for their refreshingly friendly style of work. Not last, my special thanks are due to Dr. William Linnard, who prepared the English translation in an excellent way and was even able to bring the spirit of the book, written between the lines, into the English language.

Karlsruhe, Germany CLAUS MATTHECK
Autumn 1997

Contents

Introduction ... 1

The Minimum on Mechanics .. 3
External Loads and Internal Stresses .. 3
Thermal Expansion and Thermal Stresses .. 11
The Finite Element Method (FEM) .. 12
The Component Killers: Notches and Notch Stresses 14
Crack Propagation .. 20
Overview of the Mechanics .. 21

What Is a Good Mechanical Design? ... 25

The Axiom of Uniform Stress and How Computer Methods Derive from It .. 29
Notches Without Notch Stresses? .. 29
Computer-Aided Optimization – Growth in the Computer 32
Soft Kill Option: Away with the Ballast! ... 35
Stress-Controlled E-Modulus Distribution: .. 37
The Stress-Increment-Controlled SKO Method .. 39
Presentation of the Methods at a Glance ... 41

The Mechanics of Trees and the Self-Optimization of Tree Shape 43
The Controlling Mechanisms and Their Effect on the Tree 43
Apical Dominance: The Top Rules .. *44*
Geotropism: Stand Up Straight! .. *44*
Phototropism: The Quest for Light .. *49*

The Right Load Distribution: The Axiom of Uniform Stress and Tree Shape ... 53

The Height-Diameter Ratio of the Trunk .. 53
Branch Junctions: From the High-Tech Connection to the Point of Potential Breakage .. 58
Tree Forks: Risk Only with Incorrect Loading ... 61
 The Tension Fork .. *62*
 The Compression Fork ... *64*
Roots: Ingenious Anchors with a Penchant for Social Contacts 67
Wound Healing: Points of Potential Breakage are Speedily Repaired 81
Tree-Stone Friendships: Mechanical Companionship with Inanimate Objects .. 96
Tree-Tree Contacts: Species Difference as a Mechanical Handicap 100
Tree Welds (Grafts): From First Kiss to Life-Long Marriage 104
 The Axial Weld ... *104*
 The Cross Weld .. *106*
 The Strangler Fig: Merciless Welding Artist ... *112*
Advantages of the Social Behaviour of Trees for the Species 114

Annual Rings: The Internal Diary as a Consequence of the External Situation ... 115

Reaction Wood and Helical Grain in the Sawn Section 116
The Sawn Section Through Healed Wounds ... 117
Frost Ribs: The Sick Report of the Annual Rings 118
Contact Reports: A Dead Branch Is Treated Like a Steel Tube 123
Welds: The Tree's Marriage in the Sawn Section 125
Summary of the Rules for Annual Ring Design .. 127

Wood Fibres and Force Flow: The Fear of Shear Stress 129

How Does a Tree Break? ... 141

Transverse Fracture of a Solid Cylinder .. 141
Failure of Thick-Walled Wooden Tubes by Cross-Sectional Flattening ... 142
Shell Buckling: The Tree as a Thin-Walled Tube 144
The Open Cross-Section – The Load-Dependent Chameleon 146
The Devil's Ear ... 147
The Hazard Beam: Fatal Failure or Last Resort? 148
The Wind Breakage of Shallow-Rooters .. 157
Windthrow .. 159

Fibre Kinking: The Beginning of the End .. 160

Can Trees Really Not Shrink? .. 163

Bones: Ultra-Light and Very Strong by Continuous Optimization of Shape .. 165

Bone Design: Selected Examples ... 167

The Femur: Heavily Loaded and Successful ... 167
Healing of a Femur Fracture ... *170*
The Consequences of Hip Prostheses for the Femur *172*
The Vertebral Arch – A Weak Point? .. 175
Trabecular Bone: Micro-Frameworks as Pressure Distributor,
Dash Pot and Light-Weight Internal Architecture 177
Trabecula Axis and Force Flow: The Fear of Bending Load *177*
*Drifting and Rotating: The Wanderings of the Trabeculae in the
Search for Pure Axial Loading* ... *178*

Bony Frameworks and Tree Frameworks Compared 183

Trabeculae and Air-Rooters ... 183
The Reasons Why Bones Are Better at Adapting Their Shape 184

Claws and Thorns: Shape-Optimized by Success in the Lottery of Heredity .. 185

The Tiger's Claw ... 185
Thorn Shape and Load Direction ... 187

Biological Shells ... 191

What Are Shell Structures? ... 191
Why a Shell Theory Is Inadequate for Shape Optimization 192
Tortoises and Nuts .. 195

Bracing: Ultra-Light but Highly Specialized 199

The Advantages of Bracing and Its Sensitivity to Loading
Inappropriate to the Design .. 199
Bracing at the Hip-Joint and in Trees on Eroding Sites:
A Functional Identity ... 201

 Buttress Roots from the Standpoint of Bracing .. 202

Shape Optimization by Growth in Engineering Design 209
 Plane or Rotationally Symmetrical Models .. 209
 The Orthopaedic Screw .. *209*
 Beam Shoulders ... *213*
 Shape Optimization of Three-Dimensional Components 214
 Shaft with Rectangular Aperture ... *214*
 Frameworks .. 217

Unity in Diversity: Design Target and Realization 221

Critique on Optimum Shape: Sensitization by Specialization 223

Outlook: Ecodesign and Close-to-Nature Computer Empiricism 225

New Examples of Application in Self-Explanatory Illustrations 227

References ... 271

Subject Index .. 273

Introduction

Anyone wanting to develop a new car today would not delve first into the mysteries of mail-coach design, and then mentally repeat all the main models of old cars in sequence until finally, after great delay, arriving at today's design problem. Rather, they would study the best types on the market and test how they can be further improved, in order to incorporate such modifications into the chariot of their hopes. Thus they would proceed from the best-known design and measure their product against it.

It is really staggering that, until a few years ago, very little money and manpower had been put into studying design in nature; design which can still hardly be improved upon. Admittedly, anyone who, for example, wants an ultra-light and durable crankshaft of optimized shape, can spend a long time rummaging among old bones or tree parts before finding something useful, if indeed their ever do. The idea of designing, say, a crankshaft by copying a biological load-bearing structure would furrow the brow of the most inveterate optimist with doubts about the performance of such a device under the anticipated range of conditions.

The problem, then, is that direct copies of natural structures are seldom suitable for service, and so this gives rise to a new task: to create a *method* which will deliver components of real biological design quality as regards light-weight properties and durability, without always ending up with the dog's femur, tiger's tooth or bird's wing, but which can also produce a crankshaft exhibiting exactly the high-quality features of biological design. This task was solved in the Karlsruhe Research Centre with the development of the CAO method (Computer-Aided Optimization). In order to show that this method really does produce a biologically optimum shape by computer-simulated growth, it was verified on numerous biological examples. In fact, it emerged that with CAO we can best simulate the healing of knot holes in trees, the formation of special tree-root forms and branch junctions, the shape of tiger and bear claws, forms of thorns and the healing of bone fractures etc., and we can also optimize machine components just like biological structures. All this will be presented to the doubting reader in this book.

However, first we must naturally define what we actually mean by a sensible mechanical construction, by a shape-optimized design. May more biologically oriented readers forgive me, but this cannot be done without a certain amount of basic mechanical explanation, which I will keep to the minimum required for further understanding. One comforting feature of the CAO method is that it does not require those awe-inspiring blackboards full of mathematical derivations. All

that is needed is any commercial finite-elements program with which thermal stresses can be computed, and knowledge of the mechanical loads in question, all of which will be presented to the reader in the next section, so that can be defined 'good design' in a mechanically quantified way.

The Minimum on Mechanics

External Loads and Internal Stresses

The multiplicity of external loads to which a tree component can be exposed can be divided into forces, bending moments, torsional moments and thermal stresses. If the component is not to be moved, these loads must be countered by a support exerting equally large but opposed reaction loads.

The axial forces (Fig. 1) are the simplest example. (As readers with good technical knowledge will presumably skip this section, the following technical concepts have been presented in a way at least partially adapted to a biological readership, using examples observed in nature).

Fig. 1. A bird of mass m exerts by its own weight an axial force $F = m \cdot g$ (where g = acceleration due to gravity) on a post, thus causing the compressive stress $\sigma = F/A$ (A = cross-sectional area)

A fairly plump bird of mass m causes a weight force $F = m \cdot g$, where g is the acceleration due to gravity. This bird is sitting on a post, the weight of which is disregarded here. The bird causes an elastic compression of the post in the axial direction which has a spatially uniform distribution of compressive stress $\sigma = F/A$ (A = cross-sectional area of the post). The soil below the post must exert an equally great but opposite force F if the post is not to sink into the soil. Similarly, axial tensile forces would cause tensile stresses in the post; in this case all the signs would simply be reversed.

The situation is rather more complicated with eccentric loading (Fig. 2).

Fig. 2. If the bird is sitting on a side branch, it induces a bending moment into the trunk via the branch, which increases linearly within the branch and then acts uniformly down the trunk and is added to the weight load. The branch is thus subject to pure bending stress, and the trunk to bending and compression because it also has to take the weight of the bird, as explained in Fig. 1

This time let us place our overweight bird on a side branch. For simplicity's sake, assume the top of the tree is broken off and the tree and branch have no weight. Only the bird's load, its point mass, should count. The bird's weight F acts at a distance l from the trunk, i.e. on a lever arm of length l, and the *bending moment* increases linearly from the bird's perch to the branch junction with the trunk, reaching its maximum value $M_B = F \cdot l$ there. The tree must apply an equally large but opposed rotary bending moment M_B if the branch is not to rotate downwards. As no further forces are induced and there is no change in the lever arm (because of the vertical position of the tree trunk), the same uniform bending moment acts downwards in the whole tree trunk, which finally must again be compensated by the ground via the roots, if the whole tree is not to tip over with the unfortunate bird. Moreover, as in Fig. 1, the weight, $F = m \cdot g$, of the bird must be transmitted to the ground. (In later sections we shall see what an ingenious engineering work of nature the root system of a tree is, with its manifold anchoring tricks!) As before, it causes a compressive stress, but this time acting only in the trunk.

Naturally, the same bending moment in the thin side branch causes much higher bending stresses than in the trunk. For example, assuming a circular cross-section for the branch and the trunk, then the equation for the *bending stresses* is

$$\sigma_B = \frac{M}{I} \cdot r. \qquad (1)$$

They thus increase linearly from the middle of the trunk to its surface, and are tensile stresses in the positive r-direction and compressive stresses in the negative r-direction. R is the radius of the bending beam, and I is the 'area moment of inertia' characterizing the cross-sectional shape. For the cross-section of a circle

$$I = \frac{\pi}{4} R^4. \qquad (2)$$

Inserting Eq. (2) in (1), the maximum bending stress acting on the beam surface is

$$\sigma_B^{max} = \frac{4M}{\pi R^3}. \qquad (3)$$

That means that if the trunk is only twice as thick as the branch, then with an identical bending moment to be borne, the stresses decrease to 1/8 of the branch stresses.

From Eq. (1) and the stress distributions shown in Fig. 2, one problem associated with the bending stress distribution becomes apparent. In the middle of the beam ($r = 0$) the stresses are equal to zero, i.e. neither tensile nor compressive stresses are present. Despite not being fully loaded, this zone within the tree contains wood capable of bearing a load but which is quite useless as regards bending and thus a waste of material. Obviously nature tolerates this deficiency in a tree

anchored motionless in the soil, whereas in a mobile mammal many bones in the zone of the fibres neutral for bending ($r = 0$) are hollow. Accordingly, in the latter no material is placed where there is nothing to carry. Bones are thus tubes, more-or-less.

But a tree also arranges its material sensibly within the narrower limits of its possibilities: trees loaded on one side by wind become elliptical in the wind direction. An elliptical cross-section, however, has a moment of inertia

$$I = \frac{\pi}{4} a \cdot b^3, \qquad (4)$$

where (a and b) are the semi-axes of the ellipse.

Thus, if the tree now deposits all its building materials in the zone of highest bending stress (tension side and compression side) by forming particularly wide annual rings there, this buildup goes into the third power of the larger semi-axis b in Eq. (4), while a widening in the direction of the small semi-axis is only linear. The tree thus forms a non-circular cross-section which is stiffest against the prevailing bending load, and is characterized by smaller stresses than a uniformly circular cross-section with an identical external bending moment. As we shall see later, root cross-sections may even assume nearly the shape of an I-beam which we know from civil engineering (Fig. 3), in which hardly any wood forms in the zone of neutral bending ($r = 0$). Despite all the adaptation of shape, it is probably a nasty feature of nature that the bending load nearly always represents the lion's share of the mechanical burden of a biological component. This is why the component is forced into all sorts of complicated optimizations of shape, but survival of organisms bearing such structures is proof of the success of this strategy.

Fig. 3. The I-beam is particularly optimized for bending loads; it has abundant material in the zone of higher bending stresses (tension or compression) and a web with little material in the zone of smaller stresses. Root cross-sections often assume such shapes, and the warthog's tusk also has this cross-section

Hitherto, axial tension-compression loading and loading purely from bending have been treated separately. Such cases of pure forms of loading are rare in practice. Figure 4 shows how a combination of tension and bending occurs. Here again the weight of the trunk and the large branch are disregarded. The loading occurs only by the upper crown load F_1 and the side crown F_2. Assuming complete calm, the loading will come only from the forces of gravity on the two crown parts. Therefore, in the main stem above the side branch, only the weight of the crown applies, creating there the compressive stress $\sigma_1 = F_1/A_1$. In contrast, a bending moment increasing linearly to the trunk acts in the side branch, as in the previous example (Fig. 2). Therefore, the trunk below the branch junction has to bear both the bending moment caused by the side branch which induces a linear bending stress distribution, and also an axial compressive stress which is increased by the vertical force F_2 coming from the side branch, but is also limited below by the thickening of the trunk. The combined stress distribution is obtained in elastic stress analysis by simple addition of the partial stresses of each place in the component. On the left side of the trunk we have the tension stresses of bending, which in our case are almost completely counteracted by the compressive stresses from the axial forces (F_1+F_2), while on the lower right side of the trunk, axial compressive stress and bending compressive stresses are combined. If, in addition, there was also a bending load caused by wind (not shown here), the associated bending stress distribution would also be simply superimposed. This will be discussed in great detail later.

Fig. 4. Combined axial and bending load induced by the two crown weights F_1 and F_2

Fig. 5. Shear stresses act tangentially to the reference plane. They prevent the connected bodies from sliding on each other along the reference plane

Besides the tensile and compressive stresses resulting from axial tension or compression and the bending stresses (transition from tensile to compressive stresses with a defined spatial, usually linear, distribution) there are also the *shear stresses* (Fig. 5). They are stresses acting tangentially in the shear-loaded plane, and prevent the bodies separated by the shear-loaded plane A from sliding on each other. They are therefore qualitatively very different from the tension and bending stresses acting perpendicularly to the reference plane.

The *torsion* load causes, for example (Fig. 6), a shear-stress distribution in the cross-sectional plane of the twisted cylinder illustrated, which increases linearly from the centre of the cylinder ($r = 0$) to its surface ($r = R$). These shear stresses caused by a torsional moment M_T may also be superimposed with other elastic stresses.

shear stress:
$$\tau = \frac{2 M_T \cdot r}{\pi R^4}$$

Fig. 6. With twisting (torsion) of a cylinder, shear stresses act in the circular section, increasing from the centre of the cylinder to the surface

With our tree, for example, a one-sided crown shape, with one branch extending far out towards the light, could lead to a twisting of the trunk under wind pressure and cause the same shear stresses in the trunk, which would then be added to the other loads already mentioned.

Things would be simple to describe if there really was only one stress component in each instance of loading. Unfortunately, this is usually only very approximately the case in reality. Load situations are usually multi-axial. Different stresses act in different directions. For example, a pair of braces contract transversely as they are pulled lengthwise. We do not want to grapple with the six components of the stress tensor here; interested readers are referred to the literature [34]. However, we cannot completely avoid the multi-axial stress situation because of its later relevance to growth simulation. We just wish to examine the representation of the stress situation defined by the three so-called principal normal stresses σ_1, σ_2, σ_3 (Fig. 7). An imaginary small cube of material within the component is selected so that stresses σ act only perpendicularly to its surfaces and tangential shear stresses τ are completely absent. In this case, the stresses perpendicular (i.e. 'normal') to the cube surfaces are the principal normal stresses σ_1, σ_2, σ_3. Their vectors are often called the 'force flow'. For example, if the cube were pulled in one direction ($\sigma_1 > 0$), then it would contract in the other two directions. These transverse contraction stresses would then be compressive stresses (σ_2, $\sigma_3 < 0$).

If we want to know how the cube is mechanically loaded 'overall', without being interested in the individual values of the principal normal stresses, then it is sensible to define a reference stress. Here we shall use only the *Mises reference stress* (Eq. 5):

$$\sigma_{Mises} = \frac{1}{\sqrt{2}}\sqrt{(\sigma_1 - \sigma_2)^2 + (\sigma_2 - \sigma_3)^2 + (\sigma_3 - \sigma_1)^2}. \tag{5}$$

Fig. 7. When the cube has a certain orientation, only normal stresses act on its surface, and no shear stresses. These normal stresses are then the principal stresses

This Mises reference stress is widely accepted as a failure stress for predicting plastic flow in steel. It plays a great part in this book, because we want to use it to control simulated biological growth. There are other similar stress combinations, which were all probably discovered fairly empirically.

Loosely speaking, the Mises reference stress is a measure of how our poor cube is pulled and pushed about from all sides.

The reference stress has one advantage for subsequent growth simulation: because of the square root in Eq. (5) it is always positive, even though individual stresses vary locally from tension (positive) to compression (negative). Hitherto, we have only considered stresses in the component which transmit the external loads into the bearing support. But naturally, components also undergo *deformation* under external loading.

The connection between external loading and deformations is shown for the case of uniaxial tension in Fig. 8. If a tension bar of length l_0 is deflected by Δl, for which the force F was needed, then the *strain* $\varepsilon = \Delta l/l_0$ is defined as the relative change in length. A linear correlation is simply assumed to exist between stress $\sigma = F/A$ and strain $\varepsilon = \Delta l/l_0$ for small deformations and elastic material behaviour. Hooke's law for this one-dimensional case is:

$$\sigma = E \cdot \varepsilon. \tag{6}$$

The factor of proportionality E is the modulus of elasticity or Young's modulus.

To give two examples, the E-modulus of steel is $E_S = 200\,000$ Nmm^{-2} and that of green wood is of the order of $E_W = 10\,000$ Nmm^{-2} along the grain. Moreover, in biological materials like wood, bone etc. the E-modulus is not the same in all directions, i.e. these materials are not isotropic.

For simplicity, however, we shall assume biological materials to be isotropic. This will naturally arouse mistrust in critical readers, but numerous theoretical studies have shown that in biological structures the main force flow always runs along the grain, an adaptation of their inner architecture. However, as the E-modulus along the grain varies only little within the component, it is acceptable to take it as constant everywhere, thus causing an error only for the transverse stresses which are usually small in any case. Thus we almost always assume a homogeneous isotropic material, even though this is only approximately correct.

The good agreement between theory and nature will support us subsequently and justify these assumptions.

We shall explain the concept of thermal stresses quite briefly on the basis of Fig. 8.

Fig. 8. Axial force, stresses, strain and displacement to explain Hooke's law in the simplest form on a tension bar

Thermal Expansion and Thermal Stresses

Assume that the bar is not loaded by the external force F, but is heated by a temperature difference ΔT which also causes the change Δl in length. The transverse expansion will not interest us here. If we just allow the bar to elongate by Δl, it remains virtually unloaded. However, if we imagine the bar confined by solid walls at both ends, immovably resisting its efforts at expansion, then thermal stresses will build up in the bar. Thermal expansion

$$\varepsilon = \frac{\Delta l}{l_0} = \alpha \Delta T, \tag{7}$$

(α = coefficient of thermal expansion) and Hooke's law from Eq. (6) combine to give the thermal stresses

$$\sigma_0 = E \alpha \Delta T. \tag{8}$$

The thermal coefficient of expansion is a material-dependent constant and must be determined experimentally for each material.

As we have seen, thermal stresses occurr when we prevent the thermal expansion of the bar. Thermal stresses may also occur without mechanical restriction, if temperature gradients exist in the component. We shall use similar thermal expansion processes later in order to simulate biological growth by means of a few tricks.

Simple mechanical problems can be solved merely with this knowledge of the static equilibrium, Hooke's law and the correlation between expansion and displacements. Unfortunately, biological structures usually have a wonderfully functional elegance of design, which is the basis of their survival, but which makes them a real handful to describe in terms of mechanical theory, and analytical approaches based on formulae will inevitably end in disaster after the first faltering computations, because the interrelationships of nature just cannot be captured by formulae. For example, the formulation of the mechanical conditions on

the surface of an elaborate bone simply cannot be pressed into a feasible mathematical framework. Before today's powerful computer methods became available, the shapes of components were approximated by geometrically simplified curves (circles, straight lines, parabolas, ellipses etc.). The resulting mathematical formulae were terrifying, yards long, and at the best not entirely reliable, and then often had to be further simplified for quick rough calculations. Because of all the simplifications, even the proud creator was often no longer sure where the truth stopped and fiction began.

The Finite Element Method (FEM)

It was a revolutionary step when numerical methods of component analysis came together with main-frame computers a few decades ago. Among these incredibly successful methods, the *Finite Element Method (FEM)* will be described as simply as possible, firstly because nearly all the results described in this book were obtained with this efficient tool, and secondly because the method has taken the hearts of industrial design engineers by storm, and because practically everything – from tyres to aircraft propellers, from saucers to skis – has already been investigated in finite-element models, and its stress distribution revealed.

This does not mean that component analysts have not cursed the method wildly in front of their terminals, because for some unknown reason it didn't come out properly, despite all the loving preparation. These curses, however, mean just as little as the coachman's swearing at his faithful old horse, for which he weeps bitter tears when it eventually dies.

In short, engineers in many disciplines would be the poorer without FEM, and the growth simulation presented later in this book has only become possible with this method. But how does this wonder weapon of modern structural mechanics function? The direct solution of equilibrium conditions is dispensed with, and instead the displacements, strains and stresses which ultimately characterize the mechanical load situation of the component are inferred from minimum-energy data.

The selected component is broken down into finite geometrical sections, the 'finite elements' (Fig. 9). These elements are defined with their co-ordinates by their corner points, and in their totality they describe the shape of the component, which may be very complex, without basically endangering the possibility of a solution. This ability to provide appropriate solutions regardless of the form and shape of the component is one of the great advantages of FEM.

Now we must define what material property the individual elements have, i.e. what E-modulus, coefficient of thermal expansion and Poisson's number, which describes transverse contraction. These material data may even vary from element to element, and in analytical solutions this would have caused problems in many cases, so this is a further advantage of the FEM method.

Fig. 9. Some mechanical components and their idealized finite-element models. One half or one quarter of the entire structure provides a sufficient basis for stress analysis of symmetrical components with one or two planes of symmetry. Rotationally symmetrical structures can be represented as a plane longitudinal section whose rotational symmetry is then defined by additional inputs

Initially, it is of decisive importance to formulate the basic service conditions of the component, and how the bearings, clamps, supports or guides are determined (for example, the four legs of a chair must rest on the floor, i.e. vertical displacements are not allowed). Moreover, specific loading must be defined, distinguishing here between line loads, area loads and concentrated loads (Fig. 10). Parts of the contour can be displaced by one piece, either together or one at a time, and this also causes stresses in the component. All this forms the INPUT, which would also have been needed for an analytical theory to formulate the problem.

Fig. 10. Basic mechanical load and service conditions with: **A** line loads, **B** area loads and **C** concentrated loads, and prescribed edge conditions

The component's most efficient energy state is now calculated with an FEM computer program, which in principle is just another way of determining the static state of equilibrium. The displacements, strains and stresses at each point of the component are known with very great accuracy, and the mechanical problem is solved. The actual 'physics' of this very pragmatic method, which the user still has to do, involves forming the model, for unfortunately even here we cannot proceed entirely without simplifications, especially when we interpret the results. These two thought processes will be described again later, so that one message of this book is the approach to presentations of FEM results. Many commercial FEM programs are now available, almost all of which are extraordinarily accurate and some of which are suited for personal computer implementation. As the FEM method is still quite strange to the uninitiated despite the attempted simplicity of this explanation, it will be made more familiar for prospective users by means of the following example of stress analysis of a notched component. (A more detailed introduction to FEM is to be found in [9].)

The Component Killers: Notches and Notch Stresses

The stress distribution in a tension plate with a circular centre hole is shown in Fig. 11. The stress σ_0 that is applied from outside acts at some distance above and below the hole. The hole has a double effect. It reduces the width of the plate by its mere presence, causing a higher stress value $\sigma_1 > \sigma_0$, even if stress is uniform over the weakened cross-section. However, a normal non-optimized notch acts in an even worse and less predictable way.

The force flow approaching the notch from above and below must be deflected around it, like a flowing liquid. The force flow passing around the side of the circular notch must normally cause higher stresses there. These are the notch stresses, the magnitude of which depends on the abruptness of force flow deflection.

Fig. 11. As local stress peaks, notch stresses cause many failures. The stress at the circular hole in the tension plate is increased at least threefold, depending on the distance between the hole and the edge of the plate

In order to illustrate this 'roughness' or abruptness of the force flow deflection, Fig. 12 shows some notch forms differing in dangerousness. Note the enormous dependence of notch effect on the orientation of the notch relative to the load direction. Comparison of the force flow with a flow of liquid is not so far out, although of course the force flow in solid components is a static load distribution that itself has nothing to do with a liquid. The common feature is that a notch shape resembling a ship's bow with a longitudinal surrounding flow will be 'circumnavigated' by the force flow much more smoothly, i.e. with lower notch stresses, than a notch of identical shape exposed transversely to the load, which would result in higher notch stresses. Any notch reduces the cross-section by its own width, and this stress value σ_1 determined by the residual cross-section is identical, irrespective of notch shape. The local increase in stress at the edge of the notch is, however, determined only by the shape of the notch and the abruptness of the force flow deflection which it causes. A pointed longitudinal notch 'cuts' through the force flow more easily than the pointed ends of a ship-shaped notch arranged transversely to the main load. Circular notches behave neutrally with respect to direction. The F factors represent the ratio between maximum stress and applied stress:

$$F = \frac{\sigma_{max}}{\sigma_0}. \tag{9}$$

This *stress concentration factor*, which is sometimes defined as σ_{max}/σ_1, determines the increase in stress due to the presence of a notch in the component, and thus its dangerousness as regards possible component failure [30].

σ_0

$$F = \frac{\sigma_{max}}{\sigma_0} = 1.92$$

Mises stress

high

low

σ_0

$$F = \frac{\sigma_{max}}{\sigma_0} = 9.24$$

FEM: Jürgen Schäfer

Fig. 12. Notch shapes exhibiting different notch stresses but giving identical reduction of the cross-section of the plate. The F values show the increase in the stresses σ_0 applied externally. **A** Elliptical hole

$$F = \frac{\sigma_{max}}{\sigma_0} = 2.56$$

Mises stress

$$F = \frac{\sigma_{max}}{\sigma_0} = 6.14$$

FEM: Jürgen Schäfer

B Slot with rounded ends

$$F = \frac{\sigma_{max}}{\sigma_0} = 3.15$$

Mises stress

$$F = \frac{\sigma_{max}}{\sigma_0} = 3.15$$

FEM: Jürgen Schäfer

C Circular hole

Fig. 13. Very high notch stresses near the edge cause the component to fail through the action of a crack starting on one side of the hole (circular notch) and later running also to the right after the narrow edge strip has cracked. The computer plot clearly reveals the enormous increase in the Mises stresses at the tips of the cracks and at the edge of the circular notch

Crack Propagation

Figure 13 illustrates component failure by the example of a non-symmetrical circular notch in a tension plate. The force flow presses through the bottleneck on the left between the hole and the edge, causing much higher stress there than on the right side of the hole, although it still produces a notch stress at the edge of the hole. If the component is now exposed to cyclic axial loading for a sufficiently long time and carefully enough to avoid overload breakage, the left edge breaks first and the crack propagates slowly at first until it becomes unstable and the final separation occurs with a sudden 'jump'. The slow step-wise growth is called *fatigue crack growth*, and the final rapid rupture is called *unstable crack propagation*. *Overload breakage* is the term used when unstable crack propagation occurs immediately after a first excessive loading. The radiograph (Fig. 14) of implant fractures which happened in patients' bodies illustrates the serious consequences of fatigue cracks initiated by notches.

Fig. 14. Breakage of implants by fatigue fracture initiated by notch stresses

Overview of the Mechanics

Elasto-static problem formulation is based on the following input data:

- Component geometry.
- External loading (forces, surface loads, line loads, bending moments, torsional moments, internal pressure; examples shown in Fig. 15).
- Boundary conditions (bearings, clampings, guides).
- Material data (E modulus, Poisson's ratio v, coefficient of thermal expansion α).

These input data can be used, e.g. with FEM, to calculate stresses, strains and displacements.

- Stresses transmit external loading through the component and into the bearings, which must exert equally large but opposite reaction forces.
- Thermal stresses develop when thermal expansion is impeded by external constraints, or when temperature gradients in the component cause conflicting differences in thermal expansion at different places.
- The Mises reference stress

$$\sigma_{Mises} = \frac{1}{\sqrt{2}} \sqrt{(\sigma_1 - \sigma_2)^2 + (\sigma_2 - \sigma_3)^2 + (\sigma_3 - \sigma_1)^2}, \quad (10)$$

is a measure of the multi-axial loading at each point in the component. In components with a preferred load direction the Mises stress usually coincides very closely with the greatest principal normal stress value.

Fig. 15. Different types of loading and bearing of a component

- Notch stresses develop through force flow deflection in the concave areas of the outer contour of the component (e.g. screw threads). They also occur at internal notches such as drilled holes. The dangerousness of the notch is defined by the stress concentration factor, here expressed as $F = \sigma_{max}/\sigma_0$, where σ_{max} is the maximum notch stress peak and σ_0 is a reference stress far away from the notch in an unaffected part of the component. Figure 16 shows a variety of notches, all of which are concave relative to the contour of the component.

- A notch may be completely harmless in one load direction, yet highly destructive in another load direction, even under insignificant loading. (This influence of notch shape will later be the subject of component optimization by growth, the aim of which is to find notch shapes which do not induce notch stresses.)

- Under cyclic loading, fatigue cracks may be initiated at the places where the notch stresses are highest. Each time the load is applied, stable fatigue-crack growth continues. The crack becomes unstable when it has reached a critical length, resulting in catastrophic component failure by unstable crack growth. In many fields of technology today it is quite common to continue to operate cracked components, and to fix reliable inspection intervals based on the principles of fracture mechanics. This is usually feasible, and avoids unstable crack growth with all its possibly catastrophic consequences.

Fig. 16. Different forms of notch, the concavity of which always causes a deflection of the force flow [20, 21]. The dark dots represent the points of highest notch stresses

The chain of cause and effect shown in Fig. 17 illustrates the main aspects of this pattern of failure. While the previous sections have described how stresses develop in components, how notch stresses are caused by force flow deflection, and how fatigue fractures from notches can destroy components, the following section will show ways of avoiding premature component failure.

Fig. 17. From component loading to fatigue fracture

What Is a Good Mechanical Design?

Components afflicted with dangerous notches could certainly be redesigned simply by over-dimensioning in order to eliminate the chance of failure. The idea here is to use more material (thicker walls etc.) so as to keep the stress, σ_0, acting far away from the notch, at such a low value that the maximum stress $\sigma_{max} = F \cdot \sigma_0$ caused by the notch is still small enough to exclude crack formation. There is little expertise in such a procedure as the component would be senselessly over-weight, although unfortunately this is sometimes current practice. This solution to the problem is also bad in other ways: the zones far away from the notch are by no means fully loaded and represent unnecessary ballast during the working of the component, which uses up energy, while the zone near the notch with just adequate material leads an uneasy life on the brink of potential fracture.

In the hard struggle for existence, which occurs every day in nature with terrifying pitilessness, such a design would, in many cases, be a death sentence. An antelope dragging around 20 kp more weight because its bones are poorly constructed and contain unnecessary material having no real load-bearing function would be the first to be caught by the leopard because it is the last in the fleeing herd. Conversely, a poorly 'constructed' leopard is too slow in the attack, and does not reach the light-footed antelope or lands bang on the metre-long spikes of a mettlesome oryx.

These considerations show very clearly that there can be only one good mechanical design, namely the one in which there are neither weak places (locally high stresses = notch stresses!) nor underloaded zones (useless ballast!). In the final analysis this means that for a given operating load the stresses must be completely uniform everywhere in the component, i.e. the load is fairly distributed (*axiom of uniform stress!*). Only in this case will every part of the component be fully loaded. In loading from bending this demand for uniform stress is reduced only to the surface of the component, because of the zero passage of bending stresses in the zone of the neutral fibre (as shown in Fig. 2, where the positive tensile stresses pass into negative compressive stresses). Material wastage must occur in accordance with this theory (trees, but not bones), in which case the cross-sections can be made hollow, as is often the case in bones.

One may object that the loading may well alter during the life of a component: a tree receives wind from the north and not only from a westerly direction. Quite right! But this can be taken account of by an adaptation of shape in the time-weighted average, and this also happens in nature. A tree actually experiencing only wind from the west would be a thin board with the long side of the cross-

section pointing from east to west (great stiffness!). The smallest puff of wind in the north-south direction would kink it, and with the smallest deviation its own weight would speedily assist. The clever tree takes account of the admittedly somewhat more moderate wind loading from the north or south by forming an oval cross-section, with the large axis pointing in the east-west direction (Fig. 18), in which it is therefore stiffer.

All this should make it clear that the quality of a structure is determined by processes that conform to the *axiom of uniform stress realized as an average over time*. In nature such a design is acquired in two ways:

- By *natural selection*, without any potential for short-term corrections in shape to altered loads. (An example of this is the tiger's claw, the horny material of which is practically dead and can no longer be corrected by growth, once it is present in fully grown form.)
- By *adaptive growth*, which usually makes possible life-long adaptation of the shape of trees and bones to ever new loads, and thus allows them to react flexibly. This mechanism is naturally also successful in the short term and is a work of genius by nature.

Fig. 18. Adaptation of the shape of a tree's cross-section by ovalization in the direction of the strongest wind. Conifers form compression wood on the lee side, whereas broadleaves form tension wood on the windward side

As we shall see later on, both these mechanisms allow the demand for uniform stress to be realized and thus promote optimum component shape. Only in the case of adaptively growing biological components, however, is subsequent improvement, correction and repair and an adaptation to altered loads possible. Accordingly, it is this mechanism which will be of special interest to us. Before we proceed, it may be mentioned that the biblical injunction *'bear one another's burdens'* is also in the final analysis the demand for the *axiom of uniform stress*. In no way does it mean: I'll take all the burden from my partner. As this call is directed to everyone, the end result of load sharing is a uniform load distribution. We do not wish to concern ourselves here with the realizability of biblical injunctions, but rather to restrict ourselves to mechanical design. If interested, theologians may like to test this generalization of the *axiom of uniform stress* themselves.

The Axiom of Uniform Stress and How Computer Methods Derive from It

Notches Without Notch Stresses?

However plausible everything may sound, a generally valid proof for *the axiom of uniform stress* will hardly be possible, given the rich diversity of species in nature. Still, there will certainly be hardly any real doubt that it does make sense to avoid both weak places and superfluous material, which in the final analysis is just what this uniformity of stress means. In Fig. 12 we have also seen that a notch does not always necessarily cause high notch stresses; its shape is much more important.

Shape optimization in nature is incredible and wonderful: *natural and adaptively grown notches do not cause notch stresses as long as they are properly loaded!* They deflect the force flow so suitably and gently that no excessive stress occurs. Now what this means as regards saving material is explained in Fig. 19 with the example of a tension plate. Assume that the quadrant notch in the non-optimized design (Fig. 19A) has a stress concentration factor F = 2.0 (which is a realistic value), and thus locally doubles the externally applied stress. In order to exclude premature component failure, the value of this stress σ_0 is kept so low (while giving the component an adequate thickness, t) that no crack formation occurs even at the place of highest stress σ_{max}. Now if the notch is given an optimized shape (Fig. 19B) which causes no excessive stress (F = 1), then the stress applied from outside can be increased to σ_{max}, which the non-optimum but excessively heavy component was able to withstand. With identical axial force, this thickness can be halved in the shape-optimized component, because of the reduced notch tension. The weight saving would then be 50%, and your heavy rucksack would be only half as heavy – what bliss for carefree hiking, and what a simple thing for our antelope to sprint away from the stalking leopard!

But how does this wonderful shape optimization of biological notches occur? The cross-section through a pine which had been previously injured (i.e. notched!) shows the principle (Fig. 20).

Fig. 19. Example of light-weight design in accordance with the axiom of uniform stress (tension plate). **A** Non-optimized, **B** optimized

Fig. 20. Locally thickened annual rings indicate deposition of additional material in the overloaded zone on both sides of the notch caused by earlier wounding of a pine (drawing from a photo)

The annual rings thicken locally on both sides of the notch (A-A') around which the force flow running down the stem had to be deflected, thus inducing notch stresses. Accordingly, additional material is deposited. Thus the deflected force flow has a greater area available over which it can be distributed, and the notch stresses are thus reduced until uniformity of stress is again created. Whereas trees can only build up material, bones are also capable of removing material which is underloaded and thus merely ballast. The reason for this is probably the greater requirement for lightness in mobile animals as compared with the tree anchored in the ground and which does not need to run about.

In simple words *adaptive growth* can be defined as follows:

- Buildup of material at overloaded zones.
- No buildup of material (trees) or even reduction of material (bones) at underloaded zones.

This staggeringly simple concept is now being transposed into computer methods for simulating adaptive growth. Later, we shall see how real biological components can be imitated in their growth, and engineering components trimmed to maximum durability at minimum weight.

Fig. 21. Flow diagram of the CAO method for computer simulation of adaptive growth for shape optimization

Computer-Aided Optimization – Growth in the Computer

The incredible success of this computer-aided method for optimizing the shape of mechanical and also biological components is based on exactly copying what the cambium of trees does and what the cross-section (Fig. 20) through the injured pine obligingly showed us: growth occurs at overloaded zones and no growth or even shrinkages occur at comparatively unloaded zones. The following CAO procedure (Fig. 21) was developed for simulating the application of this principle at the Karlsruhe Research Centre [17, 19]. It has since been tested on over 300 biological and mechanical components, and has been applied in many German industrial undertakings and also in institutes and commercial enterprises in other countries.

The method will be explained using a tension plate (Fig. 21) as an example. It consists of the following steps:

1. Produce a finite-elements structure corresponding to a first draft (design proposal) of the desired appearance of the component. All the functional aspects of later use are also incorporated. The FEM structure should, if possible, have a layer of elements of equal thickness on the surface, at least in that zone where later 'growth' is to occur. This layer of elements corresponds to the cambium of trees.

2. Carry out an FEM computation with the planned future operational loading and support (our tension plate is pulled on the left and clamped on the right). As a result of this calculation we obtain the nodal point displacements at each node of the network, the strains and the stresses, and with Eq. (5), the Mises reference stress. Thus we now know where notch stresses are occurring in the component. Adaptive growth is now simulated with a trick.

3. Set the computed stresses (more precisely, the Mises stresses) formally equal to a fictitious temperature distribution, which may seem like a criminal act because of the different units of measurement of stress and temperature. But that does not matter, for we still find that the places previously having the highest mechanical stress are also the hottest places in the component. Moreover we still set the modulus of elasticity in the upper layer only at ca. 1/400 of the initial value. Thus we have a soft upper layer which is still particularly warm at the previously overloaded zones and rather cold in the unloaded zones. Now comes the actual growth.

4. In a further FEM computation stage only the thermal load is considered, the previous mechanical load (tension) now being set at zero. Moreover, only the soft upper layer will have a thermal expansion factor $\alpha > 0$. The solid material under the soft upper layer, which corresponds to the cambium of trees, cannot expand thermally. During this computational stage with only thermal loading, our 'pudding-soft' upper layer will expand corresponding to its temperature distribution, and it is this that is the 'growth'. Zones which previously expe-

rienced the highest loads (in computation step 2) now have the highest temperatures and expand most strongly, i.e. they grow most. Because the layer is so pudding-soft, jamming of neighbouring elements does not occur – they all grow among each other, automatically yielding compatibly outwards in a direction approximately perpendicular to the surface. These stress-controlled thermal increments

$$\Delta l = l_0 \cdot \alpha \cdot (T - T_{ref}),$$

can still be multiplied by a sensible enlargement factor, if the calculated increment is not quite sufficient. If the FEM network has distorted badly, it can be corrected again using our software. $T_{ref} = \sigma_{ref}$ is thus a stress value to be determined by the engineer, and which we would like to have as an operating stress everywhere in the component. (A note only for potential users of the method: the simplest way for network correction was developed by my previous co-worker Dr. Lothar Harzheim: in a third computation run apply the calculated thermal increments as prescribed displacements to the structure which is neither thermally nor mechanically loaded, and the whole FEM network is displaced with it in a wonderfully staggered way and its homogeneity is best preserved. Large element deformations would otherwise reduce the accuracy of computation.)

5. The structure already improved by growth in computation step 4 is already a little bit shape-optimized, and occasionally one such growth cycle is sufficient. This is checked by again setting the E-modulus of the soft layer at the value of the basic material and starting at step 2 with a new FEM computation under purely mechanical loading, which will deliver a more homogeneous stress distribution with greatly reduced notch stresses. The computation loops 2–5 are run through repeatedly, until (as in Fig. 22) all the notch stresses are completely eliminated, or until – as sometimes happens in practical cases – construction conditions forbid further growth. One can clearly see in Fig. 22 how the notch stress (colour blotch in the notch zone!) is reduced and distributed more uniformly.

For successful optimization of a component, as we have already often done for industry, 2–5 iterations are usually sufficient, the exact number depending on how close the draft design already was to the shape-optimized form, which corresponds to the natural design.

The *advantages of the CAO method* are obvious:

- The user can use any commercially available FEM program and thus can save money on optimization software, provided that the FEM program can compute thermal stresses, which is not always the case.

Tension Plate with Narrowing Cross-Section

Fig. 22. Optimization of a tension plate by the CAO method. For constructional reasons the ends should retain their shape, and only the transitional zone near the notch may grow. For reasons of symmetry, creation of half the structure is sufficient

- Two- and three-dimensional components can be optimized in like manner, without needing any special problem-specific tricks. Only the FEM structure must be created for the component to be optimized.
- It is possible to take zones of the component out of the growth region if the later application requires this (construction constraints!).

The only *disadvantage of the CAO method* comes before it has even been applied: *in the design proposal!* Even if the proposal is pitiably defective, it will grow into a better shape-optimized form. However, this does need a solid chunk of computer time, and a certain expenditure for correcting the FEM network because of the large increments or shrinkages then necessary.

The problem of initially defective design was eliminated by the development of a method for *automatic creation of the draft design*. In a first variant this *'Kill Option'*, which excludes or eliminates the 'shirkers of the component' i.e. non-bearing zones, worked a bit too radically. However, the method was refined by my previous co-worker Dr. Andreas Baumgartner with great mechanical feeling, by no longer eliminating all the shirkers of the component at once, but rather by carefully weeding out the non-load-bearing material according to the load distribution. Moreover, the resulting optimization only takes place after repeated computational verification, without any injustice to anyone. Mathematically this is called the 'iterative process'. Because of this rather less drastic procedure, this improved method was called the *SKO (Soft Kill Option)*.

After explaining the SKO for creating design proposals, the reader will then have been given all the mechanical-mathematical tools necessary for further understanding, then its application will be demonstrated on trees, bones and machine components, and its results made credible.

Soft Kill Option: Away with the Ballast!

At a first idle glance it seems the easiest thing in the world to create a draft for a mechanical component whose later function is known.

Fig. 23. A design draft difficult to divine, with multiple load applications at different load heights, at different places and with multiple support in different ways

A look at Fig. 23 will, in most cases, suffice to transform this unbridled designer pride into inconsolable misery. Of the components pictured there, the only things known are their external measurements (length, width, height), their supports and the complex working load to which they are exposed. The task is to shape the object so that it is as light as possible and yet durable. For this, its external shape will certainly have to differ from the all too simple block form, and certainly holes and recesses will also have to be incorporated where there are unloaded zones. The only awkward thing is that a hole in the wrong place or even in the right place but of the wrong form will again cause ugly notch stresses, from which nasty little fatigue cracks will then rapidly spread during work, causing the component to break into at least two pieces with a very loud bang and great resultant damage long before the expiry of its planned working life. This means that even a conventional first design draft places the highest professional and moral demands on the creator of the future components. The SKO method reduces human error to a minimum, and in really complex cases makes it possible for the first time to find a draft design that is already close to the optimum.

The *Soft Kill Option (SKO)* can now be used computationally as follows in two ways (Fig. 24):

Fig. 24. Flow diagram of the SKO method

Stress-Controlled E-Modulus Distribution:

1. Create a FEM network for a rough design draft in which its external dimensions do not exceed the limits prescribed by the later function, but is preferably too large rather than too small because this design draft can be reduced (*Kill Option!*) but cannot be enlarged as regards its external dimensions. In simple words: the first draft can be as wrong as you like, but it should always be too large.
2. Carry out an elastic FEM calculation with the working load expected in service and the same supports, restraints and guides, which will produce a stress distribution in the component. (Mises reference stress is generally used here too, and in special cases the quantitatively greatest principal normal stress σ_1).
3. Now the local E-modulus is simply set equal to the stress calculated at the particular place ($E = \sigma$!). This means that the more highly loaded zones become harder, and the less loaded zones become softer. The industrious zones of the component become stronger and the shirkers of the component become even more work-shy. Thus, the formerly homogeneous material becomes non-homogeneous, and the component is characterized by variation in its E-modulus at different places.
4. With this new and now non-homogeneous structure, a new FEM stress calculation is carried out, in which the strong load-bearing zones carry even more, and the previously unloaded zones of the component carry even less, which causes a sharper contouring of the actual structure. Steps 2 and 3 are now repeated again and again, the stresses in the non-load-bearing zone below a certain minimum value being set at zero. Thus the shirkers in the component are 'killed'. The iteration method is ended when there is no longer much change in the component design.

Thus an automatically created design draft is produced which, as desired, only contains material at the actual load-bearing places and in which the values of the modulus of elasticity, now varying only slightly locally, are again standardized (E = const., i.e. transition again to the homogeneous material!).

However, the component drafts thus created are really only a light-weight draft which may still have considerable notch stresses and need not even be durable. The SKO method thus delivers an already pre-optimized light-weight design which then still needs to be shape-optimized to a more refined form by the CAO method, in which the last underloaded zones are shrunk away, and notch stresses are also reduced by local growth (Fig. 25).

The stress-controlled designing by SKO just described has the great advantage of converging into a final design. On the other hand, some iterations are still necessary, which can be numerically reduced by the stress-increment-controlled method described below.

Fig. 25. A Diagram of the design process by the local increments method (SKO) and **B** the global increments method (SKO), each followed by the CAO method

The Stress-Increment-Controlled SKO Method

Here, the procedure in the first run is identical to that in the stress-controlled method. In the following iteration steps the calculated stress is no longer put equal to the local E-modulus, but the local stress increment (local increments method) from the n-th to the (n+1)-th FEM run is put equal to one increment of the E-modulus $\Delta\sigma = \Delta E$. This increment is added to the existing E-modulus distribution

$$E_{n+1} = E_n + \Delta\sigma_n, \qquad (11)$$

before a further computer run is made. With this new E-modulus distribution we now continue computing and again weed out the non-load-bearing zones in the design draft by iteration. The advantage of this increments method is its rapid effectiveness even with few iterations. However, there is a little snag even here: the convergence of the method towards an optimal form is not assured without further ado. It is easy to overshoot the point where a good design is reached, increasingly dispersing a stress component (though in an entirely sensible way!), so that the limits of later manufacturing possibility are quickly passed. Indeed, foam-like micro-frameworks recalling spongy bones may even emerge, which make the manufacture of the component very expensive if not quite impossible. The art of the designer is to stop after a sensible component design has been obtained, which also allows consideration of aesthetic aspects. Anyone who fears this decision should use the *global stress-increment-controlled method* proposed by my colleague Dr. Lothar Harzheim. For this, a reference stress σ_{ref} is determined, as previously in the CAO method. Here again, we have the risk-free stress value which everyone wants as the component stress in the working of the component. This is essentially the uniform stress value after which the axiom of uniform stress is named, and which every tree or bone itself adjusts, tends and nurses by adaptive growth. Equation (11) thus becomes

$$E_{n+1} = E_n + k\,(\sigma_n - \sigma_{ref}). \qquad (12)$$

Thus the stress difference $\Delta\sigma_n = \sigma_n - \sigma_{n-1}$ is not provided with a place-dependent reference stress σ_{n-1} as in (11), but is the same everywhere. It is particularly successful if the σ_{ref} value is first selected small and is then slowly increased during the iteration up to the desired working stress. This SKO variant is particularly recommended for industry designers with deadlines.

Figure 26 demonstrates the three SKO variants, using the example of a cantilever beam. The similarity of the design in the initial phase changes increasingly as a result of the different procedures. However, the three SKO procedures all deliver a light-weight design proposal which should later be shape-optimized with CAO as a fine tuning.

$E_{n+1} = \sigma_n$ $\qquad E_{n+1} = E_n + k\,(\sigma_n - \sigma_{n-1}^{\text{local}})$ $\qquad E_{n+1} = E_n + k\,(\sigma_n - \sigma_{\text{ref}}^{\text{global}})$

n=5 n=20 n=110, σ_{ref}=3.5

n=50 n=50 n=210, σ_{ref}=5

Fig. 26. Demonstration of the SKO variants on a horizontal beam clamped on one side with an end-load (cantilever). Stress method (**left**); local increments method (**middle**); global increments method (**right**)

In a certain way the SKO method resembles the biological mineralization process in living bone. There too, more heavily loaded zones are strengthened. Like the CAO method, SKO makes do without mathematical optimization methods, and here too nature (bone mineralization) is being copied; this pays off in simple straight-line applicability with simple standard FEM programs and a far-reaching guarantee of success.

The methods have been described with due brevity but so fully that a computer buff should be able to program them without any trouble; for the reader less deeply interested in mechanics, and who has perhaps already switched off, the mechanics and the FEM, CAO and SKO methods used later are presented once again in highly compressed form in the following section. Obviously, the exactitude of the presentation must lose a little.

Presentation of the Methods at a Glance

- The technical problem is set by the approximate dimensions of the component (limiting dimensions), the external loads involved, and the limiting conditions (clamping, support, guides etc.).
- Mechanics will deliver the stresses, strains and displacements in the component, e.g. with the finite-element method (FEM) as a numerical tool.
- The *Soft Kill Option (SKO)* eliminates non-load-bearing component zones which would only be useless ballast, and thus provides an already well pre-optimized *light-weight design proposal* which may however still have notch stresses.
- With *Computer-Aided Optimization (CAO)* these notch stresses are reduced by simulated biological growth and removed by shrinking any non-load-bearing zones still present.
- *SKO* and *CAO* realize the axiom of uniform stress and create durable and ultra-light components with maximum life at minimum weight. This is shown schematically in Fig. 27 and is also summarized under the term component layout.

Expressed in popular scientific terms, the engineer's rough design draft is the axe-trimmed blank, the SKO design draft is the planed model, and the CAO result is the finely sand-papered and polished ECODESIGN.

Of the procedures presented here, SKO (analogous to bone mineralization) and CAO (analogous to adaptive growth), which *simulate the achievement of biological design*, are new [2, 17].

To show how these methods function in practice, in the course of this book they will be tested first on biological components (trees, bones, claws etc.), and then their efficiency for optimizing technical components will be demonstrated.

Because it was trees which stimulated the author to investigate biological design, it is these 'instructors' of ours which shall now be the first to be described biomechanically in some detail.

```
                ┌─────────────────────────────────────────────┐
                │         ROUGH DESIGN DRAFT                  │
                │ WITH LOADING, SUPPORT AND LIMITING DIMENSIONS│
                └─────────────────────────────────────────────┘
                      │                               │
              ┌───────────────┐               ┌───────────────┐
              │   SIMPLE      │               │   MULTIPLE    │
              │   SOLUTION    │               │   SOLUTION    │
              └───────────────┘               └───────────────┘
                      │                               │
          ┌───────────────────────┐       ┌───────────────────────┐
          │   SKO, GLOBALLY       │       │    SKO, LOCALLY       │
          │ INCREMENT-CONTROLLED  │       │ INCREMENT-CONTROLLED  │
          └───────────────────────┘       └───────────────────────┘
                      │                               │
              ┌───────────────┐           ┌───────────────────────┐
              │ LIGHT-WEIGHT  │           │ LIGHT-WEIGHT DESIGN   │
              │ DESIGN DRAFT  │           │ DRAFTS OF DIFFERING   │
              └───────────────┘           │ SIMPLICITY AND BEAUTY │
                                          └───────────────────────┘
                            ┌───────────────────────┐
                            │  AESTHETIC FACTORS    │
                            │ AND PRODUCTION ASPECTS│
                            └───────────────────────┘
                      │
              ┌───────────────┐
              │     CAO       │
              └───────────────┘
                      │
              ┌───────────────────────┐
              │     ECODESIGN:        │
              │ ULTRA-LIGHT AND DURABLE│
              └───────────────────────┘
```

Fig. 27. Component layout by biological growth

The Mechanics of Trees and the Self-Optimization of Tree Shape

The Controlling Mechanisms and Their Effect on the Tree

There are more than just three growth regulators which have been described in detail [35, 37, 39]. The fact that only three of them are discussed here is because they are particularly important. We shall also soon see that the effects of apical dominance and phototropism may even involve mechanical disadvantages for the tree, but are nevertheless necessary for its survival.

Fig. 28. Three growth regulators and their effect on tree shape

Apical Dominance: The Top Rules

It is certainly harder to hold a bucket of water with one's arm stretched out horizontally than to carry it on one's head. Despite this, many branches on free-standing trees tend to grow away from the trunk, because they are receiving a signal from the leading shoot commanding them to keep their distance; this rather favours stronger growth on the upper side of the branch (epinasty), so that the branches bend downwards (Fig. 28). This process is called apical dominance. Growing away from the trunk, the branches also receive more light than would a bundle of branches lying close to the trunk and pointing upwards. This latter situation is only found in extremely dense stands, e.g. with beech, where the wind loading of a crown located so high up in the top of the tree would act on the longest lever arm, namely the full length of the trunk. However, this is of little importance in such dense stands because of the mutual shelter. Now, if the leading shoot falls sick, or breaks right off as a result of wind or snow load, it no longer makes sense for the nearest side branches to respect their weak leader. As happens in our human society, an ambitious high-flier quickly emerges and boldly grabs the dud's place. This mechanism is called geotropism.

Geotropism: Stand Up Straight!

Geotropism, or more accurately negative geotropism, gives the side branches and also the trunk the command: grow erect against gravity. Now, if the leading shoot dies, the side branch previously obeying the demand for distance forgets all its boot-licking subservience and accomplishes sometimes quite incredible feats of bending itself in order to become a leading shoot itself after the old leadership disappears. Figure 29 shows such an example, and the corresponding computer simulation, which reproduces the biological process fairly accurately. This self-bending of the branches works rather like a bimetallic strip. The branch to be righted puts on so-called reaction wood, which in broad-leaved trees is a contracting tension wood on the upper side of the branch, and in conifers is a compression wood on the lower side of the branch (Fig. 30).

The very successful computer simulation was programmed by Dagmar Gräbe at Karlsruhe: an FEM structure of the tree is created, and the surface of the branch or stem to be righted is covered with a uniformly thick layer of finite elements, the 'reaction wood'. In broad-leaved trees this layer is simply cooled off on the upper side of the branch, which thus becomes shorter on the upper side and is pulled upwards (tension wood). In conifers, the layer on the underside of the branch is heated up, tries to expand longitudinally, and presses the still cold upper part of the branch upwards against gravity, just as negative geotropism commands. It proved advantageous to allow only thermal expansion in the direction of the longitudinal axis of the branch, and to suppress radial growth. However, it is not done by simply heating up or cooling down, because without reference to gravity this would only lead to a spiral 'winding up' of the branch. The branch must be

told a lot more before it can be satisfied with its orientation relative to gravity. This is done by a trick: just put the angle α which the branch forms with the trunk above, and which is a measure of the deviation from the ideal state (verticality), equal to the temperature in the reaction-wood layer of the FEM structure. Thus a vertically righted branch forms no more reaction wood, while a rather horizontal branch still cools down considerably on the upper side (broad-leaved tree) or heats up on the underside (conifer), in order finally to become a new top. It cannot take as much time as it likes for this, because there are often several candidates for the coveted position, which then enter into a spirited reaction-wood competition. If one wins and becomes the new top, it soon sends new signals of its dominance downwards in order to stop the competition from further reaction-wood formation, which sensibly saves the tree a lot of material. In all this, the use of thermal expansions is naturally only a computer trick to simulate the effect of actual reaction wood. The real tree does not heat up at all.

From the above it becomes clear that apical dominance and geotropism play a similar competing and yet ultimately serving role, like government and opposition in politics. An almost leafless leading shoot, incapable of absorbing light and yet holding down well-endowed side branches having lots of foliage, would correspond to a dictatorship.

Computer Simulation of Negative Geotropism

initial design

FEM: Dagmar Gräbe

Fig. 29. A side branch taking over leadership. Reality and computer simulation

Fig. 30. Tension wood which contracts on the upper side of parts of broad-leaved trees, and compression wood which elongates itself on the underside of parts of conifers

There is another interesting phenomenon with these branch corrections, namely meander formation. It is shown in Fig. 31 as the result of a computer simulation, and is often also called 'over-correction'. The story of its origin is also the explanation of this phenomenon: after the suppression or departure of the leading shoot, the side branch rights itself and soon brings its end into a vertical position. However, as the base of the branch does not itself become vertical for a long time, it merrily goes on forming more reaction wood, thus bringing the upper end of the branch (which was extremely satisfied with its wonderful vertical position) past its proper destination (verticality!) and into an inclined position on the other side. As this inclination is initially small compared to that of the base of the branch, the tip of the branch must be very thin compared to the base, if the self-bending now in the opposite direction is to keep the top in the vertical position with such a moderate stimulus. (In Fig. 29 this was not the case, however. The top remained vertical, without over-correction). In contrast, a stiff branch end may go well past the desired vertical (Fig. 31), and only when the angle assumes a significant value does the new top succeed in bending itself back again out of the over-corrected region by putting on reaction wood on the opposite side. Unfortunately, the same mishap often recurs above the secondary correction, and the branch assumes that meandering form which a more flexible top avoids, instead forming an individual knee, narrowing increasingly downwards, the radius of which is limited only by the inherent stiffness of the base of the branch (Fig. 32), the development stages of which are shown by the computer simulation in Fig. 29.

Meander Formation after Over-Correction

initial design

FEM: Dagmar Gräbe

Fig. 31. Meander formation when the end of the righted branch is very stiff

Geotropic correction is observed not only in side branches after suppression or disappearance of the leading shoot, but also in the actual trunks of trees. On steep slopes one can often recognize so-called sabre trees which have been forced out of the vertical by snow-slides or earth-slips and are righting themselves again by reaction-wood formation. The computer simulation is presented in Fig. 33, where the advantageous shift in the centre of gravity is also shown.

The biomechanical advantage of these negatively geotropic self-corrections of tree shape is firstly that a favoured branch absorbs light and facilitates height growth as a new vigorous top (Fig. 32), and secondly that unnecessary bending loads are minimized, especially at the foot of the tree where they would impose additional loads on the root system (Fig. 33).

The important mechanical effects of geotropism may be listed again as follows:

- Superseding of weak leading shoots by potent side branches.
- Righting tipped stems into the vertical.
- Hence minimizing of the gravitational bending load at the foot of the tree.

Fig. 32. A tree with an extreme knee of increasing curvature (see also Fig. 29)

- Control is achieved by the angle which the displaced part of the tree forms with the vertical. We shall not speculate here about internal receptors for measuring direction. We shall merely mention that starch globules in the microstructures of the tree are believed to play a part [3].
- With top replacement, an increasingly curved knee is formed, if the re-oriented branch has an end that is flexible relative to the base of the branch.
- With a stiffer branch end, meander formation may occur over extensive parts of the new top, reaction wood being alternately formed on opposite sides.

This wonderful mechanical counter-balance of government (apical dominance) and opposition (negative geotropism) would be a perfect object for biomechanical study, were it not for phototropism which, unfortunately often with all too good a reason, may inveigle the tree into the grossest mechanical stupidities.

Sabre Trees

initial design

FEM: Dagmar Gräbe

Fig. 33. Minimization of the bending load at the foot of the tree due to gravity by negatively geotropic shape corrections, and computer simulation. (Photo: Dr. Schwabe-Kratochwil)

Phototropism: The Quest for Light

The optimum shape is a wrong investment if the tree is in darkness. This quite banal tenet on the importance of assimilation will, by itself, give phototropism a dominant role over the two previous growth regulators. Who is then surprised that it is precisely this quest for light (phototropism) which makes trees cast aside all these mechanical advantages, apparently without a care. Figure 34 shows some such cases, where trees are still trying with outstretched branches or stems to catch a bit more light. However mechanically inappropriate this may appear, it does make sense. Without light the tree will die, and it has no other choice than to trap the extra bending load by an increase in secondary thickness growth, thus limiting the stresses.

Later, we shall see that these outstretched and then upwards curving branches, often seen in willows reaching out for the light over small ponds, may cause a fatal accident, as will be described in the chapter on the hazard beam. Here, we shall confine ourselves to stating that phototropism is the dominant tendency of trees or branches to grow in the direction of light from one side.

Fig. 34. Two examples of phototropic growth and the resultant unavoidable bending load

A summary description of these three growth regulators is repeated below:

- *Apical dominance*: the top shoot's claim to leadership, which suppresses the side branches from growing up too steeply.
- *Negative geotropism*: a righting mechanism which allows the tree to grow vertically against gravity by forming reaction wood.
- *Phototropism*: the tendency of trees to grow towards the light.

These three mechanisms act partly in unison and partly against one another. They react to environmental influences, and adapt the tree's shape to new circumstances. Each one acting for itself alone would be disadvantageous for the tree (Fig. 35). Together with other influences such as temperature, soil moisture, soil chemistry etc. (not discussed here), they are successful in a dynamic equilibrium with each other and with environmental influences. They 'watch out' for one another in competition, or they help one another, all having only the one goal of making the tree strong in its struggle for existence against neighbouring trees, its pitiless rivals in the competition for energy and living space. However, because these very competitors are using the same means from the same sources with the same goal, this is a competition for their most economical usage, i.e. for the best mechanical design. For example, in a dense stand it means growing taller than the neighbour and yet being stable enough to survive the next storm.

In the previous section it was shown that the axiom of uniform stress must be valid as a rule for an optimum mechanical design without weak places (potential fracture points) and without useless ballast, i.e. with a fair load distribution. We shall now discuss what the consequences are of this very plausible axiom for tree shape, and how it copes with external loads.

Fig. 35. The success of growth regulators lies in their interaction, their togetherness and opposition, and their self-regulating mutual control (exaggerated schematic representation). Each acting alone is disadvantageous. **A** Apical dominance alone; **B** geotropism alone; **C** phototropism alone

The Right Load Distribution: The Axiom of Uniform Stress and Tree Shape

The Height-Diameter Ratio of the Trunk

The fact that a tree trunk is thick at the bottom and thin at the top may seem so obvious to us that we are unlikely to enquire about a deeper mechanical significance. And yet this tapering of the trunk is probably the simplest and most obvious kind of component optimization which our instructor, the tree, can reveal. As the main loading of the tree is the wind load, acting transversely to the trunk and inducing a bending moment (Fig. 36), it is naturally important whether the crown of a tree is localized high up on the trunk, as is often found in trees in a dense stand (Fig. 36A), whether it increases rather linearly from top to bottom, as is often the case in free-standing conifers (Fig. 36B), or whether, as shown in example (C) in Fig. 36, the foliage is distributed almost uniformly over the length of the trunk. The latter is achieved quite well in Lombardy poplars. In Fig. 36, the relevant lengths are shown as 'h', it being assumed here that the distribution of the wind pressure is proportional to the projected crown area. The bending stresses on the trunk surface can be calculated from these distributions with Eq. (3), assuming a circular trunk cross-section. Now, assuming that the tree trunk is a component optimized over millions of years of evolution and satisfies the *axiom of uniform stress*, we only need to put $\sigma_{max} = \sigma_1 =$ constant in Eq. (3) and we obtain a relationship $D(h)$, i.e. between diameter and measured distance h, as explained in Fig. 36.

Fig. 36. Crown form and height-diameter relationship of tree trunks

These consideration were first put forward by Metzger [28] for spruce trunks. These admittedly quite rough theoretical predictions actually correspond amazingly well with reality. Discrepancies can be explained e.g. by different wind velocities at different heights, which again depend on stand structure, for example whether there are bushes growing underneath, or whether hedges, walls etc. are reducing the wind loading near the ground. A general reduction in the wind velocity only reduces the uniform stress σ_1 and thus does not disturb the functional relationship h(D). However, the proportionality factors are reduced, and the diameter differences from bottom to top come out smaller, as we have all observed in a dense pole stand. If the storm is able to break into this snug world, then the often extensive wind breakage shows very clearly that a thicker trunk would have been needed to defy this unexpected force of nature. Besides the existing shape optimization, which only provides uniformity of stress on the component's surface, the actual value of this uniform stress, here called σ_1, must also be limited in absolute numerical terms.

Finally, we shall present some amusing and yet biomechanically sensible and substantial special cases, which illustrate the tree's readiness to adapt its shape even for special mechanical situations.

Figure 37 shows a conifer on a wind-exposed site which had been rigidly fixed by a tripod of thick sticks 6 years previously, in order to support the young tree. The tree obviously thought it unnecessary to put on very much wood in the part where the sticks were eliminating the wind-bending load; the annual rings were thinner than above the point of attachment, where the tree was still on its own. Accordingly, it did not economize in this part, and this explains the interesting jump in diameter.

As my previous co-worker Dr. Frank Walther has shown with the CAO method, the tree satisfies the axiom of uniform stress in conjunction with the supports, by adapting itself, as shown in Figure 37. The stress distribution before optimization clearly shows higher stresses above the fixing point. After the adaptive growth, simulated with CAO, the trunk becomes thicker on the upper side and thus the situation of uniform stress over the whole length of the trunk is restored. If, shocked at the 'unnatural' appearance of the trunk, you immediately remove the forgotten binding, you will often need to wait only until the next storm to reap the reward for this act of sabotage on the self-optimization of the tree. Adapted to its lateral support, the tree either fractures transversely at the point of the binding, or splits longitudinally (as explained later in the chapter on the hazard beam). It had become so adapted to the neighbourly help of its supports that when they were removed it abruptly became a defective structure. The material sensibly saved before was now suddenly lacking, and the adaptive growth could not mend the weak point quickly enough, which might have been possible if the binding had been loosened off gradually in stages.

The Forgotten Tree

sawn section

Mises stress

Ⓐ non-optimized

Ⓑ optimized

high
low

FEM: Frank Walther

Fig. 37. Reduced trunk diameter of a Leyland cypress below a very stiff support by force-flow deflection into the supports. The two lower illustrations show the non-homogeneous stress distribution **A** without the tree adapting to the supports and the restored uniformity of stress **B** after adaptive growth

Fig. 38. A branch supported by two branch forks and thus largely relieved of bending load grows to an 'unnatural' length towards the light, and is thickest at the end furthest from the trunk

When the load is removed from individual parts of trunks or branches, the tree often utilizes the saved material sensibly somewhere else. The pole-stage trees already referred to, which shelter one another from the wind and thus grow slender to a great height, can only do this because of the reduced bending load in a dense stand.

The author encountered an interesting example in a beech wood [20, 21]. Figure 38 shows a sketch of the phenomenon. One branch of a young beech landed by chance in the branch fork of a neighbouring beech and, after further extension growth, again in the branch fork of a second beech further away and closer to the light of a forest road. Relieved of load by this friendly support, it grew scarcely at all in thickness but all the more in length, until it stretched out into the sunlight of the forest road in this almost incredible way. The free end was now without any outside support and probably also more exposed to the stronger winds at the side of the road, and therefore it grew more rapidly in thickness than the parts of the branch nearer the trunk but supported by the friendly branch forks of the neighbouring trees. Analogous to the previous example, this shows that the tree can adapt its h(D) ratios very flexibly to meet mechanical circumstances.

One last example here is the branch of an air-rooter (Fig. 39) which, relieved of load by a vertical support, behaves rather like the beech branch just described. The part of the branch on the trunk side is largely relieved of load by the vertical support. It is therefore thinner than the unsupported part on the left, which must be thicker if the two are to have the same stress on the branch surface.

The Height-Diameter Ratio of the Trunk 57

Fig. 39. A sudden jump in diameter in a horizontal aerial root branch at the vertical load-relieving support which leads a large part of the force flow to the ground. Thus only a thin horizontal branch is needed on the right of the support

These very simple examples of biomechanical shape adaptation should give the reader a first feel of what a powerful adaptation potential is present in nature, how flexibly it can react, and how simply all this can be explained and understood by the *axiom of uniform stress*.

Similar considerations will now be extended to the junction of branch and trunk, and the fate of branches, so similar to our human life, will be described.

Branch Junctions: From the High-Tech Connection to the Point of Potential Breakage

Each part of a tree cares quite locally, in its own place, for its own quite personal safety. The diameter-height ratio of tree trunks can also be explained in this way. Local annual ring width is based on local mechanical loading, biological influences apart. The same mechanism enables the branches to be connected to the trunk without notch stresses in the transitional zone. This only applies if both parts, the branch and the trunk, are comparably loaded. With different loading, the less-loaded part becomes increasingly neglected or, more correctly, there is no mechanical stimulus to grow stronger in thickness than absolutely necessary. On the contrary, this would be an infringement against the principle of light-weight construction.

If we examine the junction of branches on the trunk, it is nearly impossible to find even two precisely identical versions. Individual biomechanical fate is too different.

Fig. 40. The social descent of the branches, demonstrated on a tree in a dense stand. **A** Heavily loaded successful branch with optimized junction; **B** middle branch which is much less loaded than the trunk; **C** branch-shedding collar as the expected breaking place on a rotten branch

A rough classification based on previous work [20,21] may be presented here. Let us begin with branches which are high up at the top (Fig. 40A) and whose length is comparable to that of the top of the tree (measured from its tip to the junction of the branch under consideration). The wind loads which both experience are of comparable magnitude and thus both induce an approximately equal force flow into the place of union. Therefore both grow comparably in thickness, and in accordance with the axiom of uniform stress any notch stress is avoided, although the union does represent a notch in the mechanical sense. This type of branch junction is an outstanding example of biological shape optimization and high-tech design, of which one could only wish that it will soon find its way into constructional engineering as well.

The branches in the mid trunk region (Fig. 40B) are much shorter than the length of the top measured from their junction upward. The wind, which in any case is weaker lower down, still acts on the smaller lever arm and only a relatively small force flow is conducted laterally into the trunk. Because of its long lever arm to the wind load in the tree top, the trunk must overcome a considerable bending load. This force flow conducted downwards is now skilfully deflected around the branch junction, the wood fibres themselves running round the branch as force carriers. Thus, bulges are formed on both sides of the branch, which leads its own smaller mass of fibres on its underside into the trunk.

This interwoven type of branch junction (collar on the trunk over an incoming 'branch tail') will be discussed more precisely later on. The lateral bulges also reduce notch stresses which would otherwise be conceivable because of the deflection of the force flow around the branch. They thus ensure the strength of the trunk in this region. One is tempted to regard this type of branch junction as less 'optimal', but this would be a wrong assessment. The union of branch and trunk here is no less load-adapted than that in Fig. 40A. In any case, the loadings in the trunk and branch in Fig. 40B are so different that the optimum shape is bound to appear different.

The lower branches in a dense stand are even worse off (Fig. 40C). Most of their career lies behind them. At one time they were successful, and of great importance for the tree. They were near the top, fully exposed to wind and sun, and the tree rewarded them with that masterfully rounded junction, free of notch stresses, which even today in the era of space travel and genetic engineering must simply shame even the best qualified engineer.

But now these lower branches are rather like ballast for the tree: they usually carry hardly any foliage and so the wind loading is also small. They put on hardly any diameter growth. Why should the tree waste its material to preserve them! The social aspects of old-age welfare for formerly deserving colleagues are foreign to it. The trunk is only concerned with bringing its own bending moments (which are considerable because of the maximum lever arm length) safely down, past the unfortunate social descenders, into the roots and thus finally into the ground. Every year it diligently lays down a ring around the passive and sometimes already dead and rotting members. This ring represents a 'departure' or

branch-shedding collar, which will allow the rotten branch to break off at the well-defined ring notch (e.g. under snow load or by an animal brushing past). This again creates the prerequisite for rapid closure of the knot hole by stress-controlled wound healing, which will be explained in detail later on. In this way the penetration of decay is avoided, especially as the tree also erects some biological barriers on the inside too. This successfully concluded process is generally called 'natural pruning' [27].

The social descent of the branches described here (Fig. 40) takes place from top to bottom, if the tree is in a dense stand. In the case of a free-standing solitary tree, it is not so easy to correlate the branch junction with height. As Fig. 41 shows, in such trees it is often the lower branches, far outstretched to the side, which are inducing considerable force flow as a consequence of their own weight. The reader might just like to try holding a relatively light thin broom handle outstretched horizontally, in order to get a feel for the loading. Although natural pruning as described above also takes place in solitary trees, a miserable branch already encircled by a branch-shedding collar is often to be seen half way up the trunk, while lower down, gigantic side branches are inducing enormous bending moments into the trunk via optimally rounded junctions.

Fig. 41. In solitary trees the mechanical quality of the branch junction often does not exhibit such a pronounced correlation with height as in trees in a dense stand

Fig. 42. Horizontal ovalization of the large side branch of a beech tree on a Scottish meadow stiffens it against severe wind loading. Moreover, the side branches turn slightly in the wind direction, thus reducing the wind bending (shorter lever arms!)

The author encountered an interesting case in Scotland where a couple of solitary wind-swept beech trees were defying the elements on an almost perpetually wind-lashed meadow. One of them had stretched out an enormously long horizontal lower branch (Fig. 42) which caused a powerful bending moment by its own weight. For this reason one could have expected a vertical ovalization of the branch. Far from it! Even this heavy weight was obviously child's play compared to the horizontal wind loading: close examination of the branch cross-section shows a horizontal oval (Fig. 42) which optimized the cross-section relative to the wind load. It is hard to imagine a more convincing proof of the dominance of the wind load compared to a tree's own weight.

Tree Forks: Risk Only with Incorrect Loading

Botanists usually distinguish between forks and branchings by the history of their origin. As we are only considering the mechanical aspect of the external shape, this distinction is unimportant here. Any junction of two stems (or branches) which is fairly symmetrical will be called a fork in this book.

The individual variations in structure are infinitely diverse, but it does seem sensible to distinguish two mechanical groups: *tension forks and compression forks.*

The Tension Fork

The tension fork (Fig. 43) is adapted to a loading in which the two stems bend away from each other as a result of their own weight. This may be the case in solitary trees, for example, which are stretching their branches sideways towards the light. In contrast, as we shall see later, the compression fork is adapted more to gloomy life in dense stands.

An engineer familiar with notch-stress theory may well view this notch loaded in transverse tension with concern as regards its loadability. Finite-element calculations [26] showed that, as expected, high notch stresses also occur for an engineered notch in the shape of a semicircle (Fig. 44). Our instructor, the tree, can offer advice here, however. It follows the *axiom of uniform stress* and lays down material in the region of the notch stresses by adaptive growth, thus immediately reducing these stresses. This contour found with the CAO method shows absolutely uniform stresses on the inner side of the fork. The bottom of the notch, previously so dangerous, is no more in danger of fracture than the two stems above the fork. This natural phenomenon is a stroke of constructional genius, *a master design: a notch without notch stresses!*

Fig. 43. In the tension fork the inner contour of the fork is loaded in tension, because the two stems bend away from one another

Tree Fork

Fig. 44. The effect of shape optimization on stress distribution in the tree fork, which grows into a notch form without notch stresses

FEM: Uwe Vorberg

The Compression Fork

In dense stands of beech, for example, but also of conifers, the competition for light demands a tall narrow tree shape. Any twig deep down in the shade is material used ineffectively. No wonder that the two stems of a fork strive upwards close beside each other with scarcely any distance between them. Broad-leaved trees in particular still put on reaction wood (tension wood) in the narrow intervening space. However, this gap becomes increasingly narrower, even with the quite normal increment of conifers, which have their reaction wood on the outer side of the fork. The two stems increasingly come into contact with each other (Fig. 45). As will be described in detail later on in connection with tree-stone contacts and tree welds, this mechanical contact is a serious offence against the *axiom of uniform stress*, which both stems satisfied so perfectly until shortly before the start of contact. In order to restore uniform load distribution, the tree reduces the contact stresses by enlarging the contact surface. Both partners flatten off on the inner side and form a flush contact area. Now, if the annual rings running from both sides onto the contact area steadily fuse into one another without kinking, the bark is broken through and we speak of a tree weld, in this case an axial weld. These common outer annual rings also give the tree a certain limited strength against the two stems bending (away from each other!).

Fig. 45. A Diagrammatic sketch of the compression fork. A pointed notch formed by two stems squeezing against each other, in the various phases of its development

Compression Fork

Mises stress

Ⓑ

non-optimized — high / low — optimized

stress reduction 95%

FEM: Lothar Harzheim

Fig. 45. B CAO simulation (for reasons of symmetry only one part of the structure was created)

In Fig. 46, the compression fork with its included bark is excellently adapted to compression, which is transmitted very well even by this bark. With inappropriate tension loading, i.e. not adapted to the previous design goal, the included bark acts like a crack which can transmit no tension whatsoever. The compression fork, previously best adapted to the compression loading, becomes a defective structure, and the outer encircling annual rings can now easily rupture. This possible pattern of damage makes the compression fork potentially dangerous. After stand thinnings, the branches often spread out causing a tension loading of the fork, or swaying of the stems under wind loading may also cause this (Fig. 46). To ensure traffic safety, city trees with compression forks are often fitted with straps, which have proved very effective [31, 32].

Fig. 46. A the sawn section through a compression fork with compression loading appropriate to the design, and **B** with tension loading inappropriate to the design, which can lead to the splitting of the fork

Figure 47 shows the changing life of a tree fork, which first boldly develops from a tension fork to a compression fork in a dense stand. The outer annual rings fused as described before, and a subsequent stand thinning allowed the side branches to project out further again, because the neighbouring trees were no longer in the way. The centre of gravity of the crown parts moved sideways, and the downwards inclination caused by weight overcame the inwards bending of the fork caused by reaction wood. The few fused annual rings now had to withstand the enormous tension by themselves, but fortunately this tension increased only gradually. Accordingly, the adaptive growth had enough time to form board-like strappings between the stems, which also soon formed a shape-optimized inner fork contour once more, and moreover were much closer to the principle of lightweight construction than the transverse bridges in the initial situation. This example of the forming of a tree crotch shows how open tree shape is to new mechanical conditions, and how wonderfully the tree always knows how to make the best even out of difficult situations.

Fig. 47. The history of a tree fork: **A** tension fork; **B** compression fork; **C** tension fork with board-like strappings forms a crotch

Roots: Ingenious Anchors with a Penchant for Social Contacts

Roots can be divided into three basic types which tend to be genetically governed but are also influenced by the features of the site (stony or sandy ground, level of the water table etc.). Figure 48A shows the shallow-rooter like the spruce, with stronger horizontal roots, and sinker roots going off vertically downwards from them.

In earlier times, spruce often grew on frozen subsoil and therefore had shallow roots. It still largely retains this feature, even when warmth can penetrate into the deeper layers of soil. Other trees are shallow-rooters so that their roots can obtain sufficient air even in swampy ground. The tap-rooters (Fig. 48B) are the other extreme, like the pines whose central tap-root can grow to great depths on sandy soil. Buttresses (Fig. 48C) are an interesting special case, connecting the trunk and the end of a horizontal root, and thus activating the root's full length as a lever arm. They fix the trunk on the tension side, rather like guy-ropes hold a tent-pole. A particularly advantageous mechanical root design is the heart-rooter (Fig. 48D), which comes closest to exhibiting a root architecture correct for the load, as will be proved later by computation.

In nature, however, quite different forms of roots occur, which clearly have little to do with this classification. The reason probably is that the roots also have to accomplish water uptake, besides their anchoring duties. In the case of shortage of light above ground, phototropism makes the branches forget their good up-

bringing (negative geotropism). Similarly, the roots at least partially ignore their computer-true course which is correct for the force flow, and also their inherited disposition for a particular arrangement, and instead they steer confidently towards some little water-wheel. This slightly impairs the tree mechanically, but it does provide it with a delicious drop of water even in dry periods. This mechanism is called hydrotropism – grow towards the water! – and it is dominant over geotropic root growth [35], just like phototropism over geotropic branch growth. The best-anchored tree will die without water, and the best-shaped branch is useless ballast without light. This makes sense so far, even though the author's biomechanical heart may bleed a little when considering biological-mechanical compromises, for these genetic programmings and hydrotropic temptations of root morphology cannot be grasped biomechanically. However, there is one mechanical control of root growth which will be described in the following pages. It is discussed in greater detail in the doctoral thesis of my previous co-worker Dr. Matthias Teschner (Teschner M (1995) Einfluß der Bodenfestigkeit auf die biomechanische Optimalgestalt von Haltewurzeln bei Bäumen. SVK Verlag, Erndtebrück), which also contains more detailed considerations on the theoretical proof. Mohr-Coulomb's law of soil mechanics is the prerequisite for this approach (Fig. 49).

Fig. 48. Schematic representation of typical root forms, and the relevant induction of the wind loading into the ground. **A** Shallow-rooter; **B** tap-rooter; **C** buttress-rooter; **D** heart-rooter

Fig. 49. Illustration of Mohr-Coulomb's law of soil mechanics

It states that the shear strength of the soil $\tau = c + \sigma \tan\Phi$ depends on the cohesion c, the friction angle Φ (angle of slope of the $\tau(\sigma)$-curve), and especially on the normal stress with which the shear-loaded surfaces are pressed together. It does not differ much from the friction force, which also increases with increasing pressure force on the friction surfaces, as the upper two illustrations in Fig. 49 show. The sack of potatoes presses the friction boards together, thus increasing the friction proportionately. In tender youth most of us have benefited from this soil-mechanical know-how in our homely sandpit. We strengthen our sandcastle by patting the bastions with hand or spade, and even novices would never dream of trying to strengthen the sand walls by lifting them up, i.e. inducing tension. The consequence is obvious for a tree that is leaning or wind-loaded on one side. The soil on the windward side is raised, and according to Mohr-Coulomb's law is less shear-resistant, while the soil on the lee side is compressed and compacted and thus is more shear-resistant. For precisely these reasons, the soil above leaning trees on slopes is less shear-resistant than that below them, which is compressed as a result of the tree's inclination. The tree roots are in fact a kind of soil reinforcement, which must be stronger and reach further on the less shear-resistant tension side of the bending than on the compression side.

The brachial force which a poor tree root has to endure becomes clear when one realizes the enormous lever arm upon which a very heavy wind load is acting, and which is opposed by a comparatively short lever arm to the edge of the mechanically effective root plate. And yet – the much larger tree crown is surrounded by air, and the much smaller mechanically effective root plate is surrounded by soil, and it is this different 'surrounding material' with which the loading is introduced into the tree both above and below that explains the smaller dimensions of the mechanically effective root plate compared with the crown.

After this purely qualitative discourse, we shall now present some results of Matthias Teschner's calculations which were obtained in the Karlsruhe Research Centre with a modification of our SKO method.

The working hypothesis is that the roots arrange themselves in the soil in such a way that the shear stress between soil and root is uniform along the root. Accordingly, relative sliding between root and soil does not occur earlier at any one point than at another point. This could also be called a variant of the *axiom of uniform stress*. The variant of the SKO method developed by Teschner does not simulate the course of root growth over time, but it does find mechanically optimum root distributions which are also found in nature. The following self-explanatory illustrations (Figs. 51-57) confirm this. We start from the tree trunk standing without roots on the (blue) soil; the (red) mechanically optimum root distribution is formed after a few computation steps.

actual root formation

computer prediction
(Φ=20°, c=0.03 MPa)

Fig. 50. More and longer roots are needed as soil reinforcement where the soil is on the tension side of the bending and is less shear-resistant. On the compression side of the bending, fewer and shorter roots suffice to reinforce the compressed and therefore shear-resistant soil. A More roots on the windward side

actual root formation

computer prediction
($\Phi=40°$, c=0.04 MPa)

Fig. 50B. more roots upslope

actual sling formation

computer prediction

Fig. 51. If there is a pipeline on the windward side, it is of mechanical advantage for the tree root to grow underneath it like a sling, and thus to utilize this welcome anchor point ($\Phi = 25°$, c = 0.05 MPa)

Fig. 52. If there is a pipeline on the leeward side of the tree, a supporting root sprawls over the pipe, like a tipsy man on the edge of the bar ($\Phi = 25^0$, $c = 0.05$ MPa)

Fig. 53. A tree on a slope, with a large stone under its bending compression side, utilizes this anchor in the same way as a lee-side pipeline. These mechanical stone-tree partnerships still defy erosion, even though both the stone and the tree on their own would have slid down long ago ($\Phi = 35^0$, $c = 0.05$ MPa).

cohesion c [MPa]			
0.04	0.07	0.1	0.13

angle of friction Φ=20°

Fig. 54. With a fixed angle of friction and increasing cohesion, the tree prefers a tension member directed upslope, whereas with less cohesion it prefers a vertical tap root

angle of friction [°]			
10	20	30	40

cohesion c=0.04 MPa

Fig. 55. With constant cohesion and an increasing angle of friction, the tree prefers a tension member directed upslope, whereas with a smaller angle of friction it prefers a vertical tap root

Fig. 56. Summary of a study of parameters: angle of friction and cohesion. If the friction increases, the tendency to form tension roots upslope also increases, whereas with decreasing friction the anchorage tends to be based on pressure, which also causes the greatest soil strengths

angle of friction Φ=20°

	c=0.03 (low)	c=0.05	c=0.08 (high)
high force F [N]	F=0.3	F=0.35	F=0.4
	F=0.2	F=0.25	F=0.3
low	F=0.1	F=0.15	F=0.2

cohesion c [MPa]

Fig. 57. Change in the optimum root morphology with the applied wind load and cohesion. With cohesion constant, in the case of small loads the tree anchors itself by means of tension roots on the windward side (**below**); with increasing loads, lee-side prop roots are best. The sad conclusion can only be that if the tree experiences a higher wind load than it is prepared for, its root plate is not only under-dimensioned but it also becomes a defective construction! (The low forces in the N unit are explained by the choice of thickness in the 2D model with t = 1 mm). **A** Angle of friction ϕ = 20°

Fig. 57B. angle of friction ϕ = 40⁰

Root Cross-Section with Pure Bending Loading

Mises stress

FEM: Dagmar Gräbe

Fig. 58. Sawn section through a spruce root under pure bending loading, and CAO computer simulation

In his doctoral thesis, Teschner also succeeded in optimizing a soil anchor by this method of root growth. This offers enormous potential for further research on soil mechanics and on the optimization of foundations.

It is not only the arrangement of the roots relative to the trunk, but also their cross-section that is shape-optimized. This was qualitatively described in Fig. 3. Using the CAO method, my colleague Dagmar Gräbe has predicted the effect of the loading to be transmitted on the cross-sectional form of the root for a few cases, and she has presented the results in the form of general images. For example, Fig. 58 shows the cross-section of a spruce root which was loaded in pure bending, as indicated by the symmetrical arrangement of the annual rings on the sawn section.

Fig. 59. Bending loading with superimposed tension produces one-sided root growth in good agreement with the CAO prediction (drawing from photo)

Root Cross-Section with Combined Tension and Rotating Bending Loading

FEM: Dagmar Gräbe

Fig. 60. This very interesting sawn section through a spruce root was caused by a combination of tension loading with superimposed bending. The bending axis rotated, as shown by the course of the annual rings and the computer simulation, which was stopped after a few cycles

The CAO simulation starts with the circular profile shown on the left which, as expected, on the CAO command 'grow into a state of more uniform load distribution!', assumes the form of a figure eight. The individual steps are shown in the picture on the right, and coincide fairly well with the annual rings. The effects of combinations of tension and bending loads on the root profile are shown in Figs. 59 and 60.

The phenomenon of the cross-sectional adaptation of roots is also found in the aerial parts of trees which, however, are often less specialized because of the wind load which is seldom entirely from one side. It is seen immediately that a root which has all sorts of mechanical contacts below ground, involving both inanimate objects, stones, etc. and also other roots, must have an insensitive and adaptable character. In fact, a root plate ripped out of the ground by the wind exhibits a true paradise of apparently crazy knots, plates and loops, each one of which is an example of the *axiom of uniform stress*.

Figure 61 shows some examples which were drawn to my attention by my forester friend Hermann Kliegel. If a fairly cylindrical root gets between two stones (Fig. 61A), the resultant surface pressures are very quickly reduced by an enlargement of the contact area, as we have already seen in the compression fork (Fig. 45). The knots thus formed not only reduce the danger of tearing under the edge of the stone but they also cause better anchorage of the roots in the soil. We can be absolutely sure that the transition between slender cylindrical root and knotty plate is just as brilliantly shape-optimized as the branch junction on the tree. This means that here too the deflection of force flow from the thick cross-section into the slimmer one takes place without any excessive increase in stress.

Here again, our ingenious tree is fulfilling the dream of every designer: *notches without notch stresses*.

Figure 61B also shows schematically the origin of 'post-horns'. The process is initially the same. A fairly cylindrical root, which in contrast to Figure 61A is curved, gets this loop between two stones. As before, it enlarges the contact area and thus reduces the area pressure in accordance with the *axiom of uniform stress*. However, in this case there is not unlimited space in the inner concave part of the loop and the two arms of the U-shape soon touch, thus forming a new contact surface, which must be extremely uncomfortable because of the pointed notch formed. This notch is filled up with material as quickly as possible and the concave part straightened, this often being accomplished in a 'weld'. As in the compression fork (Fig. 46), notches here were filled with material and bridged over by a common all-embracing annual ring. What was of great mechanical advantage in the tree fork is now just as beneficial for the post-horn (Fig. 61B). The tree uses the same mechanism above and below ground to reconcile mechanically constrained parts to a narrow space: it fuses them into one part! (Enterprises in rivalry for space merge together.)

Fig. 61. The roots react to mechanical contact loads by adapting their shape, which should restore a uniformly distributed stress. **A** Knot formation; **B** post-horns; **C** 'welds' (grafts)

Figure 61C shows one further example, in which two roots get into cross-contact with one another. Starting from the plausible assumption that prior to contact each of the two roots was approximately equally loaded and therefore of equal diameter both before and behind the place of contact, then the new diameter ratios in the fused condition are a detailed record of the now redistributed loading. The thin and still fairly circular root cross-section has its load largely relieved by the graft, while its oval unilaterally broadened other end with its figure-eight shape indicates considerable bending loading which is conducted obliquely into the underlying thicker root. All the corners of the union are well rounded and free of notch stresses. This is a successful cross union in nature, which sensibly makes this expenditure because the alternative would be life-long abrasion of the contacting roots, and a recurring friction wound would have been a welcome entry port for rot pathogens of all kinds. A further advantage is the desired framework effect with economy of material and the binding of soil and root system like wire-mesh.

All three cases (Fig. 61A-C) characterize the root as a highly social being which eases mechanical contacts by almost 'friendly' shape adaptation, and unites tormenting elements that are constraining one another by means of ingenious 'welding', while still ensuring shape-optimized, light-weight design free of notch stresses. One can spend hours studying an apparently boring root plate of a wind-thrown oak or beech tree, scratching out of the soil new and mutely expressed stories of root acquaintanceships and tiffs with subsequent fraternization. This experiencing of mutely announced and highly condensed truth will fascinate the observer, and finds its counterpart in the idle party prattle of human society.

These considerations on shape adaptation in the root system show once more the considerable restorative potential of the tree, if its constantly fostered condition of uniform stress, i.e. its mechanical optimum, is disturbed.

Further examples of restorative growth with modified external loading will be presented in the following sections.

Wound Healing: Points of Potential Breakage are Speedily Repaired

The sweetheart's name lovingly carved in the bark of a beech tree is a silent avowal, a confiding in the tree, an eternal wish. It most certainly is. Not a few people talk to trees and even seek comfort by touching them.

From the mechanical standpoint, this wound is a serious disturbance of the ideal uniformity of stress which the tree has fostered and cherished throughout its life. No wonder then, that it hastens to close this potential fracture place (notch) with locally excessive stress. This process goes on most rapidly where the highest notch stresses apply. This also explains the formation of those spindle-shaped wound openings which we have all seen in partially healed branch holes (Fig. 62).

Wound Healing: Isotropic Model

Mises stress

CAO

stress reduction 46%

FEM: Jürgen Schäfer

Fig. 62. Stress-controlled wound healing (isotropic model). **A** Notch stresses at the circular notch; **B** stress distribution in the initial state, and inner contours with increasing wound healing; **C** stress distribution with wound healing well advanced; **D** real branch hole

Wound Healing: Points of Potential Breakage are Speedily Repaired

In addition to axial bending stresses in the tree, there are also growth stresses [11] caused by swelling processes in the new growing wood. Therefore every tree is loaded in tension on its surface and in compression in its interior. In addition to the wind loading, this axial tension must also be deflected round the branch hole and causes additional notch stresses. The highest notch stresses apply at the margin of the fresh branch hole, and consequently this is where the greatest deviation from the optimum state of uniform stress occurs. Therefore repair is carried out there as quickly as possible by the deposition of material. As always, the tree senses where there are potential fracture points which could cost it its life in the next storm, and rapidly repairs these defects [20, 21].

Jürgen Schäfer has simulated this process with the CAO method at the Karlsruhe Research Centre. Figure 62B shows the fresh branch hole with the relevant Mises stress distribution. The high notch stresses at the side of the branch hole are clearly visible, and engender the quickest healing there. The individual inner contours of the steadily narrowing wound spindle are drawn inside the initial contour. Alongside is shown the stress state around the last wound opening, i.e. the most occluded one (Fig. 62C). The stress reduction from the non-occluded circular hole to the wound spindle in the stage shown is 46%. The real branch hole is also healing into a vertical spindle shape (Fig. 62D).

Wound Healing: Orthotropic Model

Mises stress

A **B**

CAO

stress reduction 57%

FEM: Jürgen Schäfer

Fig. 63. Stress-controlled wound healing (orthotropic model). **A** Stress distribution in the initial condition and inner contours of the wound spindle during the course of occlusion; **B** stress distribution around the smallest computed wound spindle, i.e. with occlusion well advanced

This example also shows the influence of orthotropy, i.e. the different modulus of elasticity E_{long} and E_{trans} in the longitudinal and transverse directions in the wood (Fig. 63). There is no basic difference in the course of wound healing. This further justifies the use of isotropic models with material characteristics independent of direction, especially as a large number of previous analyses have shown that orthotropy rarely has a qualitative influence. For now, the simplest explanation for this is that the tree directs its fibres along the force flow, and this will be confirmed later with computer examples. If we take the E-modulus of the wood in the direction of the grain, this describes the main force flow quite well, and only the smaller transverse effects are somewhat falsified. We shall discuss the optimum course of the grain more precisely later on.

Fig. 64. The computed inclined force flow in the stem of a pollarded plane tree agrees excellently with the longitudinal orientation of the spindles of two partially occluded wounds. (Photo: Wilhelm Eisele)

Fig. 65. Force flow in the tree and the longitudinal axis of the wound spindle as a compass for the direction of force flow [20, 21]

Moreover, this theory applies not only for the vertical wound spindle. A force flow inclined to the vertical also causes an inclined wound spindle, because then the maximum stresses are no longer placed precisely at the side of the notch but are displaced in height. I obtained a very fine example from Wilhelm Eisele (Fig. 64). The large side branches of this plane tree induce an inclined force flow laterally into the pollarded stem [14]; this force flow was computed and printed as a host of small black arrows over the stem. The longitudinal axes of the two wound spindles are lying precisely in the local direction of the host of arrows. *The longitudinal axis of the wound spindle can therefore be regarded like a compass needle showing the direction of the force flow.* In field experiments, circular notches were punched into various interesting places on rapidly healing trees, using a hollow punch of 22 mm diameter. In fact, this also revealed a clear coincidence of force flow and longitudinal axis of the wound spindle (Fig. 65).

Hitherto, we have only investigated the wound healing of circular notches. However, differing notch stresses can be caused on the two sides of the notch by selecting a more complex and especially an asymmetrical notch shape. A fairly extreme case is shown in Fig. 66. The left-hand tip of this triangular notch deflects the force flow very abruptly, while the upper and lower tips on the right divide it gently, rather like a ship's bow, and deflect it to the side. Thus the highest notch stresses were to be expected on the left (I) and in fact the wound callus covering the wound developed there first, growing extraordinarily quickly. The right-hand corners (II) healed later and more slowly, and the right-hand side in the middle (III) healed the slowest of all. The callus edges coming in from both sides soon came into contact and formed the vertically directed wound spindle within the area of the triangle, though it is displaced well to the right in the triangle because of the expected quicker wound healing on the left-hand side.

Mises stress

stress reduction 83%

Fig. 66. The highest notch stresses at I cause quicker wound healing than at II, which again heals more quickly than at III; this is a convincing proof for the mechanical control of wound healing. **A** Stress distribution in the initial condition and inner contours of the wound spindle during the course of occlusion; **B** stress distribution around the smallest computed wound spindle; **C** triangular notch almost completely healed on white poplar

Fig. 67. The highest notch stresses at I cause much more rapid occlusion than at point II above, where the force flow is deflected more gently. **A** Stress distribution around the freshly cut notch and inner contours of the individual occlusion stages; **B** stress distribution around the smallest computed wound spindle; **C** triangular notch almost completely occluded on white poplar

This process was computer-simulated by the CAO method, and the result is also presented in Fig. 66. As expected, the stress distribution shows the stress pattern already discussed (Fig. 66A). (In the first approximation a more refined rounding of the corners was dispensed with!) The inner contours show the course of the wound healing. Alongside, Fig. 66B shows the stress distribution around the partially occluded wound. The stress reduction is 83%. Comparison of a computed wound spindle shortly before complete occlusion shows excellent agreement between theory and experiment. Another triangular notch, turned clockwise by 90^0, was cut (Fig. 67). In this case, the most abrupt force-flow deflection is in the region of the two lower corners, while the tip pointing upwards can again deflect the force flow more gently, like a ship's bow. The drawing in Fig. 67 shows the course of the wound healing which, as expected, begins below at the sides, and starts later above. In both cases, the computer simulation shows behaviour identical to reality (Fig. 67).

All these results should have convinced even the doubters that wound healing is mechanically controlled. But what else could have been expected? If the tree works its whole life long at distributing loads uniformly, in order to avoid potential fracture points (notch stresses) and underloaded regions (useless ballast), then it *must* jump to it to rectify the damage when this optimum is disturbed.

The social descent of the branches was described as 'natural pruning' in the section on branch junctions. This process corresponds in human society to the departure of a deserving colleague from work on account of age.

Similarly, the following description of artificial pruning is fairly closely comparable to jobs 'axed', which is used very appropriately in professional competition. It means that a colleague who actually did not need to go yet (who, like the branch could still have absorbed light and supplied assimilates) is removed from his position, severed from his attachment. The reasons could be justifiable or not, as circumstances dictate. In exactly the same way, in artificial pruning the reason for cutting off a branch may be quite sensible. For example, it might give promising branches better scope for development, or relieve the tree of less effective elements in order to be able to withstand the loads (e.g. from wind, snow etc.). Branches are also often cut off for aesthetic reasons, or for the sake of traffic safety. In short, there are genuine reasons or pretexts enough for getting rid of an undesired branch. However, anyone who cuts off the best branches and leaves the wrong unproductive branches will destroy the tree. While on the subject of comparisons, the nepotism of the official mafia in the communist dictatorships provided an eloquent example. But enough of this.

One question often posed is where the severance cut should be made in artificial pruning. This question has been answered satisfactorily in all respects by Alex Shigo [33]. In this book a further mechanical answer can be given.

Wound Healing: Points of Potential Breakage are Speedily Repaired

Fig. 68. Stub pruning (**A**), pruning parallel to the stem (flush cut) (**B**), and the relevant force flow shown qualitatively. The cut most recommended (**C**) is at the edge of the branch-shedding collar away from the stem

Figure 68 shows the two extremes of executing the cut, the optimum presumably lying somewhere between them. The two extreme cuts are based on the following considerations: from the mechanical standpoint a cut leaving a stub (Fig. 68A) leads to a mechanical isolation of the cut place avoided by the force flow. In the context of the *axiom of uniform stress* there is no reason to expect large amounts of material to be laid down on the stub end which is already underloaded anyway, and which would only lead to further load relief and thus to even worse disturbance of the ideally uniform stress distribution. This lack of mechanical stimulation for wound healing leaves the stub end open, it starts to rot, and decay pathogens penetrate at least some way into the trunk. As it is only a stub, it is unlikely to break off very quickly at the developing branch-shedding collar as a result of snow load. Opponents of pruning close to the trunk hope nevertheless that a biological barricade against the decay will be formed at the inner end of the branch, as supposed long ago by Mayer-Wegelin [27]. Shigo [33] has pioneered a more general compartmentalization theory. Axial saw cuts through branch-trunk junctions confirm this in many cases, even several years after green pruning. He recommends not leaving a stub, but making the cut at the outer edge of the branch-shedding collar (if such a thing should already be present!), which in fact also corresponds most closely to the breaking of the rotten branch at the expected place of fracture.

Pruning close to the trunk, which is carried out in the highly loaded region (Fig. 68B), usually leads to vigorous callus formation and rapid wound healing of the admittedly larger wound area. Shigo [33] claims that it destroys the safety barriers, and that decay will penetrate despite rapid wound healing, and this has been proven in many cases.

Fig. 69. A The course of the trunk and branch fibres, based on Shigo [33]. **B** A cut too near the trunk severs the trunk fibre bundles running to the branch from above and below, relieving them of their load and **C** in some cases leading to the complete absence of wound healing at the upper and lower edge of the wound

A rule emerges for the limiting distance of pruning close to the trunk, which is based on purely mechanical considerations and has nothing to do with biological barricades. The trunk fibres are deflected on both sides around the branch, whether it is alive or dead, while the fibres coming in from the branch at its end near the trunk are turned downwards and then inserted between the layers of the trunk fibres (Fig. 69A). This deflection of the branch fibres only downwards is surely sensible, for they simultaneously strengthen the trunk which below the branch junction has to carry the additional weight and bending moment induced by the branch. Thus the branch fibres, like the force flow of the branch, are deflected downwards into the trunk. Now, if one were to injure the collar of the trunk fibres very badly with a cut too near the trunk (Fig. 69B), then the fibres running upwards and downwards but severed by the saw cut in the ring region are relieved of load. (This is comparable to a partially cut rope, the severed fibres of which no longer carry anything). Only via shear stresses can the severed fibre bundles distribute the wind load induced from above to the neighbouring fibres. It

may be thought that the part of the tree partially relieved of its burden, at least at the upper and lower edge of the wound, is also less stimulated for further growth in thickness. In other words, increment may not occur at the upper and lower edge of the wound (Fig. 69C), because the severed fibre regions are located there. This is also reported by Shigo [33].

For the other extreme case of stub pruning, Matthias Teschner's FEM calculations, which were compared with real stub-pruned branches, showed that the boundary contour of the ongrowing material agrees excellently with the boundary of the loaded region (Figs. 70, 71). One can naturally argue that the pruned branch stub does not conduct any more assimilates downwards itself and therefore does not increase, which is certainly true. However, supply from the trunk is surely possible. As Teschner's calculations showed, this also happens to the same degree as the force flow from the unpruned part goes into the dead and unloaded part. The extent of the branch-shedding collar in natural pruning can be explained by these calculations. From the purely mechanical standpoint, at least the limit of the green-pruning cut away from the trunk can be determined: never cut outside the region which would be filled by the branch-shedding collar when the branch dies, i.e. outside the region affected by the trunk's force flow pushing out laterally. From the purely mechanical standpoint, the limit of the green-pruning cut near the trunk must run outside the wood fibres running down the trunk and around the base of the branch. Accordingly, the vertical course of the trunk fibres should not be severed, because this would cause regions relieved of load above and below the branch junction, which the tree would then rather neglect in accordance with the *axiom of uniform stress*, delaying healing and favouring decay. This also fits in with the symptoms involved with biological safety barriers. The explanation of these symptoms is in any case a purely mechanical one here.

Things are simpler in dry pruning, i.e. sawing off branches long dead: a pronounced branch-shedding collar is usually present here. Simply make a 'close-to-nature' saw cut precisely at the expected fracture place, which is the boundary of the branch-shedding collar away from the trunk. That's where the branch would have broken off in any case at some time (cut C in Fig. 68!).

Besides the making of wounds, i.e. notches, mechanical contacts can also lead to local stress peaks which the tree must deal with. The final result of its shape-adaptation will depend on whether it is a contact with an inanimate object, a tree of a different species, or a tree of the same species, as will be shown in the following sections.

Fig. 70. Formation of an oblique callus collar after stub pruning along the boundary of the loaded region

The Branch-Shedding Collar

FEM: Matthias Teschner

Fig. 71. A Stub-pruned branches at approximately right angles to the trunk, with the callus edge of the branch-shedding collar as the boundary of the region loaded from the trunk. **B** The branch-shedding collar is also formed around an iron bar

Fig. 72. A foreign body contacting a tree laterally becomes increasingly enveloped, the contact stresses thus being reduced by enlargement of the contact area. **A** The 'cushion effect' reduces stresses; **B** an armless crucifix being enveloped by a tree fork. (Photo: Reinhardt)

C The arch of an iron gateway is enveloped by poplar wood (Photo: Biruta Kresling);
D pronounced prop formation of a tree leaning over a gravestone. (Photo: Frank Dietrich)

Tree-Stone Friendships: Mechanical Companionship with Inanimate Objects

Anyone who has sat down unsuspectingly on a pointed stone would be quite clear what a local surface pressure is, i.e. a contact stress. Moreover, anyone who has had the rare good-fortune to roll off on the perhaps round stone will have experienced a contact stress locally variable over time, and thus will have experienced what a ball-bearing has to endure its whole life long.

Now let us assume that we had no other option than to sit on the stone, because perhaps we couldn't move away, just as a tree cannot. One solution would be to sit down on a thick cushion which encloses the stone intimately and distributes the contact force over an enlarged area. *The principle is: Reduction of the contact stresses, i.e. the local surface pressure, by enlargement of the contact area!* Trees also act just as sensibly when they see their lovingly cherished state of uniform stress distribution disturbed by external mechanical contact.

Figure 72 gives several examples, all showing the same principle: in every case the contact area is first of all enlarged by local widening of the annual rings. Thus the contact stress is reduced while the contact force remains constant. Accordingly, the tree again approaches the condition of uniform stress, its mechanical optimum. The potential point of fracture, which here could have caused a kinking of the tree with a small contact area, is rendered safe.

Fig. 73. The stem of a large bush leaning over the edge of a steel railing forms an elephant's foot contact surface. Below the railing the stem, relieved of load, puts on little diameter growth. The **arrows** illustrate the division of the force flow between the foot of the stem and the railing

A Railing Being Enveloped by a Tree

Mises stress

non-optimized optimized

FEM: Lothar Harzheim

Fig. 74. CAO shape optimization of a tree stem which, pressed against a steel railing, optimizes itself in conjunction with the latter

However plausible these qualitative explanations may sound, there is still no computational proof for the restoration of the condition of uniform stress. We shall present one example of a stem contact with a steel railing. The interesting phenomenon, shown in Fig. 73, can be seen in the botanical garden at Singapore. Certainly it is not mere chance that the stem squeezed on to the edge is forming an 'elephant's foot', in order to distribute its weight load well over the steel support. The weight of an elephant is also better distributed over a wider area.

The stem leads a considerable part of its weight loading into the railing via this supporting prop limiting the contact stress. Hence, the base of the stem below the railing is relieved of bending and axial pressure. Nature makes due allowance, largely restricting the stem's diameter growth to the part above the place of contact.

Figure 74 shows the computer simulation of the shape adaptation in two-dimensional approximation done by Lothar Harzheim with the CAO method. Even this simple plane approximation, which really only describes a longitudinal section through the tree, provides very good results. The clearly visible stress concentration in the non-adapted stem on the upper edge of the railing is completely reduced after formation of the shape-optimized prop-like thickening of the stem.

Fig. 75. Intimate mechanical partnership of tree and rock. If the rock were removed, the stem would fracture in the direction of the previous support. (After a photo by Marita Mattheck)

The tree is now adapted to the new situation, and shape-optimized in union with its mechanical companion, the steel railing. As it has adjusted itself to this new support, the state of uniform stress distribution has been restored. Now, if the tree had 'its' steel railing taken away, this would be like an act of treachery. The tree would immediately become a defective construction. At the end of this book we shall discuss in detail the fact that optimization necessarily also means specialization. Shape adaptation to an unusual load situation makes the tree more sensitive to other loads. A track and field athlete injures his back by weight lifting, and the weight lifter his ankle by jumping. One extreme example is a Turkish olive tree which is literally sprawling on its rock in a particularly intimate partnership (Fig. 75). The tree flattens out a lot, and lies like a board on the rock which supports it from below. As the stem only has to tolerate moderate bending in the direction of the rock edge, at the foot of the tree, (Fig. 75B), the place of the highest bending moment, it forms the figure-eight profile of the rounded I-beam, unilaterally stiff in bending, already referred to in Fig 3. Trusting completely in the mechanical support of the rock, this olive tree also specializes itself to a good distribution of the contact stresses over the full breadth of the 'stem board' (Fig. 75A), and is also resistant to bending with wind loading along the rock edge. Now, if the rock were removed from under the supported surface, the tree would fall over under its own weight on the side not resistant to bending. But who would have the heart to destroy this intimate partnership?

Fig. 76. A traffic sign firmly nailed or screwed onto a tree blocks the increment every year and is thereby enveloped and integrated. (Photo: Frank Dietrich)

I am indebted to Frank Dietrich, one of our former doctoral students, for his interesting photos of tree contacts with metal signposts. As Fig. 76 shows, this interesting natural phenomenon is not the result of active external loading, but is rather the tree's annual increment squeezing itself, as it cannot push the sign away, which is firmly anchored by nails deep into the trunk. The result of this increasingly intensive mechanical contact is an increasing area pressure. The tree forms more and more new annual rings in the narrow space between itself and the sign, which is fixed by a nail immovably wedged in the interior of the trunk. This has the same effect as if the sign were being pressed against the trunk from the outside. The load initially induced almost linearly on only a narrow vertical strip is soon distributed over the steadily widening contact area. Freshly growing wood spills out over the sign from above and below, and the middle of the sign is soon fully integrated. The engulfing tissues from above and below meet and fuse, and there the tree can grow normally again. Things are different at the sides of the sign where, as before, the wood is pressing up against the back of the sign from behind. However, as the plate is already firmly held by the trunk in the middle, it usually buckles outward. With further growth, the traffic sign is increasingly integrated and swallowed by the tree.

The wondrous achievements of trees as swallowing artists are confirmed by an example reported to the author of a badly corroded dynamo (!) found in the interior of an oak tree near a road.

The advantages which trees gain from these quite expensive overbridging, enveloping and integrating processes will be summarized at the end of the section on tree welds (grafts) in general for the mechanical social behaviour of trees. First, however, we must describe the social contacts of trees of different species.

Tree-Tree Contacts: Species Difference as a Mechanical Handicap

The ultimate good fortune of forming common annual rings, as will be described in the next section, is basically ruled out when trees of different species get in contact. Such trees treat one another like inanimate objects. The basic difference from tree-stone contacts is that both partners envelop one another, while the indifferent stone retains its shape, no matter how intimately the tree embraces it. The contacting trees of different species both enlarge the contact area and mutually envelop one another. If complete integration of parts of other tree species does take place (Fig. 77), this usually ends badly. Although the advantage of a framework formation with mutual relief of loading may be observed at first, unfortunately the integrated part of the foreign tree usually dies off, decays and leaves behind a nasty hole, having all the disadvantages of a notch, point of potential breakage, and entry port for decay. Nevertheless, even after the decay of this 'erroneously' integrated foreign branch, the tree can repair the residual weak place. In Fig. 77B this self-repair has already had considerable success. If peak

loadings do not trigger fracture during this new shape-adaptation, later on only a local widening of the trunk will indicate the deluded hopes of this mechanical partnership. In fact the word 'error', however anthropomorphic it may sound, is not out of place here. The tree suffered mechanical contact loading, naturally could not 'know' that the contact partner would die, and adjusted itself fully to it in its shape-adaptation. This 'non-prescient shape adaptation' is a considerable handicap in trees. They react only to the demands of the moment, which may appear quite different by tomorrow.

Fig. 77. Interim frameworks formed by the form-fitting enclosure of foreign tree parts are of little advantage, which is lost with the decay of the integrated component. **A** Integrated branch of a different species (photo: Frank Dietrich); **B** after the foreign branch has decayed, the contact opening closes up again

Fig. 78. If strangulation does not occur, form-fitting (intimate enveloping) will avoid abrasion wounds in the long term

Though all of this may sound like defective construction, it is clearly also advantageous in the case of different species to reduce contact stresses and to enclose and envelop one another. In many cases this will avoid long-term frictional abrasion caused by wind movements. Trees cannot avoid mutual jostling by stepping aside, as we humans would usually do in such cases. Even avoidance growth movements are insufficient, and would soon be rendered useless again by growth in diameter, at least at the foot of the tree. All they can do is to embrace and envelop each other closely, thus reducing relative movements and abrasion (Fig. 78). If the trees in contact are unable to develop this form-fitting enclosure, e.g. because of strong wind movements, then deep abrasion notches will result, which are an indirect proof of the advantages of such enclosure and the associated stilling of the relative movement (Fig. 79).

In genuine tree welds (graft fusions) which represent the crowning of social tree contacts, these advantages are further increased by the formation of common annual rings.

Tree-Tree Contacts: Species Difference as a Mechanical Handicap 103

Fig. 79. If a form-fitting connection does not develop, then deep abrasion notches (point of potential breakage) will soon endanger the tree

Tree Welds (Grafts): From First Kiss to Life-Long Marriage

The Axial Weld

Consideration of the first attempts at approach of two neighbouring trees (Fig. 80) which have locally come into mechanical contact does in fact bring to mind comparison with a kiss. These outstretched 'lips' are formed even if the trees do not come into mechanical contact permanently but only as a result of wind movement. The *axiom of uniform stress* can only be fulfilled as an average over time, but the wind often changes, and snow load is absent in summer just as the weight of the leaves is absent in winter.

Therefore it does not matter if the contact load leading to kiss formation does not apply all the time. On average over the year the parts of the trees touching will experience higher loading, viz. the contact stress. In calm weather the conspicuously outstretched contact region does suggest comparison with longing for proximity and union.

Fig. 80. The trees kiss: local contact stress leads to a bulge-like widening of the annual rings, the trees approach each other in the contact region and finally fuse here axially. **A** First approach; **B** permanent kiss; **C** intimate form-fitting; **D** completed union with common all-embracing annual rings

In the course of the normal diameter growth of the trunks, the contact distance is reduced and therefore the contact loading itself becomes more frequent and intensive, which again accelerates the local growth with the well-known aim of reducing the contact stresses by enlarging the contact area. If the contact becomes permanent, mutual enveloping occurs, and usually a vertical extension of the contact area (Fig. 80C). The kiss now becomes an intimate permanent embrace, in which the biological housekeeping is still separate even though the partners are already largely sharing their mechanical problems. The culmination of this tree partnership consists of the actual fusion, i.e. with a certain arrangement of the annual rings running to the contact area from both sides, the separating bark at the edge of the contact region is broken through and the first all-encircling annual ring is formed. The marriage is consummated. From now on, the partners also help each other mutually with water and nutrients, and this too is a biological gain. Because of the framework effect the tree can economize on material below the graft fusion. The trunks tend to become thicker above the place of union, where each stem is still on its own mechanically.

As regards the *biomechanical circumstances*, the axial weld described here largely resembles the compression fork (Figs. 45, 46), which also results basically from an ascending axial contact of the narrowing tension fork.

Even more spectacular is the transverse contact of trees of the same species, which perhaps represents the peak achievement of adaptive growth in trees.

Fig. 81. The course of cross-welding and the form of the annual rings in the sawn section. **A** First contact and abrasion wound; **B** mutual enveloping and form-fitting suppresses relative movement and abrasion; **C** formation of common annual rings after the transverse branch forms a flattened profile. The 'weld' is accompanied by a rounding of all the corners with the aim of avoiding notch stresses

The Cross Weld

Figure 81 shows diagrammatically the development of a typical cross-weld (transverse graft), where the arrangement of the annual rings in an imaginary axial sawn section is also of the greatest biomechanical interest.

A side branch of one of the partners touches a neighbouring tree. Wind movement causes an abrasion wound (Fig. 81A). The contact region becomes wider in order to limit the area pressures in the usual way. Mutual enveloping takes place, which stills the relative movements of the contact partners (Fig. 81B). Normally the thinner transverse branch widens locally much more than the thicker partner, which is accustomed to quite different loadings caused by wind than the area pressure caused by the contact. For the former, however, the contact stress means a genuine challenge. It flattens into a pointed oval, as the sawn section shows. We shall discuss in the section on annual rings how necessary this flattened profile is for the actual welding.

In contrast to the axial weld, in which the wood fibres of both the contact partners were directed vertically, in the case of cross-contact, the fibres run horizontally in the transverse branch and vertically in the partner trunk. Now how is the force flow to be brought from the vertical trunk fibres into the horizontal transverse branch fibres? Sawn sections have shown that the weld union only takes place when the cylindrical sheaths of the 'annual-ring cylinders' of the trunk flow without kinking into the flattened annual ring of the adoptive branch, *and* when the latter's flattened outer part is largely in the direction of the vertical force flow. These two conditions are finally fulfilled in Fig. 81C. Common annual rings later show a fibre orientation in the direction of the dominant force flow (usually vertical). This expensive shape adaptation of the internal and external architecture is a real stroke of genius by nature, and moreover is by no means rare. Beech trees in particular 'weld' quite readily in our woodlands.

The frameworks thus formed become effective, especially when the wind is blowing in the direction of the framework. The stems can then mutually relieve each other of load, and can lag behind in growth compared to parts of the trunks above the branch bridge. However, if the prevailing wind direction is at right angles to the plane of the framework, the trunks will sway beside each other without any significant frame effect, and no abnormal diameter relationships are to be expected. We all know this effect from the bicycle. Even the best mountain bike is more sensitive to jolts at right angles to the frame than to loadings in the plane of the frame (for which it is designed!), in which one can do the craziest leaps without bending it. This is also an example that optimization must necessarily mean specialization for a selected case of load. Figure 82 shows some more tree welds which are not so rare in our native woodlands and are more common in broadleaved trees than in conifers.

Tree Welds (Grafts): From First Kiss to Life-Long Marriage

Fig. 82. Typical tree welds

The mechanical advantage of this shape optimization will now be demonstrated by computer for three selected examples. Figure 83 shows a forked beech in a fairly dense stand near Lyon la Forêt in France. Not too far above the fork it has already formed fully shape-optimized branch bridges with rounded corners free from notch stresses. The wind seems to blow mainly in the plane of the framework, for the left-hand stem especially is much thicker above the bridge than in the region of the framework. A comparable thickening cannot be expected in the right-hand stem too, because there the branch bridge is conventionally attached and is thus leading its own fibres downward into the trunk. An engineering draft design with semi-circular transitions was used to begin the CAO computer simulation [17, 19]. We also made the plausible assumption that before the 'welding' the left-hand stem was of about equal thickness above and below the bridge. A plane model, i.e. a longitudinal section through the tree framework, was considered the simplest approximation. Despite these simplifications the agreement between CAO prediction and nature is very good. The left-hand stem prefers to put on increment above the branch bridge, as is the case in reality. Because of these shape adaptations the maximum stresses are reduced to about half, which is a tremendous gain for the fracture strength of the tree. As loading we assumed a bending apart of the stems, as can easily occur with non-synchronous wind loading of crown parts differing in size.

Tree Framework

Fig. 83. CAO simulation of the framework formation in a slender beech fork with considerable thickening of the stems above the branch bridge

Tree Framework

Fig. 84. Good agreement between CAO prediction and nature in the case of a framework formation in a beech tree (Found by Jörg Sigmund)

Fig. 85. Qualitative agreement between CAO prediction and nature. Here, we started from the known situation of 1955. (Photo: Heinrich Kuhbier)

Tree Welds (Grafts): From First Kiss to Life-Long Marriage

Figure 84 shows a beech consisting of two stems having a common rootstock and connected by a bridge. Here, too, we started with an engineering design with circular notches in the connecting places and, as before, theory and experiment agree very well. The reduction in the maximum stresses is again about 50%.

Figure 85 shows an interesting tree which was kindly drawn to my attention by Mr. Heinrich Kuhbier of Bremen, who also gave me a photo of the same tree taken about 35 years ago – a rare piece of good fortune. The computer simulation was done at Karlsruhe by Matthias Teschner using different approaches. Figure 85 shows his result. The basic process of the twisting of the transverse connection is reproduced well, and will be discussed later in comparison with trabecular bone. However, this very interesting case reveals an inadequacy of the plane model. The actual tree (Fig. 86B) forms a relatively thin 'bracing board' above the thick transverse connection, which presumably takes mainly tension. In the plane model a uniform thickness had to be assumed for this bracing board and for the rest of the tree. The real thinner board is more pronounced because it must transmit the force flow on its thinner cross-section. Accordingly the higher stresses make the upper edge of the thinner board grow more rapidly in nature than those of the board used in the computer simulation (which was as thick as the tree). The two-dimensional approach becomes critical if differences in thickness are too great. Similar bracings are found in the crotches of forks (Fig. 47C) or in buttresses (Fig. 48). Naturally, a guy-rope as in Fig. 86C would be more energy- and weight-saving for the tree. However, as trees cannot lose material like bones do, the load-bearing upper edge of the bracing, which fulfils the actual guy-rope function, must be formed by growing upwards from below. The bracing is, so to speak, the 'record of growth' of the 'rope' moving upwards with its attachment (Fig. 86C).

These examples of social tree contacts were only an aid to avoid rubbing and abrasion, but there is one kind of tree which has made this social fraternization into its own murderous survival strategy.

Fig. 86. Two stages of growth of the same tree. **A** 1955; **B** 1991; **C** rope-like action of the bracing board, the annual rings of which record the increasing tightening of the guy-rope

The Strangler Fig: Merciless Welding Artist

The strangler fig is often carried by birds to a host tree, and sends down stringy hanging roots only a few millimetres thick which soon reach the ground. When they anchor there they contract somewhat, and thus help to stabilize their host tree like tent ropes. In this way, air-rooters save a lot of material which they would otherwise have had to spend on trunk and branches like the host tree. According to Zimmermann et al. [38, 39] the anchored aerial roots tighten themselves up so much that they can easily raise a pot of soil in which they are anchored. Thus, as long as the strangler fig cannot stand on its own thin ropes, its anchoring helps the host tree, upon whose stem it originated high up in the light.

With increasing age, the strangler fig now also forms transverse connections between the vertical roots, which first serve for strengthening on the host tree and later fuse into a genuine framework (Fig. 87). It is incredible how readily these air-rooters join together and thus form both an artistic structure and also a mutually supportive transport system. The stem of the host tree, increasing with normal diameter growth, now presses more and more from the inside against the horizontal slings of its increasingly burdensome foster-child. In turn, this tensile loading stimulates the aerial roots to new growth, and because trees of different species do not 'weld' and form a common transport system, the strangulation of the unfortunate host tree is only a matter of time. The ungrateful strangler, however, still has leisure enough during the destruction of the host tree to adjust from the hitherto dominant tensile loading to take over the axial pressure load (weight) previously borne by the trunk of the host. The vertical roots can thicken up so much that they fuse together like ribs and form hollow dummy trunks. The decaying host tree forms a welcome humus for the ungrateful strangler.

Fig. 87. The strangulating strangler fig forms artistic frameworks with a multitude of shape-optimized notches without notch stresses. The large diameter of holes in the framework points in the direction of the force flow

Because of its lack of secondary growth in diameter, the palm as a host tree has quite a good chance of survival for a relatively long time inside the constricting corset, as Fig. 88 clearly shows. After anchoring itself, the strangler fig's strategy then is to support the host tree by guy-ropes until it has formed a supporting framework itself, which may go as far as the formation of dummy trunks.

Then the host tree is either strangled or disadvantaged by overshadowing. If it dies, its humus is also welcome. Thus, with increasing independence the strangler fig changes from being a helpful foster-child to a thankless murderer of its foster-parent. Here, one advantage is the large surface area of the numerous guy-ropes, which represents a much higher potential for adaptation than the simple ring of cambium in normal trees.

Fig. 88. An almost completely enclosed palm in the dummy trunk of an air-rooter makes quite a lively impression in spite of everything

Advantages of the Social Behaviour of Trees for the Species

The advantage of this rather selfish behaviour of the strangler fig needs no further explanation. But this contact behaviour of trees with inanimate objects and with trees of other species, and the 'welds' of trees of the same species, is associated with enormous advantages for the tree:

- minimization of contact stresses by enlargement of the contact area.
- minimization of contact stresses by the suppression of rubbing movements, from form-fitting envelopment to enclosure of the contact partner.
- by mutual support, the material expenditure for the enlargement of the contact area can be compensated for later by reduced diameter growth of the regions relieved of load.
- with tree welds, the framework effect often leads to significant saving of material. The trees also help themselves as regards their nutrient regime when, for example, parts of the crown or roots of a partner fail.

Accordingly, everything indicates that trees do not avoid mechanical contact but actually seek it. They grow in the shape of bulging protuberances (see 'the kiss', Fig. 80) to the mechanical partner. In accordance with the definition of tropisms as direction-dependent growth regulators [35], the definition of a new tropism suggests itself here: *Mechanotropism induces growth in the direction of contacting mechanical partners. It is a consequence of the axiom of uniform stress.*

Annual Rings: The Internal Diary as a Consequence of the External Situation

Within one growing season the tree lays down some rather more porous earlywood first, and then the often rather denser and stronger latewood. The annual rings are particularly distinct in conifers like Douglas fir, pine and spruce, and are also good in oak, but are less clear in beech.

During the period of its formation, every annual ring was the outer contour of the tree. Accordingly its surface must satisfy the *axiom of uniform stress on the surface of the component*, both axially and circumferentially, because the growing annual ring is actually the tree's surface.

The thickness of an annual ring averaged over its circumference depends upon many influences such as temperature, rainfall, site, etc. In contrast, the distribution of the thickness of an individual annual ring over its circumference is largely controlled mechanically. A locally increased stress causes a thicker annual ring at this place in order to distribute the stress uniformly once more. Figure 89 shows a section through the trunk of a sweet chestnut tree at the level where it is in contact with a stone. The thicker annual rings at the place of contact are clearly seen, while they are much thinner on the side of the trunk away from the stone. Besides disturbing the uniformity of stress on the tree's surface, a deviation from geotropically upright growth can also alter the annual ring width locally.

Fig. 89. Drastic widening of the annual rings will reduce the pressure exerted by a stone by enlarging the contact area. The ends of the annual rings are perpendicular to the contact area

Reaction Wood and Helical Grain in the Sawn Section

As described earlier, leaning broad-leaved trees straighten themselves into an upright position by forming tension wood, while conifers do so by forming compression wood on the lower side (Fig. 30).

The compression wood of conifers often has a reddish colour ('redwood'), and is therefore easy to recognize in the sawn section. Several examples are shown in Fig. 90. In Fig. 90A compression wood is found only on one side of the trunk, which was always the under side, and over-correction did not occur. Figure 90B is a section further up in a meandering tree. The side turned towards the ground changes after geotropic over-correction. As the two compression wood zones are exactly opposite one another, the tree has not twisted. In contrast, Fig. 90C clearly indicates spiral growth (more accurately, helical growth). Each year, the compression wood zones are displaced a bit further in the circumferential direction, or to put it more accurately, the 'redwood' sickles are always formed at the same place, namely on the side of the tree then turned towards the ground, and the trunk winds itself round its longitudinal axis, so that it finally acquires a usually rather helical bent form.

Fig. 90. Reaction wood ('redwood') of pine trees in sawn sections. **A** One-sided deposition of compression wood indicates that the tree is in a leaning position; **B** if the compression wood changes sides, generally the tree's position has deviated from the vertical, first to one side and then to the other; **C** with helical growth the sickle-shaped deposits of red compression wood are displaced in the circumferential direction

If no compression wood is formed, it means that this section of the trunk (not necessarily the whole tree!) was standing precisely perpendicular that year. Such sections without reaction wood are often found in meandering trunks, before the compression wood changes from one side of the trunk to the other (Fig. 90B). If reaction wood formation is absent from a certain annual ring, then the tree is satisfied with its vertical position, at least at this particular cross-section.

The new annual rings then no longer contain any red colouring, and are equally wide everywhere, unless any other mechanical stimuli are acting. This naturally does not mean that the cross-section greatly ovalized by the previous unilateral deposition of reaction wood is immediately circular again. Only the last annual ring formed after the righting is uniform. The dead oval cross-section remains preserved for us as a witness of the earlier desperate attempts at righting (Fig. 90A), its protest against over-corrections (Fig. 90B), and its twisting distortions with constantly new correction of the bending axis (Fig. 90C).

The Sawn Section Through Healed Wounds

If a healed branch hole is sawn through transversely to the trunk, the peculiar 'rolling in' of the annual rings is strikingly evident (Fig. 91A). In order to understand this phenomenon, it is best to investigate what happens if the rolling-in process does not occur (Fig. 91B).

The inherent stresses or growth stresses of the living tree are compressive stresses on the surface of the tree, acting in the circumferential direction. These circumferential stresses must be distinguished from the tensile stresses acting on the surface of the tree in the longitudinal direction [20, 21]. Now, if the annual rings did not roll inward, as shown in (Fig. 91B), the outermost annual ring would slide off the underlying ring somewhat in the wound direction. This would lead to a shearing load on the annual rings, to which wood is particularly sensitive. In contrast, the inward-rolling occlusion movement leads the circumferential pressure perpendicularly into the wound area and thus traps the shear.

The complete course of wound healing is shown in Fig. 91C. The occlusion rolls coming from the two edges of the wound soon touch in the middle, their bark pressing together. Thus a pointed outer notch is formed, which the tree usually fills up within just one year with a great local effort. Then the annual rings coming in from both sides are perpendicular to the contact surface, i.e. to the included bark. This bark is now broken through, and a common continuous and kink-free annual ring seals the wound healing. It is noteworthy that in fusing the annual rings the tree clearly waits until a kink-free, all-embracing ring is possible. A kink would load the annual ring unnecessarily in bending, and probably also cause shear between the annual rings, thus weakening the 'tree component' locally.

Fig. 91. Annual rings around a partially healed wound. **A** The annual rings coming onto the wound from the side in the circumferential direction are thicker at the edge of the notch and roll in perpendicularly on the area of the wound. **B** The growth stresses of the green tree are compressive stresses on the tree's surface in the circumferential direction. If the ends of the annual rings did not roll in, these would cause dangerous shear stresses between the annual rings on the area of the wound. **C** Wound healing completed, with two all-embracing annual rings already in place

Frost Ribs: The Sick Report of the Annual Rings

The formation of frost cracks is a complex process, perhaps involving the freezing of ice lenses in the wood structure [12]. In the context of the elastic theory of the phenomenon presented here, we prefer to leave this field to the tree biologists. It is enough to know here that the green tree, normally experiencing compressive stresses at its surface in the circumferential direction (Fig. 92B), not only reduces these when it cools down considerably but even changes them into tensile stresses (Fig. 92A), otherwise these cracks could not develop.

These tensile stresses now cause longitudinal cracks sometimes centimetres wide in the tree, which gape open at people walking through the woods in winter. When these low temperatures abate and the tree becomes green once more, the growth stresses start to operate again. They squeeze the two surfaces of the crack

together, especially near the trunk surface (Fig. 92B). However, the fracture surface along the vertical split is rough, and it is no longer possible to create an intimate contact over the whole area. Therefore, the circumferential compressive loading must go mainly through the narrow eye of the needle near the trunk surface, which is thus correspondingly heavily loaded and reacts to this with greater local thickness of the annual rings. If the following growing season is favourable, a common fused annual ring can quickly seal the crack, and if the following winters are mild the problem is overcome, and no frost rib is formed. However, if the next winter is very cold again, as unfortunately often happens, and if the only annual ring overbridging the frost crack is quite weak, then the frost crack often opens up again with a report like a pistol shot. This distressingly unsuccessful self-medication lasted for over 15 years in the oak shown in Fig. 92C, and led to the formation of the pronounced frost rib – a sign of fate inscribed in its case history.

Fig. 92. Formation of frost cracks and development of frost ribs. **A** Frost crack formation as a result of cold-induced tensile stresses on the tree's surface. **B** After the cold period, renewed contact of the fracture surfaces tends to occur at the surface, imposing a heavy load on the outer annual ring and making it grow thicker locally. **C** Frost rib as a consequence of repeated frost-crack formation and repair; an example in an oak

Frost Rib Formation

Mises stress

initial design

high
low

FEM: Lothar Harzheim

Fig. 93. Computer simulation of frost-rib formation

The formation of these ribs is also a consequence of the *axiom of uniform stress*, as the heavily loaded annual ring overbridging the crack becomes much thicker in order to reduce the local stress peak. This was computer-simulated by Lothar Harzheim using the CAO method at the Karlsruhe Research Centre. Figure 93 shows the result in a self-explanatory way. It is interesting that with loading in bending, the computer only formed frost ribs when mechanical contact of the fracture surfaces in the interior of the stem was largely suppressed, which is plausible because of their roughness. The circumferential stresses, i.e. the growth stresses, were simulated by thermal loading which simulated the compressive growth stresses there following heating up of the tree's surface. The result agrees well with nature, but do not think it is possible to define a standard frost rib. This complex procedure – controlled not only by the individual roughness of the fracture surface, by biological, biomechanical and weather influences, but also by previous history – will never run in an identical way for all trees. However, the main aspects can be credibly described with this stress-controlled computer simulation. Recent results by M. Teschner show that torsional loading in particular can lead to rib formation in front of radial cracks.

Fig. 94. Pointy-nosed ribs indicate elongated cracks, with the tip of the crack either poorly closed or not closed at all

Conclusions can also be drawn from the shape of the rib as to whether there is a stationary or an elongating crack hidden behind the rib. Pointy-nosed ribs, their length often rivalling Pinocchio, indicate an elongating crack, making things difficult for the tree's efforts at healing (Fig. 94). Snub-nosed, rather rounded forms of rib, like the good-natured English bulldog, indicate that several annual rings are already successfully overbridging the tip of the crack; the crack is stationary and healing has conquered (Fig. 95).

Practical expert assessment of trees, and field experiments in the Palatinate Forest in Germany, in which trees were slit diametrically with a chainsaw, have shown that moderately long cracks in straight trees usually do not lead to failure. However, very long cracks, running to a height of several metres, can bring down even straight trees. In contrast to this, a leaning oak tree which was slit over a length of only ca. 80 cm, fractured after about two months as a result of creeping shear failure. The saw cut became the sliding surface. With cracks in straight trees the greatest risk seems to be the penetration of decay, changing the cracked tree into a hollow tree which can fracture when more than 70% of the radius is rotten or hollow [23]. Cracks which form at rightangles to the prevailing wind direction are usually caused by shear stress.

Fig. 95. Snub-nosed cracks indicate usually well-closed stationary cracks

Contact Reports: A Dead Branch Is Treated Like a Steel Tube

As already shown in Fig. 40, the social descent of branches ends in the formation of the branch-shedding collar, the outer contour of which is still reached by the force flow of the trunk coming out laterally. The shape is determined mechanically (like the shape of the whole tree), and represents in an advanced stage a ring notch around the base of the branch long ago written off by the tree. This passive part of the tree usually breaks off in a defined way at this fracture place. It is precisely this inability of the dead branch to form its own annual rings itself which hinders it from filling up the ring notch formed by the trunk around the base of the branch, i.e. from caring for its own fracture safety. The tree trunk is caring for a fail-safe deflection of the force flow (wood fibres) around the old branch, with the sole aim of avoiding trunk fracture.

We can confidently expect no more growth from a steel tube than from a dead branch. The steel tube will also tolerate the forming of the branch-shedding collar without filling up the ring notch. Thus the dead branch and the steel tube both fail to form new annual rings. The trunk again adjusts to this, directing its annual rings perpendicularly to the surface of both of them, in order, as before, to minimize the shear between the annual rings and thus the risk of failure.

A sawn section through a pine tree is shown in Fig. 96, the arrow indicating the annual ring of the death of the side branch. From there on the trunk rings roll in on to its surface perpendicularly. Similar shear-minimizing behaviour is to be expected with the enveloping of any inanimate object (stones, shrapnel, etc.).

Fig. 96. The sawn section shows the year of death (**arrowed**) of a side branch in a pine tree

It was a very tempting problem to predict the formation of annual rings around a dead branch ascending steeply from the trunk and which is being increasingly swallowed up and integrated by the trunk from below. Figure 97 shows the whole process and also a sawn section. The reason why we can reliably hope for good results here when using the CAO method is obvious, as we have already mentioned. The surface of the tree, whose shape is defined by the *axiom of uniform stress*, is described by the annual ring currently growing. Although this involves a contact problem with constantly increasing contact area, according to these plausible considerations regarding transferability there is no reason whatsoever to doubt the success of CAO.

The annual rings are predicted purely by mechanical control, assuming identical environmental conditions (moisture, temperature etc.). They agree very well with the sawn section shown alongside. One particularly interesting effect emerges when the dead branch is enveloped on both sides, and the annual rings of the trunk coming over the branch from left and right (Fig. 97D) meet (**arrow**). A new contact area is formed there, but this time between living parts of the tree. Because of the previous history, this initially represents a horrible notch, which strongly deflects the compressive load coming in from both sides and thus causes notch stresses. This behaviour by the tree is initially perplexing, as notches are normally avoided and not formed anew. It may sound anthropomorphic but in fact the tree has been 'surprised' by the success of its eager efforts to envelop the contacting old branch. However, the tips from both sides unexpectedly striking each other are usually capable of filling up the notch within a year, and thereafter form a kink-free all-embracing annual ring by breaking through the bark and fusing. In this way, the dead branch is increasingly integrated from below upwards, and yet always has at its upper end the branch-shedding collar which allows it to break off there if overcome by a sufficient storm and its increasing rottenness. The small hole remaining would be enveloped, thus saving material for further integration of the now absent upper part of the branch. The tree itself is then the living grave of a formerly vigorous but now dead branch. The computer simulation (Fig. 97) was carried out very diligently at the Karlsruhe Research Centre by Dr. Lothar Harzheim and Thomas Fleig.

Tree Rings around Dead Branch

FEM: Thomas Fleig

Fig. 97. A steeply ascending branch near the trunk is integrated. The CAO simulation shows the growth from the first contact to complete incorporation. **A** The combination of living trunk and dead branch being investigated; **B** sawn section X-X'; **C** CAO prediction of the annual rings; **D** filling up the new contact notch usually within one year (diagrammatic)

Welds: The Tree's Marriage in the Sawn Section

The cross-welding of contacting tree parts was described previously as a stroke of genius of adaptive growth, a successful biomechanical fraternization, and a sensible alternative to life-long rubbing and abrasion.

On the basis of earlier work, we shall once more consider the diagrammatic progression of events (Fig. 81) and a sawn section from nature (Fig. 98), in order to formulate the necessary and sufficient condition for cross-welding. As shown in Fig. 81, the first contact starts with additional loads (Fig. 81A) which disturb the previously cherished state of uniform stress. In contrast to the previous example of the integration of a dead branch, both tree parts are alive and both therefore react

by an enlargement of the contact area, both envelop one another (Fig. 81B) and stabilize the union against relative movements. If the axial annual rings of the lower branch pass steadily and without kinking into the circumferential annual rings of the branch shown in the cross-section, and if this steadily formed line is still approximately in the direction of the force flow, then everything is perfect for finally consummating the marriage. The bark melts and a continuous annual ring seals the union. However, there is still one small problem: the wood fibres of the two cross-welded partners were at rightangles to each other before the welding. How do they run now in the all-embracing fused annual ring? The author cannot yet give a conclusive and universal answer to this question, and intensive investigations are still going on at the Karlsruhe Research Centre.

However, one fundamental trend is immediately and evident. The weld will also influence and alter the loading of the components in the cross-union in accordance with external circumstances and embedding into the rest of the tree's structure, and an orientation of new fibres along the new force flow is highly probable.

Figure 98 shows very nicely that a weld need not necessarily occur with the formation of annual rings going into one another without kinking. Even on the annual rings inclined at 45^0 these always go into one another, but they are not yet oriented with the force flow running vertically along the stem. Everything fits at places A and B: a kink-free annual ring along the force flow welds and integrates the branch, which needed almost 10 years from the first contact by the still circular annual ring to form this incredibly graceful pointed oval, which nestled more and more laterally to the stem and finally fused with it.

Fig. 98. Tree welding. Despite kink-free annual rings, the welding only occurs at **A** and **B**, where the direction of the continuous annual ring coincides with the direction of force flow

Certainly this information on the mechanical control of annual ring formation is not yet entirely complete, but the results are credibly reliable according to the best of our knowledge using modern computer methods, and can be regarded as rules for the internal architecture of trees.

Summary of the Rules for Annual Ring Design

- Annual rings form along the force flow, i.e. along those lines which are not loaded in shear in the loaded component. This is of great advantage because wood fails very easily under shearing load.
- Therefore, annual rings adjust perpendicularly on contact areas of inanimate or living contact partners, thus also minimizing the bending load of the individual annual ring.
- When parts of the same tree species come in contact, welding of the outer annual rings occurs when:
 1. The annual rings running into the contact area from both sides pass into one another steadily and without kinking,
 2. This steady line of union also runs in the direction of the force flow.
- If the arrangement of the annual ring no longer satisfies the rule of development in accordance with the force flow, as a result of changes in loading, injuries, etc., then the new growing annual rings hasten to adapt to the changed situation. Older annual rings remain unaffected by this; they report on past loading situations. Wood readily relates its load history, and shows the courses of earlier force flows and shear-free areas. It is different with a bone: it can reduce structures formed earlier and cause them to disappear, thus erasing its mechanical past. An old knot hole, a 'wood defect' in the wardrobe of a dreary hotel room, can become a merrily chatting companion, readily reporting on its relationships to the trunk, the load burdens and often even the year of its death. For the knowledgeable observer, an otherwise empty and dreary hour is filled by reading in the book of nature.
- While the annual rings can usually be interpreted very well in the trunk cross-section, misunderstandings may occur in longitudinal sections if the annual rings (better, annual cylinders!) are cut obliquely. These tangential sections are often called 'flares' (Fig. 99). The contours of these 'flare figures' have nothing to do with the course of the grain, because within an annual ring the fibres naturally run downwards inside the 'cylinder of the annual ring tube' without being able to leave it, as this would mean jumping into an earlier or later year. The grain is of decisive mechanical importance in the direction of the trunk axis.

Fig. 99. Tangential section – wood 'flares' and grain direction shown by crack formation have nothing to do with each other

Wood Fibres and Force Flow: The Fear of Shear Stress

The flare figures shown in Fig. 99 do not coincide with the cracks running around the knot. These cracks do however provide very good information on the grain direction around branch holes, knots, inclusions etc. The flare figures are only a consequence of cutting the annual rings (better, annual cylinders) obliquely.

In the previous section it was deduced from the computer analysis of the annual rings in a transverse section of the trunk, that they form along the force-flow lines, thus minimizing the shear loading between the annual rings. Naturally, one might think that a longitudinal sliding of the fibres relative to each other within an annual ring could be avoided in the same way. Examination of the field of the force-flow vectors (Fig. 103) reveals a strong similarity with the course of the grain (cracks), even if uniform material behaviour (isotropy) in all directions is first assumed. One can also proceed iteratively, subsequently assigning grain distribution to the force flow. This happens by assuming a much higher modulus of elasticity in the direction of the force flow (i.e. in the grain direction!) than transversely to it, exactly as is the case in wood. The change in the material properties in turn also causes a change in the distribution of the force-flow vectors, and the directional dependence of the elastic material constants must be adapted anew to the changed distribution. This iteration method is successfully ended when the force flow no longer changes, but retains its spatial distribution from one computer step to the other. Then the shear stresses between the fibres are also minimized in the best possible way.

Such an iteration method was programmed by Jürgen Schäfer at the Karlsruhe Research Centre. The optimized distribution of the wood fibres has a quite significant effect on the shear stresses in all cases. The shear stresses between the fibres decrease drastically in the transition from a fibre arrangement calculated for the isotropic case (initial model) to the finally optimized case. There is no need for surprise at this, as when using the CAO method we have often found that quite small changes in shape cause a tremendous reduction in notch stresses, extending the working life over 100-fold.

CAIO

FE-analysis under service load
Unidirectional orientation of the orthotropic axis

↓

CAIO calculation
Arrangement of the local orthotropic axis along the principal-stress-trajectories

↓

FE-analysis under service load
New calculated orientation of the local orthotropic axis

↓

Sufficient reduction of stress? — No → (back to CAIO calculation)

Yes ↓

Aim of optimization achieved

Example:

non-optimized optimized

shear stress
high ▬▬▬ low

Fig. 100. Flow chart of the CAIO method (Computer-Aided Internal Optimization), which calculates fibre patterns appropriate for the force flow in composite materials

With the method described here, which we have called *CAIO (Computer-Aided Internal Optimization)*, we can imitate the internal architecture of the tree, namely its optimum grain direction. It is conceivable that this too will be used in the optimization of technical composite materials made of fibres. The manufacturing possibilities for the optimum 'weaving' of fibre composites in accordance with previously optimized distribution are not yet as well developed as the modern CAM (Computer-Aided Manufacturing) possibilities for the manufacture of highly complex and computer-optimized component shapes. However, we should not lose sight of this goal with fibre composites. With these, a true *ecodesign* would mean not only optimization of the external shape but also of the internal fibre distribution. What could emerge is *'technical wood'* with the possibility of artful connections finding their highest degree of perfection e.g. in the copying of a branch junction. The CAIO method was used on various two-dimensional models at Karlsruhe by Ralph Kriechbaum in his doctoral thesis. (Kriechbaum R (1994) Ein Verfahren zur Optimierung der Faserverläufe in Verbundwerkstoffen durch Minimierung der Schubspannungen nach Vorbildern der Natur. Bericht Nr. 5406, Karlsruhe Research Centre). Figure 100 shows the flow chart of the CAIO method. Naturally, in the FEM model real fibres cannot lie transversely through the finite elements, but each element can be assigned an individual direction-dependent material behaviour, giving it its own local orthotropy system. The CAIO method then simply twists the axis of greatest stiffness (grain direction) in the direction of the force flow, i.e. in the direction of the quantitatively largest principal normal stress. Naturally, the course of the force flow also alters a little with this new orthotropic distribution corresponding to a particular fibre distribution. Accordingly, it must be calculated again in another run. This is carried out iteratively until the distribution of local orthotropy axes, i.e. the 'grain', no longer changes. Then the shear stresses between the fibres are also minimized: the fibres are lying like the principal normal stress trajectories which are defined by their absence of shear stress. Grain and force flow coincide. Figure 101 shows the example of a tension plate with a circular hole. If this is simply drilled transversely through fibres running uniaxially, then high shear stresses will result (dots near the circular hole in Fig. 101, above). After using CAIO, the fibres run gently like spindles around the hole and the shear stresses are now equal to zero (Fig. 101, center). As part of a co-operative agreement, the AKZO company in Holland wove this programmed arrangement of fibres (Fig. 102). Comparative tensile tests indicated a failure load 1.5 times higher for the CAIO-optimized structure. Accordingly, it pays to arrange fibres appropriately to the load. In this case, the degree of mixing, i.e. the fibre density, was not optimized. With the transverse contraction of the hole, the fibres near the hole naturally experience a superimposed bending load. In contrast to the SKO method, it is advantageous here to make the more heavily loaded part of the fibre distribution softer, thus relieving the fibres near the hole somewhat and putting more load on the fibres far from the hole. This can also be done by iteration, until a uniform stress distribution is present over the cross-section at the level of the hole. Industrial acceptance

of the CAIO method is less, compared with CAO and SKO, because until now, scarcely any manufacturing possibilities have existed for programmed fibre-weaving. The existence of this method may be a stimulus for the manufacturers of CAM equipment.

Optimized Grain

FEM: Ralph Kriechbaum

Fig. 101. Optimization of fibre course (grain) around a circular hole in a sheet of wood. The fibres deflected like spindles experience minimized shear loading

Summary of the Rules for Annual Ring Design

Fig. 102. Prototypes manufactured by AKZO Holland

Fig. 103. Fibre course (grain) found by CAIO around a knot-hole agrees with nature

Fig. 104. Complex fibre arrangements (grain) in old pieces of wood report on the course of force flow in times long past. (Photo: Biruta Kresling)

The complexity of this problem is shown by some photographs which, despite all the apparent diversity, still satisfy the common design rule: *'agreement of force flow and fibre course (grain)'* (Fig. 104).

This section on the self-optimization of the course of grain in trees would be incomplete without considering the phenomenon traditionally known as spiral grain but more accurately as helical grain (Fig. 105).

We should believe that every natural design which was able to survive and maintain itself in competition is of functional advantage. According to latest knowledge, helical grain has both mechanical and biological advantages. The latter were described very clearly by Kübler [13]. One of Kübler's important points is that with the presence of helical grain, water and assimilates are better distributed over the circumference of the stem if parts of the roots or crown are missing on one side. The transport systems otherwise arranged vertically thus follow the helical growth winding around the stem. In this way, according to Kübler, all parts of the stem are cared for with assimilates and water, which a sickly branch or a dead root could not supply. In addition to these plausible biological advantages, there are also possible mechanical benefits beyond those already reported by the author [20, 21].

Summary of the Rules for Annual Ring Design 135

Fig. 105. Schematic representation of helical growth [20, 21]

Let us first consider the distribution of the force flow in a solid cylinder of homogeneous material (Fig. 106). The tensile force flow σ_1 follows the cylinder surface in a 45^0 turn, and so does the compressive force flow σ_2 but at right angles to these windings (Fig. 106A). It is obvious to lay the tension-resistant wood fibres along the σ_1-lines. Thus they would be loaded in pure tension, no shear would occur between the fibres, and moreover, splitting of the wood by the transverse compression σ_2 which presses the fibres against one another would be largely avoided. A tree loaded by unilateral twisting appears to utilize these indisputable advantages of helical grain. Naturally, the fibres do not always lie inclined at 45^0, because wood is less stiff in the transverse than in the longitudinal direction, and because the case of pure torsional load is relatively rare in nature. Nevertheless, helical grain is found relatively often, especially in trees which are heavily loaded by wind.

A branch projecting far out to the light on one side usually suffices to act as a lever arm for the torsional moment. This arrangement of the wood fibres in the direction of the coiled tensile force flow with torsion represents an optimization of the internal architecture of the tree's trunk, i.e. its grain. Like every optimization, this too is a specialization for a particular load. Figure 106 shows what risk there is in this specialization if the torsion reverses its direction. The rope twisted in the direction of its lay (Fig. 106B) becomes stronger, fibres pressed close together transversely forming an increasingly dense structure. The rope twisted against its lay (Fig. 106C) increasingly unravels itself, is compressed in the direction of the fibres, and the latter are pulled apart in the transverse direction. The load thus precisely attacks the weak points. This design, loaded in opposition to optimization can offer scant resistance to its fate. Therefore, anyone wishing to saw off a long side branch should check whether this is perhaps the cause of the helical

grain in the tree's trunk, as it acts as a preferred unilateral lever arm for the wind load. In such a case, the counter-rotating lever arm on the opposite side of the tree should also be sawn off at the same time, in order not to reverse the direction of the torsional moment induced by the wind. If that were to happen, helical longitudinal cracks would result.

Figure 107 impressively shows the self-strengthening effect of helical grain correctly loaded. The 'harp' beech illustrated would never have coped with the middle trunk which swings like a pendulum out of the plane formed by the three trunks, if the horizontal part of the trunk were not tremendously twisted. The harp tree either arose from three separate beeches with fused roots, the middle one of which first fell and then righted itself, or the tree arose from one beech which fell and whose side branches became trunks, the middle pendulum one also lying down laterally in this case.

This example also shows how a situation initially considered a misfortune, viz. the almost horizontal lateral position of the middle stem, later becomes the basis of its chance of survival and its success.

In human society too, someone who has been battered by fate and gone through numerous trials of life is often more successful and dependable than the pampered stay-at-home whose smooth face knows neither the traces of victory nor defeat.

Similarly, a tree which has been severely tested by natural forces has a more interesting physiognomy than a well-tended little tree in a dense stand [8].

Fig. 106. Force flow distribution in a twisted solid cylinder. **A** The shear-free lines run inclined at 45^0 to the vertical and are loaded in pure tension in the direction of twist, and in compression at right angles to it. **B** A rope is excellently optimized and self-strengthening when loaded in the correct direction of twist. **C** In contrast, the rope fails with a small loading in the wrong direction of twist

Summary of the Rules for Annual Ring Design 137

Fig. 107. Self-strengthening of the horizontal carrier of a harp beech by helical grain, caused by geotropic righting of the formerly horizontal middle pendulum trunk

Another particularly striking example of helical grain will be presented here. The ponderosa pine shown in Fig. 108 is standing in southern Idaho. The tree probably grew from a seed that fell between two large boulders. In its earliest youth it came into contact with the rocks which allowed it only tortuous paths to the light. By secondary growth in diameter, the pine finally succeeded in bursting parts of its stony prison until encountering a narrower sheet of stone which pressed against it obliquely and was enveloped. Through all these twistings and contact areas at the base, the tree had such a great girth below that even the formation of a lot of reaction wood was not sufficient for it to twist and right itself. It formed a harp tree with branches directed upwards like strings. Only the more slender top shoot succeeded in assuming a vertical, i.e. geotropically ideal, position. Because of the rocky outcrop shattered by the tree, it is difficult today to say exactly how the external loading acted. But the internal loading, the mechanical stresses, are 'frozen' in the tree's diary, its assembly of annual rings and its grain, and after its death they will still report on the youthful years of incarceration in its rocky prison.

In these last sections we have seen how the tree forms its outer shape in accordance with the axiom of uniform stress, thus largely avoiding both potential fracture points and also superfluous material.

Because the annual ring currently growing is identical to the outer contour of the tree, the formation of the annual ring (insofar as it is mechanically controlled) can also be explained by this axiom, and even predicted by computer. The annual rings largely follow the force flow, and thus dangerous shear stresses between neighbouring annual rings and bending loads within an annual ring are avoided. Finally, the vertical wood fibres also follow the axial force flow, divert around

attached branches and, after bark removal, are the surest indicator of the direction of the force flow. Accordingly, the main mechanical design rules (Fig. 109) for the tree's growth are: the minimization of external loads; the uniformity of stress on the tree's surface; and the avoidance of shear between neighbouring annual rings and wood fibres by their orientation along the force flow. The external and internal architecture is outstandingly well adapted to mechanical demands, and unnecessary bending loads are avoided by geotropism as the crown's centre of gravity is placed in the best possible position over the centre of the roots.

Now, if everything is so perfectly optimized, why do trees ever fracture, let alone in considerable numbers in severe storms or with wet snow? This will all be investigated in the following sections.

side view
from the right from the left

Fig. 108. Unusual helical growth, locally very limited, on a ponderosa pine in Idaho, caused by early stone contacts against the young tree

Summary of the Rules for Annual Ring Design

```
                        ┌─────────────────────┐
                        │   TREE MECHANICS    │
                        └─────────────────────┘
                                  │
              ┌───────────────────────────────────────┐
              │ AIM:                                  │
              │ TO ABSORB AS MUCH LIGHT AS POSSIBLE,  │
              │ USING THE LEAST MATERIAL POSSIBLE     │
              └───────────────────────────────────────┘
                                  │
                          ┌───────────────┐
                          │  REALIZATION  │
                          └───────────────┘
```

- MINIMIZATION OF THE EXTERNAL BENDING LOADS
 - REACTION WOOD
 - CROWN CENTRE OF GRAVITY ABOVE ROOT CENTRE

- CORRECT DISTRIBUTION OF UNAVOIDABLE LOADS IN THE STRUCTURE (UNIFORMITY OF STRESS)
 - LENGTH/RADIUS FORMULA
 - SHAPE-OPTIMIZED BRANCH AND ROOT JUNCTIONS
 - WOUND HEALING
 - ENVELOPING OF CONTACT BODIES

OPTIMIZATION OF LOCAL ANISOTROPY BY THE COURSE OF TREE RINGS AND WOODEN FIBRES ALONG SHEAR-FREE LINES

TREE DESIGN

Fig. 109. Schematic representation of tree mechanics [20]

How Does a Tree Break?

It is certainly possible in principle to make a tree absolutely safe against failure with even worst-case loading, and thus that tree would be safe against many cases of load which it would never actually experience because of its siting. What a waste of material, what a need for nutrients and energy to prepare this material, and what a competitive disadvantage against the neighbouring tree, which boldly and somewhat light-heartedly grows up tall, dispensing with excessive safety, and leaving the heavyweight safety hypochondriac in the shadow of the dare-devil.

Who dares, wins. And this does not seem to be so different for trees too. Competition for the most light and the greatest growing space is the driving force for light-weight construction. Certainly the risk of fracture does increase, but the slender tree growing tall to the light in a dense stand will only fracture *perhaps* – but the tree which is much too thick and therefore much too short will *certainly* decline in the shade of the others. For the preservation of the species it is better to have many trees with the lowest possible material expenditure and moderate fracture risk, than a few totally fail-safe heavyweights with a lot of trunk and little crown which can certainly stand but scarcely absorb solar energy.

The same applies to an even greater degree for our own bones, which even shrink and save weight when underloaded. We would certainly not be so fortunate if our bony skeleton was made fail-safe against frontal impacts by a heavy motorbike. At least all kinds of movement sports would then no longer be an unmixed pleasure. The suffering, pain and depression known by everyone who has had a serious mechanical accident – all that counts for nothing in nature. The suffering of the individual is readily paid as the price for the efficiency of the species. That's why trees and bones fracture!

As will be shown in the following pages, there is usually a wide range of possible failures, largely defined by the load situation and the local geometry at the place of fracture. This will now be explained for trees [22].

Transverse Fracture of a Solid Cylinder

From the mechanical standpoint, a sound tree trunk without decay is, like the branches, a solid cylinder of wood having a round or oval cross-section. We can calculate the maximum bending stress for a cylinder quite easily with Eqs. (1) and (2). But how do we know at what external bending moment M the round beam will fracture?

Fig. 110. A solid cylinder of wood (tree trunk, branch etc.) fails in bending by fibre kinking on the compression side, followed by fibre tearing on the tension side

There is a critical stress σ_c which must be determined by experiment, at which wood fails under compressive loading, as individual fibres start to buckle and thus induce fracture. Naturally, wood also fails under tensile loading, but it can withstand tensile loads more than twice as great as compressive loads. If a tree trunk is loaded as in Fig. 110 by a bending moment with one side in tension and the opposite side in compression (bending stress distribution!), then wood usually fails first on the compression side of the bending by fibre kinking, and only later by fibre tearing on the tension side. We shall see later on just how dangerous even moderate fibre curvatures of the wood, e.g. around old branches, can be, because they reduce the compressive strength of the wood.

The pattern of damage just described can be calculated quite easily because of the simplicity of the geometry at the place of fracture if we write

$$\sigma = \sigma_c, \qquad (12)$$

as a failure criterion with Eq. (3). Hence we can calculate the maximum bending moment and from that, the permissible wind load. σ_c is the compressive strength of wood. If there are knots in the wood, as there almost always are, then it is *forbidden* to use the table value for clear (knot-free) wood. The various mechanisms triggering damage at branch junctions have been described qualitatively elsewhere [23], and were quantified in extensive experimental studies by my colleague Dr. Klaus Bethge at the Karlsruhe Research Centre in collaboration with the National Forest Products Laboratory, Madison, Wisconsin. The results of this work should also set new standards for the traffic safety of city trees.

Failure of Thick-Walled Wooden Tubes by Cross-Sectional Flattening

If a thin axial hole is drilled longitudinally in the middle of a tree trunk (solid cylinder), the trunk will fail in the same way as before by transverse fracture, induced by fibre kinking on the compression side of the bend. If the hole drilled has a larger diameter, so that the solid cylinder becomes a thick-walled wooden tube (hollow tree trunk), it can no longer be imagined that the cross-section of the place of fracture will simply retain its circular form on failure. With increasing

curvature, an inwards-directed transverse force is also produced, which is indicated in a simplified way in Fig. 111 as the radial resultant of the upper-side tensile and lower-side compressive forces. These radial forces have a cross-sectional flattening effect, which crushes the tube's cross-section into an oval form, making it softer in bending, increasing its curvature, flattening even more, etc., etc. Although this is not a really unstable process, it results in rapidly growing deflections without the need for a significant increase in the bending moment. This can be easily visualized by bending a piece of rubber or an insulating tube and noting a local flattening of the previously circular cross-section. In wood, however, a typical mechanism occurs long before the rubber-like flattening. Caused by the low transverse strength of wood, longitudinal splits occur with increasing flattening of the cross-section. These axial splits eventually lead to total collapse of the cross-section, which finally consists only of two layers of 'boards' lying one on top of the other. As these boards previously formed a tube, they all still exhibit a certain convexity.

After the collapse of the cross-section, the bending stiffness of the tube has deteriorated so much that the external bending moment usually breaks the individual board elements transversely very easily. The fracture of the hollow tree is then complete.

Fig. 111. Because of the curving of the tube, cross-sectional flattening forces occur, which lead to the complete collapse of the cross-section with axial stem splitting

Fig. 112. Breakup of the tube into a parallel row of almost flat boards as a result of the tendency of the semi-circular profile to flatten

Because of the importance which the axial splitting of the tube wall obviously has in the course of damage, and will also have in the following examples of shell buckling, it is explained with a very simple example in Fig. 112. We start with a round half-tube (Fig. 112A) of wood. We bend it, and in accordance with its tendency to flatten the cross-section, it splits longitudinally in the middle and perhaps is still held together a little along the fracture line by untorn fibres (Fig. 112B). Now, if we load these two pieces (tube shells) similarly, they will also split in the middle (Fig. 112C). This tendency for longitudinal splitting is favoured by the low tensile strength of the wood across the grain. The longitudinal splitting will only stop when the tube shells have split axially so often that they represent virtually flat boards and exhibit no further tendency for cross-sectional flattening on bending.

All these processes can be easily demonstrated in tests with a stalk of straw or with a piece of elder wood from which the pith has been pushed out. They are also involved in the shell buckling described next.

Shell Buckling: The Tree as a Thin-Walled Tube

The thick-walled tube indicated the start of failure by cross-sectional flattening, before the tube self-destructed by axial splitting and cross-sectional collapse, but buckling failure of a very thin-walled tree is much nastier because it happens by surprise.

Anyone unfamiliar with the concept of buckling should go straight to the fridge, quickly empty a can of drink, and then grasp the can at both ends and bend. With just a little extra increase in load the initially quite stiffly resistant can will suddenly give up all its resistance and fail by buckling. This abrupt failure with just a little increase in load is the spiteful thing about this damage mechanism, which will be discussed in more detail later, taking biological shells as examples.

The thin cross-section of the wall of the wooden tube is under such high compression on the compression side of the bending that the fibres buckle spon-

taneously, without the need for cross-sectional flattening to happen first. It is the abruptness of the damage that makes it so dangerous. Moreover, as it presupposes only a thin wall thickness in comparison with the radius of the hollow stem, which reacts sensitively to small defects (knots etc.), the pattern of damage is also very varied, as Fig. 113 shows with a few examples. Any thin-walled hollow tree is in danger of buckling. Buckling failure is still further promoted, as always, by crooked contours on the surface having a force directed inwards – or outwards – perpendicularly to the surface of the shell. Fibre curvatures around living or dead knots in the tree's interior will be discussed later on as regards their damage-triggering effect.

The tree does not capitulate very rapidly with decay, however. On the contrary, because an internal local decayed area in the tree's trunk weakens the cross-section there, and thus disturbs the state of uniform stress on the tree's surface at the level of the decay cavity, the tree often tries to restore this uniformity of stress by forming an annular bulge as a result of locally widened annual rings. In other words, it lays down more material in the form of a convex bulge in a ring around the decay cavity. A CAO simulation by Harald Gerhardt proves the restoration of the condition of stress uniformity in this case too. The occurrence of such bulges indicates to the tree-care expert a decayed place in a tree which is still sound enough to at least venture attempts at rescue (Fig. 114).

So far we have considered the failure of round closed cross-sections. However, open cross-sections, which are not uncommon in old street trees like limes, chestnuts and also pollarded willows, are particularly 'diverse' as regards pattern of damage.

Fig. 113. The failure of thin-walled tubes by shell buckling demonstrated on hollow tree trunks reminds one of a drinking can

Fig. 114. The bulge indicates a struggle between progressive spread of a decay cavity in the tree's interior and adaptive growth on the tree's surface. The tree's aim is to maintain the condition of uniform stress

The Open Cross-Section – The Load-Dependent Chameleon

Open cross-sections of tree trunks can be formed by mechanical rupture of the wall of trunks that are already hollow, or when injuries on one side lead to extensive interior decay, the wound itself remaining open. These tree cavities are not only an ideal place for city children to play in, and a cosy home for many kinds of animals in the wild, but are also a veritable wonderland for damage information. This is because with wind from almost any direction such a tree will give up the ghost of its stability in a different way and at a different height of loading. This interesting component can, as Fig. 115 shows, fail by cross-sectional flattening (Fig. 115A), by forward shell-buckling (Fig. 115B), which greatly resembles the local buckling of plates, and finally also by backward shell-buckling (Fig. 115C), which most closely resembles our drinks can. Note that this diversity of failure applies for the case of loading by bending. In addition to this, there would be the damage patterns for compression loading (quite similar to Fig. 115B) and for torsion (somewhat more distantly similar to Fig. 115A).

Fig. 115. The diversity of failure of the open cross-section with bending in different directions. **A** Cross-sectional flattening; **B** buckling forwards at the sides; **C** shell-buckling backwards

The Devil's Ear

A not uncommon and quite amusing form of damage occurs when a tree has extensive decay above the ground but has a solid trunk further up. Under wind loading the solid trunk rotates as in a hinge, leaving pointed ears on both sides, the so-called Devil's ears (Fig. 116). The Devil's ears probably do not tear off because they are in the zone of the non-loaded fibres in the neutral zone, i.e. where tensile stresses go over into compressive stresses. Instead, the inner side of the ears is sheared off by the stem tipping over. It often also appears as if the end of the stem had slipped down into the cavity while tipping, and as if the two ears had acted as guide bars for it on each side as it fell down. Because of the transition between hollow and solid trunk cylinders, this type of damage is a mixture between transverse fracture and hosepipe kinking. Accordingly, it is quite problematical to give a theoretical description of it. If you walk through the woods at dusk or in the moonlight, it often really does look as if a Devil with pointed ears were sitting there in the thicket to catch a stray traveller.

Most of the cases of damage described above were the result of decayed places which were already present before the fracture and which weakened the trunk. At least in principle they were detectable as a weak place, however difficult this might be in the individual case. The following example, however, is quite different and dangerously so.

Fig. 116. The Devil's ears are formed by the solid stem rotating over a large decay cavity below it. The lateral ears act like guides

The Hazard Beam: Fatal Failure or Last Resort?

When any crooked part of a tree, be it trunk, branch or merely bundle of fibres, is bent up or straightened by tension, it experiences tensile stresses in the transverse direction, and is a hazard beam. If the simplified vector presentation in Fig. 117 is still too complicated, imagine the upper, i.e. concave, side of the hazard beam as a rope trying to become taut on the tension side of the bending. However, with this tautening it moves away from the underlying compression-bearing wood on the lower side. Transverse tensile stresses occur which – and this is what makes the situation so explosive – act perpendicularly to the grain, where its tensile strength is less than in the longitudinal direction.

It might be thought that the tree is at the limit of its intelligence with these internal stresses which are equal to nil at the surface of that part of the tree (Fig. 118). There is no cambium in the interior of the stem where the stress maximum would be measured, and outside, where the cambium could measure the stresses, these failure-relevant transverse stresses are nil. A strange situation? Not for the tree. My previous co-worker Dr. Wolfgang Albrecht was able to show in his doctoral thesis (Albrecht W (1995) Untersuchung der Spannungssteuerung

radialer Festigkeitsverteilung in Bäumen. Bericht Nr. FZKA 5634, Karlsruhe Research Centre) that the tree also has the possibility of mechanical self-defence in its interior. Albrecht took cores 5 mm in diameter which had been removed in the radial direction along the tension-loaded contour of crooked parts of trees, and broke them in increments of about 1 cm using a *Fractometer*, a pocket instrument for testing wood (Fig. 119).

The distribution of the transverse strengths was read into a finite-element structure of the tree profile and plotted as a colour distribution. Then Albrecht calculated the transverse tensile stresses during loading by wind-induced bending. Figure 120 shows the encouraging result. The highest Fractometer values, i.e. radial bending strengths, are found fairly precisely where the highest radial tensile stresses also occur and threaten the poor tree with splitting. Incredible but true: there is a mechanism in the wood already formed which can, as it were, subsequently cause locally higher strengths. Many a tree biologist will frown disbelievingly, but there is more: as this strength maximum is located, like the radial stress maximum, about a hand's breadth below the trunk's surface (irrespective of the diameter of the tree), it must move outwards with the radial growth. That means that strengths no longer needed inside are reduced, and higher strengths are caused further out. The mechanism involved is the subject of ongoing investigations, but a vague attempt at a speculative hypothesis may still be permitted. Figure 121 shows tangential sections of wood anatomy kindly prepared for us by Prof. Dr. F. H. Schweingruber in Switzerland.

Fig. 117. **A** The hazard beam is a crooked component or bundle of wood fibres which is straightened by external loading. **B** The delaminated upper part acts like a brace preventing further tipping of that part of the tree. **C** If the upper part is still crooked, it may split again longitudinally

Fig. 118. The central red patch (**top**) is the place of greatest stress, which triggers the longitudinal splitting (**below**) [24]

It is clearly seen that there are more and thicker rays in the zone of the strength maximum, and these rays also have a more rounded form, optimized more for tension than for bending. (Note for the novice in wood anatomy: wood has fibres and vessels in the longitudinal direction, and in the radial direction it has the rays which, so to speak, hold the fibres together like radial spokes of a bicycle wheel [23].) As the six sections investigated showed a similar pattern, this suggests that the rays are responsible for regulating the transverse strength. This is being investigated further, and opens up the prospect of being able, with a lot of luck, to construct a 'smart structure' which is form-optimized, light-weight and strengthens itself in the interior by stress-control. Despite all this, it is obviously not always possible to plait an eternal bond even with self-strengthening, because in practice, hazard beams will still be formed, especially in woods having thin rays. Anyone wanting to learn more about the mechanical significance of the rays is referred Mattheck and Kübler (1995) Wood – the internal optimization of trees, Springer Verlag, Heidelberg.

Fig. 119. The Fractometer determines the radial bending strength by breaking a core 5 mm in diameter

Fig. 120A. The radial bending strengths measured with a Fractometer [23] in the tree are highest where the highest transverse tensile stresses were calculated with the FEM method. Here is a sabre tree with stress-controlled strength distribution

DISTRIBUTION OF LATERAL STRENGTH ACCORDING TO LATERAL STRESS

BENDING

FE-MODEL

LATERAL STRENGTH
PERPENDICULAR TO GRAIN
(MEASURED)

LATERAL TENSILE STRESS
PERPENDICULAR TO GRAIN
(CALCULATED)

HIGH

LOW

FEM: Wolfgang Albrecht

B Camouflaged hazard beam in the root spur with stress-controlled strength distribution

What happens after the first process of longitudinal splitting? There are two possibilities: firstly, if the upper part of the hazard beam is practically straightened after the formation of the axial crack, then according to the vector parallelogram shown, the transverse stresses in the upper part are naturally equal to nil. The lower delaminated part is loaded in compression in the transverse direction and therefore has no tendency to split longitudinally, its fibres rather being pressed together in the transverse direction. As a second possibility, however, if the upper part still under tension loading is still crooked even after the longitudinal splitting of the hazard beam, then it represents a new hazard beam again, which under sufficient loading will split longitudinally once more and form a secondary crack. Theoretically a third and even a fourth axial crack would be possible. The author has not yet encountered this in nature, but Dr. Klaus Bethge was able to prove it in a laboratory experiment on a thick crooked beech stem. In fact about 20 different axial cracks formed in this bending experiment. The upper part of a double split hazard beam is usually pulled straight and acts like a brace, while the lower parts have to bear the compression part of the external bending load. Either way, the tree succeeds in converting the previously crooked hazard beam into straight braces which exhibit no more transverse tensile stresses and stabilize the critical zone very well with their stressed bracing. The price for this is the axial crack, a gaping entry port for decay pathogens of all kinds. But this is not all: a completely new component has been formed by the axial cracking. It is obvious that the external shape was optimal only for the uncracked tree. This optimization breaks down when the longitudinal cracks form, because then we have a completely new component divided into two parts [22].

However crushing this failure of our design instructor may at first appear, especially because it involves the failure of the sound undamaged tree, the situation does have its advantages. The wood fibres on the upper side, loaded in tension, act like a rope lying above the compression-loaded wood fibres located beneath and connected with them by a certain 'transverse strength'. Now if the angle is bent up, the upper rope becomes taut and tears off from the support. The rope is fully tightened and stiffens the bent up angle in a way which cannot be improved upon. The tree has made the best of the material available, by straightening the tension fibres. The sceptical reader may object that the price that had to be paid for improving the design is a horrid fracture split and possible decay. That is unfortunately true, but this decay will not destroy the branch immediately. The tree has time to form substitute branches, and can also pass a practically unhindered stream of assimilates along the damaged place (the crack), i.e. the branch still 'functions' (Fig. 117). The objection can also be made that the breakdown of the life-long shape optimization of the tree at the moment of axial splitting is a further disadvantage. High notch stresses at the tree's surface are the immediate result. Unfortunately, this also is true. In practice, however, nature shows that even the tree's small safety reserves usually still overcome these notch stresses and – what a gain! – these notch stresses are found again at the tree's surface where the tree with its 'intelligent' cambium can tackle them vigorously

by adaptively growing and repairing. The oppressed tree so to speak converts an inner transverse stress maximum into a maximum of axial stresses on its surface. There this is immediately recorded and reduced by the cambium, until the *axiom of uniform stress* again rules in the longitudinally split former hazard beam.

Beech (*Fagus sylvatica L.*)

Ⓐ

TRUNK

Fractometer value: 12.5 MPa

Ⓑ

ROOT-TRUNK JUNCTION

Fractometer value: 20.6 MPa

Fig. 121. Cross-sections of rays. **A** At breast height, beech has narrow and high rays; **B** in the zone of the strength maximum there are more rays and their cross-sections are rounder (optimized for tension)

Considering all this, the hazard beam almost appears to be an ingenious act of despair by the tree. It creates a brace which recalls the tensioning bands of muscles in the skeleton of mammals. We may also think of that courage of despair which we also know from the animal kingdom. A fox or leopard caught in a trap will rip or bite its leg off and escape, severely injured and horribly maimed, *but alive*! A fox with three legs is better than a dead fox, and a branch with a longitudinal crack is of more use to the tree than a branch completely broken off. The pain and suffering of the injured are unimportant in nature – only survival counts.

Figure 122 shows some hazard beams from nature, illustrating the diversity of this phenomenon.

Fig. 122. Examples of hazard beams. **A** An extended branch with longitudinal crack; **B** a sabre tree represents a hazard beam over its entire length; **C** the hazard beam as an ecological niche. A tawny owl lives in this fracture split

The Wind Breakage of Shallow-Rooters

This section could have been presented in the description of the hazard beam, as it represents merely a special case. Because of its great importance in forestry – the storm damage of winter 1989/90 alone amounted to billions! – we shall give it a special place here. A shallow-rooter (e.g. spruce) fails in a typical way which recurs amazingly frequently in nature [18, 20, 21]. First, an axial crack is formed in the grain direction (Fig. 123) on the windward side of the spruce in the transitional zone between horizontal root and the stem; this crack is the consequence of the well-camouflaged hazard beam (shown by the dotted area). The axial tensile stresses on the windward side of the bending are deflected from the stem into the root, and again they cause a transverse force F_R perpendicular to the grain direction which triggers the root splitting (Fig. 123A, B). On the one hand, this splitting may come to a stop at a vertical sinker root (Fig. 123C), and then there is a rope-like bundle of fibres that is still attached above on the stem (at approx. shoulder height) and below on the horizontal root. With strong or repeated gusts of wind it is abruptly tautened. It then induces a transverse force like a jerk in the stem at the upper attachment which makes the stem fail here regularly. On the other hand, with a powerful gust of wind the horizontal root may split over its entire length, and the 'wooden rope', still under enormous elastic stress, tears off spontaneously at the bottom and whips up. This mechanism also leads to stem fracture at shoulder height, the dynamic catapulting movement of the strand of wood torn off at the bottom also playing a role like the sudden change in stem cross-section at its upper and still intact place of attachment. My previous co-worker Dr. Harald Gerhardt has computer-simulated both failure mechanisms with FEM, and the agreement of theory and natural experiment is encouraging [7]. Figure 124 shows the result of the calculation and an actual example from nature. In both cases we clearly see the fracture-triggering compressive stress maximum above the ground, at about shoulder height. The wood fibres then start to kink on the lee side, and later to tear on the windward side. The calculations are a very nice example of how relatively complex damage events can be quantitatively determined with FEM. As already mentioned, here too the tree is trying to counter the longitudinal splitting by a local transverse strength maximum (cf. Fig. 120B).

Fig. 123. Wind breakage of shallow-rooters induced by root delamination. **A** Formation of the crack-triggering transverse force in the hazard beam (**dotted**); **B** axial splitting of the root buttress; **C** the crack stops at a vertical sinker root, and trunk fracture occurs at the upper end of the 'rope' tautening itself in the wind; **D** alternative complete root delamination with subsequent fracture of the trunk at about the same height

Fig. 124. Comparison of the natural place of fracture with the theoretical prediction (compressive stress maximum) from FEM analysis. **A** The crack stops and stem fracture occurs with tautening of the strand of wood fibres; **B** root splitting completed and whipping upward of the strand of wood fibres

Windthrow

Stem fracture during storm loading is only one possible case of damage. Windthrow (Fig. 125) also occurs relatively frequently, when the unbroken tree tips over and the 'fibre composite material' consisting of the roots and soil in the form of a more or less coherent soil plate hinges out of the ground. We are currently carrying out theoretical calculations on this complex problem, which must also contain a mechanical soil model (!), in the Research Centre at Karlsruhe. However, we can distinguish two types of windthrow, on the basis of qualitative considerations and knowledge of the natural pattern of damage.

The extremely shallow-rooting tree (e.g. spruce) is characterized by long horizontal roots, which are increasingly loaded in bending as the flat and thin root-plate hinges up, because the ground becomes increasingly less effective as a pressure carrier. This bending load increasing outwards often leads to the fracture of the horizontal roots (Fig. 125A), the diameter of the soil plate lifted out being defined as the fracture edge of the root-plate. In the other case of less extreme horizontal rooting of the tree (heart roots), the roots experience tensile loading which they cope with much better. Therefore, they break more rarely, and instead tend to be torn out of the soil (Fig. 125B), as is very often seen in windthrown beech trees. This pattern of damage is known as 'pull-out' in fibre composite materials. Ultimately, it is a shearing failure along the surfaces of the individual root strands. It is basically difficult to prevent this type of damage because in this case it is not actually the tree that fails but the composite material, consisting of soil plus root system. The presence of a large root-plate is quite definitely of advantage, and reduces the soil reaction forces which balance the wind. The formation of buttress roots extending far out could advantageously stiffen the horizontal roots. The ongoing FEM analyses and experiments will certainly illuminate this interesting and multi-facetted problem.

So far we have tended to describe the failure of the tree looking at it from outside. However, as a tree consists mainly of wood fibres, it is also appropriate to study its failure at the fibre level.

Fig. 125. Windthrow with root plate lifted out. **A** Extreme shallow-rooter with fracture of the horizontal root ends; **B** heart-root systems tend rather to tear the root strands out of the ground ('pull-out'), and then the root ball rotates with much friction in the ground.

Fibre Kinking: The Beginning of the End

The compressive strength of wood is much less than its tensile strength, because it is obviously easier to cause a thin fibre to buckle laterally under axial pressure than to tear it by axial tension. Therefore, trees generally fail first on the compression side of the bending by fibre kinking, and only after this compression-side collapse is the failure finally completed by fibre tearing on the tension side of an applied bending load. Matters are in fact much worse. There are additional weak places favouring the fibre kinking. We shall see shortly that in the real tree the compression strength of the defect-free wood is insufficient for a computer prediction of the failure. The reason for this is the presence of so-called imperfections. By these we mean small curvatures or bends in the grain, as are necessary when, for example, the fibres are deflected around an enclosed branch. Such a lateral bulging out of the fibres greatly facilitates their kinking. We need to do much less axial work on an already crooked knitting needle to make it kink, than would be the case if it were completely straight! The compression strength of the wood is therefore seriously reduced by the presence of pre-bent fibres, e.g. in the vicinity of old branches etc. Now a tree has very many branches, around each one of which the fibres must steer in a crooked way. Therefore, all these places will fail much earlier by kinking than would have been predicted by the compression strength of knot-free wood.

The different failure mechanisms at living and dead knots and at branch holes are described in a special study [23].

Fig. 126. The vicinity of branches as places of potential fracture (cf. Fig. 69!). **A** Easy fibre kinking caused by fibre curvatures near the branch; **B** the explosive effect of kinking fibre bundles in the lateral direction; **C** typical appearance of damage around an old branch

Figure 126 shows the mechanism schematically, and also the photograph of a trunk fracture around an old branch. Neighbouring fibres, even ones that are only slightly curved or straight, are pushed away sideways by this kinking, and this cumulatively acts like a small explosive charge and also produces axial splits in the whole stem (Fig. 126B). These longitudinal splits in turn weaken the tree trunk (even one that is not hollow!), and with increasing axial pressure, e.g. on the compression side of the bending with snow or wind loading, they lead to the buckling of whole parts of the stem (Fig. 126C), finally followed by the tearing of the fibres on the tension side of the bending. Numerous wind-broken trees which have been investigated clearly showed a damage-triggering effect of branch holes on the compression side of the bending. Indeed, the branch hole always seems to be the source of damage (if large decay zones are not present in the tree), as long as it is on the compression side of the loading. On the tension side, the straightening of crooked fibre bundles (hazard beam!) tends to be involved, this leading to axial delaminations with subsequent damage. In failure on both the tension and the compression side in the vicinity of a branch hole, it very often happens that axial delamination of the bundles occurs before the fibre kinking or tearing. They are first separated from one another, in order to fail more easily individually.

Now if, by misfortune, an old branch with fibres deflected around it is found in a part of the trunk weakened by decayed places, then we are definitely faced with a veritable firework of combined kinking and buckling processes, and the potentially explosive tree deserves the expert's deepest suspicion. This expert, who has to assess the tree's safety as regards traffic, bears a heavy responsibility. And yet, however dubious it may sound, there are plenty of ways out! If one first gains the impression that the tree is still quite vigorous, has plenty of foliage and not too many bifurcations, then it has a good chance of fighting successfully for a while yet in the battle against any internal decay that may be present [4]. But how safe is the actual tree shape against failure?

The VTA (Visual Tree Assessment) method was developed in the Karlsruhe Research Centre to answer this question, and is described in detail in the *Handbuch der Schadenskunde von Bäumen* [23]. The book was published in Britain by the Department of the Environment under the title, *The Body Language of Trees*, as a guide for British foresters and arboriculturists. The VTA method has spread very rapidly world-wide, not least because it mainly involves visual monitoring, which is cost-effective and gentle on the tree. The idea is that when a tree exhibits apparently superfluous material in its shape, these are repair structures to rectify defects. Thus they are also an *indication* of such defects; they are warning signals in the body language of trees.

If these are found – and only then! – as suspicion becomes increasingly well founded, more detailed investigations are made on the tree, either by sound-velocity measurements, determination of drill resistance by a Resistograph with a drill needle of 3 mm diameter, or finally by determining the fracture strength with the Fractometer. The defect thus measured is evaluated with failure criteria, and then appropriate measures for preserving the tree are determined. If there are none, it should be replaced. Death is part of life! The VTA method has already been the basis of several judgements at Regional High Court level in Germany. However, it should never be forgotten that even healthy defect-free trees can fail, e.g. when stimulated in their resonance frequency.

There will also be accidents in the future, some fatal, with trees declared safe for traffic, in just the same way as there will be axle breakages, gear-box damage and aircraft crashes with fatal results. The special duty of care for our friends, the trees, is however also based on the fact that it may take over 100 years to replace a characterful old tree, whereas it usually only takes a few hours to replace the technical component.

As a 'mechanical component' the tree is a complex structure, and certainly more difficult to grasp theoretically than a machine component. On the other hand, description of the damage in mechanical tree failure was a fascinating task, which has already waited far too long for its solution [23].

Until now, tree fracture has been classed rather as a negative failure. However, the breaking of parts of trees in nature – not in cities! – also has a thoroughly positive aspect.

Can Trees Really Not Shrink?

Because of competition between trees, light-weight construction is more active, and green parts are essential, in order to utilize the building material as effectively as possible. In contrast to bones, which can actively break down unloaded material in order not to carry the ballast around, trees leave dead material in situ at first. The leading shoot which has died off can remain, just like the dead side branch. And yet some day they will break off. How this happens has already been described in connection with natural pruning. The tree forms a branch-shedding collar in the form of a ring notch around the dead part. After progressive decay has greatly reduced its strength, this fragment breaks off. The tree closes the wound, and smoothes out any unevenness remaining on the surface. It will reveal the history of this loss only to the practised eye, and as the years go by it becomes increasingly difficult to recognize and interpret the details of its body language (Fig. 127). However, the tree will never actively obliterate its history, as bone does.

Fig. 127. Tree fracture is a primitive possibility of passive mechanical shrinking. With increasing age the former shape therefore becomes difficult to discern

Tree fracture plays a thoroughly positive role in connection with the removal of dead parts of trees. It is, so to speak, the tree's health inspector and cleaning lady rolled into one. The tree is not bothered by the fact that it needs rather longer for this passive shrinking achieved by mechanical fracture than the active shrinking of bone.

Trees do not move their ballast, they do not run around like animals. Moreover, in relation to the life of a tree, the time taken for natural pruning is not so very different from the time taken for healing of bone fractures or major corrections of bone shape in the life of a mammal.

Actually, we could end this book here. Our design instructor, the tree, has betrayed to us almost all the secrets of biological design optimization. But we still wish to continue, because we also want to demonstrate and prove the general validity of the axiom of uniform stress for other components such as bones, claws, thorns, shells etc., in order finally to round the book off with the transfer of these design prescriptions into technology, i.e. ecodesign!

Bones: Ultra-Light and Very Strong by Continuous Optimization of Shape

As mentioned above, as regards our design considerations, bones differ from trees by the possibility of active shrinking, carried out by so-called bone-eating cells (osteoclasts). Bone building is stress-controlled by another building brigade of cells, the osteoblasts (crib: clasts chew, blasts renew!). Muscles relieve bones of tensile loading by bracing, and by active contraction of muscle length they cause the actual movement of the articulated parts of the skeleton (bones) relative to one another. This makes sense, for in contrast to wood, bones have much higher compressive strength than tensile strength.

In the context of this rather phenomenological approach, we cannot go into the microstructure of bones here. Interested readers are referred to the relevant literature [5, 36].

In principle, bones consists of a lamella structure like particle board, with tough fibres and brittle materials. Within this composite material, there also run small supply channels which are also shape-optimized [5]. All further phenomenological explanations will be discussed on the basis of one heavily stressed area of bone, namely the upper femur (upper thigh bone) of man.

Bone Design: Selected Examples

The Femur: Heavily Loaded and Successful

Figure 128 sketches how the femur is loaded when standing on one leg. The abductor muscles play an important role here, preventing the upper body supported on the ball of the hip joint from tipping inwards (Fig. 128A). Because of the unfavourable lever relationships, the neck of the femur must transmit about 2.5 to 6 times body weight as axial loading (Fig. 128B). These enormous loads can only be coped with by an outstandingly well-adapted design. In the zone near the joint the femur is filled with trabecular bone, also called spongiform bone. This is a micro-framework of very fine small struts of bone which fill the whole head and neck of the femur. Further down they run into the bone-free marrow cavity in the middle, and laterally into the compact bone wall (cortical bone). In the lower region, the femur, which is almost exclusively loaded in bending, is a simple tube with a non-circular cross-section. This is certainly sensible, for we have the highest bending stresses at the edge, and in the middle, i.e. in the marrow cavity where there is no bone, the stresses are correspondingly equal to zero. (A hollow tree is therefore not so bad, for it too has no bending loads in the middle!)

Fig. 128. The upper femur and its loading via the hip-joint. **A** Pelvis-leg skeleton; **B** upper femur with hip-joint

Fig. 129. The effect of the abductor muscles on the shape of the neck of the femur. **A** With full bracing effect of the abductors, the notch is formed on the upper side of the neck of the femur; **B** with complete absence of the abductors, the whole femur migrates under the hip socket, and the laterally angled neck of the femur shrinks, giving a columnar femur

What is the function of that fine framework of trabecular bone in the zone near the joint? Its function is not so much to save weight but rather to distribute the load from the hard bone wall over a greater area, i.e. the surface of the head of the femur which is located in the hip socket. This more homogeneous loading reduces wear on the cartilage, which therefore lasts longer, and normally no hip-joint prosthesis is necessary. Moreover, this elastic bony framework also acts as a shock-absorber or dash pot, helping to intercept excessively violent shocks somewhat. However plausible all this may sound, if you regard the femur with the eyes of an engineer familiar with notch stresses, you cannot avoid a rather uneasy feeling. There is no doubt that the upper side of the femur is the tension side of the bending, and equally certainly there is a notch (arrowed) there. This interesting and apparently explosive phenomenon was investigated by Jürgen Schäfer at Karlsruhe using the CAO method. He started from an initial design looking almost like a crutch, which did not have this notch. The pelvis with the abductor muscles was also produced, together with the hip-joint (Fig. 129). In fact it emerged that the abductor muscles fanning out from the femur to the pelvis relieve the upper neck of the femur of load so much that it shrank inwards and formed that initially irritating notch. The place where the notch is now was previously an area of very small loading in our initial design. The material found there would have been ballast, and shrank away in accordance with the *axiom of uniform stress*.

In order to show that the bracing of the abductors is responsible for the notch formation, in the next case (Fig. 129B) they were simply omitted completely. The result was both fascinating and logical. The whole femur became columnar and migrated under the hip-joint and no longer had an actual neck. We know this form of femur in the skeleton of elephants and graviportal animals in general. Obviously, these heavyweights do not like to rely on the bracing of the abductor muscles to prevent a fracture of the neck of the femur.

Moreover, stress fractures caused by prolonged oscillating or swelling loading almost never occur in bone, because during rest phases (at night) the micro-damage that occurred during the day is repaired by the industrious building battalion of osteoblasts. But if these rest phases should cease, as may happen in young recruits on forced marches, marathon runners etc., the repair activity of the bone no longer makes good the accumulated damage. So-called march fracture occurs (Fig. 130). What is interesting and consistent with our theory is that this march fracture [16] occurs precisely where maximal stress occurs without the effect of the abductors in the neck of the human femur. This again proves convincingly that the march fracture is also a consequence of increasing muscle fatigue. The bracing effect of the abductors decreases, the notch is no longer in the region supported by the muscles, and an audible fracture of the neck of the femur is often the painful consequence of unrestrained strenuous activity (Fig. 130).

However, the bone fracture, no matter how painful and protracted it may be, is not the absolute end for the unfortunate fellow. The same also applies for free-living creatures which often have at least one healed bone fracture. The reason is

similar to wind breakage in trees – an absolutely fail-safe design makes the species too ineffective in competition as regards energy.

Like the wounds of trees, bone fractures also heal in a stress-controlled way, in accordance with the *axiom of uniform stress*, as will be described in the following pages.

Fig. 130. March fracture at the place of maximal stress, occurring as a result of loss of bracing by the abductor muscles

Healing of a Femur Fracture

Figure 131 shows a fractured femur (lateral X-ray) left out of position for some reason or other. The healing process was simulated with CAO for the dominant case of loading by pure bending. The initial design was based on the actual radiograph of the condition shortly after the operation. The calculations were carried out by Martin Mitwollen at Karlsruhe. On the usual CAO command: 'Grow into a shape with uniform stress on the surface of the component!' the bone first rounds out its notches, thus removing its potential fracture places which could have caused a re-fracture with premature loading. Only then is superfluous material removed, and the femur grows first into a gentle S-shape and then straightens completely. (With a more refined presentation of the physiological loading beyond the rough approximation of pure bending, the bone would also have assumed that slight curvature which characterizes natural femur design). Naturally such drastic changes in shape are to be expected only in quite young patients.

The Femur: Heavily Loaded and Successful 171

Fig. 131. A broken femur left in a defective position grows into a shape-optimized form again in a young patient

172 Bone Design: Selected Examples

The complex of problems concerning the femur would be incomplete if account were not taken of the adaptive bone reactions when hip-joint endoprostheses are applied. These still offer great potential for biomechanical investigations.

The Consequences of Hip Prostheses for the Femur

Adaptive growth with its incredible shaping possibilities can cause serious disadvantages for the patient after the insertion of hip prostheses. The author expressly points out that this may happen in unfavourable cases, but need not necessarily occur – so don't panic! Figure 132 shows diagrammatically what can happen in the worst and fortunately not very frequent case, after insertion of a prosthesis shaft that is too stiff [15].

Fig. 132. Possible patterns of damage if the bone is supported too much by a prosthetic shaft that is too stiff. **A** The prosthetic shaft takes the majority of the force flow and relieves the bone which partially shrinks; **B** the force flow conducted abruptly into the bone at the lower end overloads the bone locally there, leading to plug formation; **C** the consequence is fracture of the prosthesis at the edge of the bony plug surrounding the shaft; **D** the prosthetic shaft sitting on the bony plug attracts even more force flow, relieving the bone still further until it becomes so thin that it ruptures; **E** comparison of supporting the femur from inside by a prosthesis, and supporting the tree from outside by sticks

The inserted stiff prosthetic shaft supports the bone surrounding it and thus reduces its bending stresses. However, as the full stress is still acting in the bone below the prosthetic shaft, and is even higher directly below the tip of the prosthetic shaft, the condition of uniform stress is significantly disturbed. The bone will do everything to restore it. First therefore, the supported region of bone surrounding the prosthetic shaft shrinks to a thinner wall thickness, until the stress has risen again to the previous required value. Below the tip of the prosthetic shaft its force flow must again be conducted into the bone (where else?), locally causing a high stress peak. This can also be imagined as an abrupt change in cross-section from the prosthesis/bone union to the bone alone below. This locally high stress there can only be reduced by *more* material than the required value. A plug-like thickening therefore fills the marrow cavity under the prosthesis, and an annular bulge also grows around the femur externally (Fig. 132B). This all ends when the *axiom of uniform stress* again applies over the whole bone surface, i.e. when the loading in the bone is properly distributed again. Then the bone shape is ideally adapted to the presence of the prosthesis.

In unfavourable cases, however, this process may go awry. Then the prosthesis sits increasingly with the lower end of the shaft on the bony plug which becomes even more heavily loaded and thickens. Moreover, the wall of bone surrounding the shaft thus becomes even thinner, and the prosthetic shaft carrying the entire load either fractures at the edge of the plug (Fig. 132C), or in a mini-accident the wall of bone which has become extremely thin will shatter (Fig. 132D), which would be even worse. This is one of the quite rare cases where the adaptive growth – caused by human intervention – can act to the disadvantage of the component (bone).

Before discussing how this damage could be prevented, let us make one more quick comparison (Fig. 132E). The femur, supported from within by the prosthesis, reacts quite similarly to the stem described earlier, which was supported externally too rigidly with sticks (Fig. 37). For better comparison, we have shown it upside down. Both these biological components exhibit reduced growth in the supported region and thickening in the overloaded region, which can be explained very nicely with the *axiom of uniform stress.*

But how can we now prevent this failure of the prosthesis/bone union? There are almost as many opinions on this as there are scientists working in the field. Here, we shall propose only one way which we have drawn up and verified with modern computer methods at the Karlsruhe Research Centre. Three requirements are vital for a good prosthesis:

1. It must be flexible enough so that it does not support the surrounding bone too much or the bone will shrink.
2. It must have a steadily tapering tip, in order to conduct the force flow not too abruptly into the walls of the bone, which could cause plug formation.

3. It must have a wide collar which is well supported medially (on the body side) which ensures the natural course of force flow.

From the technical operational aspect, a moderate step-cut when severing the femur head will ensure that this prosthesis collar sits in an ideal way medially (on the side nearer the body) and not laterally (on the side away from the body). Only thus can the natural course of force flow be reasonably preserved even in the presence of a hip-joint endoprosthesis.

Figure 133 shows a possible prosthesis design which meets these requirements quite well, and the recommended saw cut through the neck of the femur. The proposed prosthesis design consists of a slotted steel tube (marrow nail) into which a prosthetic shaft formed with an extremely tapering tip is inserted and secured against twisting. The wide prosthetic collar sits well on the medial bone edge, and thus conducts the force flow coming from the head of the prosthesis directly into the bone below the collar of the prosthesis. FEM calculations by Manfred Prinz and Uwe Vorberg in the Karlsruhe Research Centre have shown that in this way the supporting of the bone surrounding the prosthesis can be significantly reduced, and that the flexible tip of the prosthesis makes the formation of a bony plug beneath the end of the shaft less probable. The tusks of the warthog (Fig. 3) also have a finely tapering hollow-shaft design! All in all, joint endoprosthetics offers wide scope for giving younger patients a really durable joint replacement if necessary. The examples have also shown that the CAO method is very well suited for replacing experiments on animals (which none of us really likes) in wide areas of biomechanical studies. If bone growth can be computer-simulated, perhaps real bones will not need to be grown in animal experiments.

We shall present one final bone study before turning to the micro-frameworks of trabecular bone.

Fig. 133. A prosthesis principle which ensures largely natural force flow, and the appropriate saw cut. The tusks of the warthog also have a finely tapering 'shaft tip' and in cross-section resemble the figure-eight profile of the spruce root in Fig. 3

The Vertebral Arch – A Weak Point?

Together with a complex system of bracing muscles, the spinal column stabilizes the trunk in man and prevents it from collapsing or buckling. If, for example, we hold out a bucket of water with arm outstretched horizontally, its weight is pulling on the lever of our full arm length. The bending moment must be conducted along the spinal column into the ground. As the muscles in man are arranged very close to the spinal column, they therefore have to exert much larger counter-forces pulling on the shorter lever arm. As muscles can only take tension, similarly high compression forces must be transmitted from one vertebra to another. Thus the vertebrae, which together form the spinal column, have to transmit considerable compression loads. Therefore, it is at first sight surprising to find a deep notch in this bony part. Accordingly, the aim of this investigation is to evaluate the shape-optimization of this so-called vertebral arch with the CAO method. These calculations were carried out by Axel Öhlert at Karlsruhe. Figure 134 shows the result. The initial design selected was an arcade bounded by a semi-circle above, and this was then improved by computer-simulated growth with CAO. As in almost all constructions known to us, here too the circular notch proved unfavourable. A high notch-stress maximum is clearly visible in the upper part of the semi-circular non-optimized notch. After a few growth steps in the CAO method, the vertebral arch grows into a form no longer symmetrical but one which is, as expected, outstandingly shape-optimized. The stress maximum is drastically reduced. As already done with trees, forks, and branch and root junctions, here too adaptive growth succeeds in shaping *notches without notch stresses*. The vertebral arch is therefore constructed in the best way, and as Fig. 134 shows, the rather skewed arcade form calculated agrees excellently with the real vertebral arch (photo). Here, too, a two-dimensional homogeneous and isotropic finite-element model gave a sufficiently good approximation. Later on we shall present the shape-optimization of an orthopaedic screw used to fix implants on the spinal column. These implants are used for example when the front wall of the vertebrae buckles because of excessive compression loading. More on this later.

176 Bone Design: Selected Examples

Fig. 134. Proof of the shape optimization of a vertebral arch

Trabecular Bone: Micro-Frameworks as Pressure Distributor, Dash Pot and Light-Weight Internal Architecture

We have already briefly mentioned the function of the trabecular bone in connection with the design of the femur. It distributes the loading over larger areas, especially in the region near the joint, thus reducing wear and protecting the cartilage on the sliding surfaces of the joint. This elastic framework also probably acts as a dash pot or shock-absorber in damping short-term load peaks.

Considering all we already know about shape optimization, no one would seriously doubt that the connection places of trabecular bone are excellently shape-optimized. However, there are further adaptations in the spatial arrangement of the trabeculae, which were brought to my attention by Curry's book [5].

Trabecula Axis and Force Flow: The Fear of Bending Load

Right at the beginning of this book, when introducing bending stress, it was pointed out that loading a solid cylinder in pure bending must always mean waste of material. In the middle of the cylinder the bending stresses are neither tensile nor compressive stresses, but are equal to zero. For this reason, long tubular bones are hollow inside; they have no material in the region of zero stress. They are hollow cylinders, i.e. tubes. The bony trabeculae try to avoid squandering material in another way, by largely dodging the bending load. We can confidently take this literally, as we shall soon see. If a solid cylinder is loaded only in axial compression or tension, it has a uniform stress everywhere in the cross-section. Remember here the plump bird sitting on the post in Fig. 1, which induced a pure axial force and thus caused a wonderfully uniform stress over the whole cross-section, which means optimum material loading!

Thus, if we succeeded in placing the trabecular bony struts precisely in the direction of the force flow, they would be loaded in the best possible way in tension or compression, and as little as possible in bending. Their cross-section would be homogeneously loaded in the best way possible, and waste of material would be minimized. Cross-connections of the trabeculae, saving them from kinking failure, would then be required in the direction of the other principal normal stresses (Fig. 7), i.e. the transverse force flow.

And this is what the clever trabecular struts in fact do. The fascinating thing is that they do not need to learn anything new for this. They simply behave exactly like the large bones, inside which they are hiding! They follow the *axiom of uniform stress* exactly like the house whose filling they represent. Two effects play a special role here [5]: lateral displacements and rotations of the trabeculae.

Drifting and Rotating: The Wanderings of the Trabeculae in the Search for Pure Axial Loading

Figure 135 shows the essence of the trabecular movements diagrammatically, adapted from one of Curry's illustrations [5]. Trabecular drifting (Fig. 135A) is a wandering of the trabecula under the action of a force at a certain distance. Here again the condition of uniform stress is created. Just like our well-known plump bird perching on the branch well away from the stem in Fig. 2, the offset force applied causes both axial loading and bending moments. And it is precisely the latter that must be avoided. These are the bending stresses which with reverse signs are added to the axial compressive stresses on one side of the trabecula and subtracted from them on the other side. This alone produces higher stresses on one side of the trabecula than on the other. The bone will put on material on the side with higher loading, and the eager dismantling gang of osteoclasts will reduce the bone on the other side. This behaviour, solely dictated by the *axiom of uniform stress*, is virtually the actual drift process. When the trabecula, after wandering for long enough, is finally content under the induced force, it is loaded only under axial compressive stresses which are distributed homogeneously over its cross-section. From now on, the *axiom of uniform stress* forbids any further wandering. It has the same stress on both sides and there is no reason to put on or take off material on one side. The trabecula now remains under its axial force.

Fig. 135. The two basic mechanisms of trabecular bone for achieving pure axial loading without bending. **A** Drifting in the direction of the line of action of the force flow; **B** rotating in situ in the direction of a force flow inclined to the axis of the trabecula

The process of rotation can be explained by similar reasoning. Let us start with a trabecula inclined to the direction of the force flow acting vertically. It experiences a rather more complex bending load which reverses its bending direction of rotation in the middle of the trabecula, thus producing a zero moment there. Accordingly we must expect the most changes at the upper and lower end of the trabecula. There it is intergrown with other bony parts running horizontally, which in turn are loaded horizontally in the direction of their own axis. It probably makes little sense to adduce the same reasoning again: the reader may like to try to understand fully the case of drifting described in detail above. He will then be able to explain the adaptive rotating similarly.

Thus we can summarize:

- Trabecular bone is directed along the field of the force flow.
- With disturbances, trabecular displacements are undertaken in accordance with the axiom of uniform stress. These can be roughly subdivided into drifting and rotating, and weighted combinations of these.
- The individual trabecula satisfies the axiom of uniform stress when it is under pure axial loading, i.e. its longitudinal axis coincides with the force flow.

After explaining this wonderful mobility of the trabeculae qualitatively, we shall present a computer simulation of these two examples (Fig. 135A, B). These CAO simulations involve some expense, because the changes in shape are considerable. When a trabecula drifts or rotates, its FEM network does the same. It is not a trivial problem to get a good network quality with such drastic increments, but this is essential for computational accuracy. The initial calculations were done by Axel Majorek, and completed later by Dr. Heidemarie Huber-Betzer on the basis of this experience. Figure 136 shows trabecular drifting. For reasons of symmetry, only the upper half of the structure is created. On the left one can clearly see the wandering of the trabecula in the various stages, and also the increasing homogenization of the stress distribution. When the trabecula is finally standing beneath its force as desired, it again shrinks a little and thus reduces its weight to the minimum. (Moreover, in Fig. 129B the femur behaved quite similarly in the absence of abductor muscle bracing. It drifted under the hip joint in order to minimize its bending loading.)

Analogously, Fig. 137 shows trabecular rotating with the trabecula initially in a sloping position. The priorities set by nature here are particularly interesting. The trabecula thickens considerably at its upper and lower end, and remains slender in the middle in the region where the bending moment is equal to zero (reversal of bending moment). Only after completion, when all the bending stresses are eliminated over its whole length, does its diameter shrink again to a certain reduced thickness. *Safety clearly has priority over light-weight construction.* And that is surely sensible, for a broken trabecula is of no more use to the bone around it, even if it were shrunken ultra-light.

Adaptive Drifting of Trabecular Bone

Fig. 136. CAO simulation of trabecular drifting under an initially eccentric concentrated load

FEM: H. Huber-Betzer

Fig. 137. CAO simulation of trabecular rotating in the direction of a load inclined to the axis of the trabecula

But how do all these changes in the force-flow field, necessitating the drifting and rotating of the terrified trabecula, actually come about in everyday life? Now if your best girl-friend makes the bold decision to change from low-heeled walking shoes to high heels, this is like a bolt from the blue in the secure world of the trabeculae. Do not imagine either that even with the same heel height unchanged the loading would always correspond to the lattice-work of the bony trabeculae. It cannot be equally adapted to standing on one leg, high-stretch jumping, and pedalling a bicycle. The trabecular micro-framework is adapted to a time-weighted average of the various loadings. But this again means that any change in the time-weighting of the individual loads will involve on average a change in load, even if all the previous activities are still being practised. The decisive thing here is the altered time duration. We do not particularly need to explain that insertion of prostheses, bone fractures healed in a faulty position, sudden use of walking sticks etc. will alter the load assemblage. We already understand this after looking at trees, whose partially oval stem cross-section also cannot be equally well adapted to all wind directions, so that here too the time-weighting of the particular load is important. We have also already encountered the orientation of elements of the internal architecture of biological components, when investigating annual ring formations and grain fibre arrangements inside trees.

But what is the basic difference between the fine structure of wood and bone? By this we do not mean the ultimate micro-structure down to cells, molecules and atoms, but we shall consider the trabeculae in bones and the fibres in wood as the smallest size of components. As both the fine structures and also the whole form satisfy the *axiom of uniform stress*, larger bones or parts of trees will also be included in this comparison.

Bony Frameworks and Tree Frameworks Compared

Trabeculae and Air-Rooters

The frameworks illustrated in Fig. 138 show trabecular bone (Fig. 138A) and the welded framework of an aerial-rooter (Fig. 138B) from which the host tree has fallen away or rotted. The two components are pleasantly similar in conception, and both certainly satisfy the axiom of uniform stress for their loading. The fact that they have arisen in different ways is unimportant, but the question of what distinguishes the adaptive potential of their design with a possible change of shape must certainly be discussed in this book.

Fig. 138. A Trabecular bone framework, compared with **B** a framework-like welding of aerial roots

Basically we already know the answer: both components would lay down more material at the appropriate places if overloaded, and not do so at underloaded places. The trabecular framework would largely shrink away these places, but the air-rooter cannot do this. The air-rooter will certainly widen overloaded zones, but as it cannot 'reduce' the underloaded zone, it cannot achieve a genuine drifting or rotating of individual parts of the roots. This difference is less significant in fairly stationary loading than in drastically changing loading.

The Reasons Why Bones Are Better at Adapting Their Shape

The main advantage of bones is the fundamental possibility for active reduction of material, which in trees only happens passively by the combination of decay and mechanical fracture. As trees do not run about, whereas in bones each superfluous gram has to be lugged around for distances that depend on the particular animal's activity, this is probably a major reason for the almost miserly behaviour of bones.

There is one further reason. The tree no longer needs to worry about its internal wood, and does not actually feed it, although it does have some storage function for biological supplies. As the internal wood costs the tree practically no expenditure on maintenance, it is quite willing to leave these parts of the body alone. This applies when these are virtually unloaded, as the stem interior always is. The tree does not actively hollow itself out, as the long tubular bones do. The latter would still have to feed inactive zones of bone. In this way bones would have self-maintenance costs which simply do not occur in trees. That is the second main reason for the active reduction mechanism which can pare away non-load-bearing zones in bones, thus making them mechanically superior to trees. Nevertheless, trees are still comparatively 'clever' because they can carry out short-term and successful shape adaptations via diameter growth.

Certain kinds of thorns, claws, horns etc. do not have this advantage. They are consigned to a time-consuming trial-and-error method, which took a long time in evolution but led to high-tech components fully comparable to trees and bones but which can no longer react to subsequent changes in loading.

Claws and Thorns: Shape-Optimized by Success in the Lottery of Heredity

The Tiger's Claw

The experienced finger-wrestler in the pub might think he had a feel for the loads that a good rip-hook has to withstand. Quite wrong! The load in finger-wrestling is a slow quasi-static pull. It is more accurate to imagine jumping up beneath a high washing-line and hooking on to it while swinging freely: a dynamic process which would arouse some self-doubt in even the fittest finger-wrestler. And yet this kind of load is what happens when a tiger lands on the back of a bullock, buffalo etc., claws itself on firmly, is shaken about and finally conquers or is hurled down. A tiger weighs about 200 kp, so just imagine having to hold some swinging sacks full of potatoes with one's finger nails. As the tiger does not hurt itself in doing this, its claws must be especially well shape-optimized, and the horn material must also exhibit a high tensile strength. The striped predator cannot allow the slightest local excess stress which would mean a design weak point and could have painful consequences for it during the tussle. These few preliminary observations make the tiger's claw – or the claws of predators in general – an attractive object for study. The FEM and the CAO methods were used in the mechanical analysis [25]. Figure 139 gives an overview of the results of the calculations. The initial design was a hook of 'engineered' shape, consisting of two arcs of a circle. As in all the cases considered previously, here again the circular contour is a design catastrophe with a dangerous stress maximum in the last third of the claw (Fig. 139B), as also emerges from the stress distribution for the non-optimized circular contour. These stresses are reduced and homogenized after using the CAO method. A claw formed as a logarithmic spiral is produced, and this must therefore be the optimum form.

The equation of the logarithmic spiral is:

$$r = ae^{b\Theta}, \qquad (13)$$

where a is the initial radius with $\Theta = 0$. Further investigations [25] show that the stress distribution assigned to the spiral is also relatively insensitive to variations in the parameters of the spiral. In other words, computer FEM analyses showed that it does not much matter what size of arc resembling a logarithmic spiral is used as the claw contour. They are all a better solution than the circle.

Fig. 139. CAO evaluation of the shape optimization of a tiger's claw

Without going into these mechanical design advantages, D'Arcy Thompson long ago pointed out the frequency of the logarithmic spiral in nature in his much-quoted pioneering work [6], and with these and other investigations he laid the foundation for geometric descriptions of biological design. However, his work was quantitatively descriptive rather than mechanically analytical, and scarcely touches upon the concept of shape-optimization. To the best of my knowledge, this is first found in Metzger [28] in connection with spruce stems.

The tiger's claw, like antlers etc., cannot be optimized or even repaired by secondary adaptive growth in thickness. The best form was, so to speak, selected by trial from generation to generation. The non-optimized tigers died. This procedure for component improvement naturally took a very long time, but even today a considerable number of technical components are still developed by the trial-and-error method. Similarly, proving in practice does play a part with technical components, but other non-functional aspects (fashion, publicity, price etc.) are also important for the survival of technical products.

Another important difference between technical development and evolution is the fact that in technology there can be quite discontinuous leaps in development, e.g. from leaf spring to spiral spring. In evolution the spiral spring would have to develop step by step from the leaf spring – no matter how – and create transitional forms between leaf spring and spiral spring (unimaginable in this example!).

The thorns investigated in the following section originated similarly, provided that they developed from the bark and not from woody parts of the tree.

Thorn Shape and Load Direction

In contrast to the tiger's claw, we cannot just guess the loading of a rose thorn. Therefore here we shall *believe* that thorns are also shape-optimized in the sense of the *axiom of uniform stress*, and merely investigate what loading of the thorn would lead to what form of thorn. Basically, thorns should protect the plant from being eaten or from other mechanical damage, or should serve for climbing. Accordingly, imagine one lateral force onto the shoot and one along the shoot in different combinations. The effect of these force combinations is shown in Fig. 140. In each case, the CAO optimization leads to a drastic reduction in stress in the optimized design compared with the arbitrarily devised initial design, which moreover still exhibits dangerous circular notches at the thorn/shoot transition.

The following load influences are found in the shape of thorns:

- High loads transverse to the axis of the thorn widen its base, i.e. its 'place of attachment' on the stem, as they stress the thorn in bending.
- High additional longitudinal forces in the direction of the thorn axis cause an asymmetrical form of thorn, because they increase the bending stresses on one side of the thorn and reduce them on the other.
- The thorns point in the direction of the resultant force.

The relationship of axial force F_2 to transverse force F_1 is shown self-explanatorily for each example. As optimization was done according to Mises stresses (Eq. 5), both forces could also be applied in reverse, which corresponds closest to reality.

Proceeding from our *axiom of uniform stress*, and in the certainty that forms of thorn developed from bark by selection will – like the tiger's claw – satisfy this general biological design rule, it is possible to determine the thorn's most important loading from the form of the thorn found in nature. Accordingly, using Fig. 140 the reader can assign any thorn found in the field biomechanically, according to the design load for which it is dimensioned. Mixed forms of thorn, or forms assigned to further load ensembles, are also conceivable. The calculations presented in Fig. 140 were carried out by Reinhard Steiner at the Karlsruhe Research Centre.

All in all, with the examples of claws and thorns we have gained an impression of the optimization of short transverse beams with superimposed axial force. We have seen that, after a long enough time, even a trial-and-error method in nature will bring about the optimized shape via the lottery of inheritance associated with the higher mortality rate of the non-optimized shape. Short hooks can be optimized by shaping according to the logarithmic spiral. This is probably because the bending moment changes greatly over short zones from the tip to the attachment. In contrast, with a slender transverse beam which is long in comparison to its thickness at the base, the bending moment hardly changes in the attachment zone. Accordingly, this is usually described quite well by the Baud curve [1], which has already been presented for tensile loading in Fig. 22. For loading by bending it appears rather more slender. However, the tensile Baud curve is also best suited for a bending load. Like the logarithmic spiral, it is found in many junctions of slender structures bearing bending loads, such as branch junctions, root spurs, bone connections etc. It was first found by Baud [1] in an inspired experiment, by filing off a plexiglass blank and subsequent stress-optical monitoring of stress uniformity. This was a stroke of genius that attracted little attention at that time only because of the absence of the manufacturing possibilities which we now have with CAM (Computer-Aided Manufacturing). Industry shrugged its shoulders – no application. Today almost any form of component can be program-manufactured, and this was probably one of the reasons for the rapid acceptance of the CAO method in industry. Anyone who can manufacture the optimum form without problem will be eager to acquire an effective method of determining it.

It is interesting to trace back the different approaches to solving the same problem. Metzger [28] formulated the *axiom of uniform stress* in a rather disguised form for his spruce stems, and did not bother much about technology. Baud [1] primarily wanted notches without notch stresses, in order to create durable components, and he had no recognizable ideas on the self-optimization of nature. This is a good example of the importance of multi-disciplinary thinking. With the high intensity of research found in almost every special field today, the grapes hang lowest in the areas where the subject fields overlap. Here, knowledge

is needed from both the neighbouring fields, which somewhat limits the intensity of research.

After this excursion into the world of hooks, we still have the thin-walled components, shells, as a further object of study as regards optimum shape.

Fig. 140. Various cases of load for thorns which, starting from the same design proposal, grow steadily into different CAO-optimized forms

Biological Shells

What Are Shell Structures?

Everyone knows what a plate is. It is a plane component whose thickness is small compared to its other dimensions. Now if this plate has a curvature, it is already a simply curved shell. One example known to us all is the thin-walled tube. If this tube also changes its diameter along a curve in the axial direction, it is a doubly curved shell (Fig. 141).

Before going on to optimization, we want to consider the rather nasty kind of failure known as shell buckling. Whole books have been written about this, and it is impossible to initiate a multi-disciplinary readership into the theory of shell stability en passant. Instead, we shall clarify the qualitative difference between buckling failure and simple cross-sectional collapse.

Fig. 141. A A Plate. **B** simply curved shell and **C** doubly curved shell

Fig. 142. A stable cross-sectional flattening and **B** unstable shell buckling as a genuine rupturing problem with the relevant qualitative force/deflection curves

In Fig. 142A we see the stable process of cross-sectional flattening of a thick-walled transversely compressed tube. The tube fails by flattening of the cross-section into an oval profile. As explained earlier (Fig. 111), wood would very quickly split along the grain at the place of the highest circumferential stresses, without assuming the pronounced flat-oval form. In wood, the force/deflection curve, as explained previously, would exhibit a steep fall by fracture when axial splitting occurred (Fig. 112), which requires no buckling process. The latter is shown as a genuine rupturing problem in Fig. 142B.

The thin-walled tube finally releases its elastic energy in a kind of mechanical desperation, as it ruptures downwards. This rupturing is called 'unstable behaviour'. It is characterized by a force/deflection curve falling steeply after reaching the buckling load. The unpleasant thing about this pattern of damage is the collapse of carrying capacity virtually without warning. The drinks can on to which we stepped as a youthful frolic was quite 'stiff' until it suddenly collapsed without warning with only a small increase in load.

Why a Shell Theory Is Inadequate for Shape Optimization

Out of regard for the non-technical readership, here we shall dispense with presenting the analytical basis for the mathematical description of shells. Instead, we shall merely present the 'shell element' which is used in finite-element programs, with the simplifications contained in it (Fig. 143). It is described by four or eight nodal points lying in one plane like a two-dimensional element, and it is given a finite thickness as a further input parameter. All this means that the stresses in the thickness direction can alter only linearly as a curved stress profile,

but never like a real notch-stress distribution. And there's the rub! Under loading, a shell structure will react no less sensitively to a locally excessive stress than any other mechanical component. It can and will fail at such a place, e.g. by buckling (under compression) or by tearing (under tension). A finite shell element by its mathematical conception basically does not 'perceive' such notch stresses but only calculates local bending moments and the tensile and compressive forces in the shell plane; naturally it cannot serve for finding an optimal shape which avoids these unperceived notch stresses. If you can't see in the dark, you can't clear stones out of someone else's way. Accordingly, in the CAO optimizations of highly curved shell structures, the latter are always modelled by several layers of three-dimensional finite elements, with which we can calculate even highly non-linear notch-stress distributions varying over the thickness of the plate. Figure 144 shows a simple example of such a CAO application. A circular tube is compressed transversely by a pair of vertical forces. As already discussed in bending failure by cross-sectional flattening, it has four stress maxima, which are displaced by 90^0 and accompanied by a horizontal ovalization. The CAO optimization carried out by Dr. Heidemarie Huber-Betzer, in which growth was arbitrarily permitted only on the inner side, led to local increases of wall thickness at the places previously highly loaded. With great reduction of the notch stresses, the long circular tube grows into a tube which is strengthened inside with four axial ribs. Numerous variants of these tube cross-sections strengthened with longitudinal ribs are found in nature on the shoots of many plants. Sunflowers also have distinct axial ribs, especially under the leaf junctions.

Fig. 143. A The shell element in FEM programs, **B** the stress distributions 'recognizable' from it, and **C** the real notch-stress distributions not recognizable from it on shell curvatures

Fig. 144. A circular tube compressed transversely by a pair of vertical forces grows into a tube longitudinally strengthened with axial ribs

As we have seen, the application of the CAO method to shells requires no special manipulations. We only need to introduce several layers of three-dimensional finite elements over the thickness of the shell, in order to trigger non-linear stress gradients in the thickness direction. Pure shell elements only trigger stress gradients in the plane of the shell, but not over its thickness, and are therefore absolutely inadequate, especially in highly curved shells.

The following examples of biological shell optimization should demonstrate the common features of apparently different but functionally largely identical shells.

Tortoises and Nuts

If an armoured tortoise is lying on the ground, a large contact area is certainly of advantage. This minimizes the contact stresses, similarly to what we have already seen with tree-stone contact (Fig. 145A). The underside of the shell will therefore need to be shaped rather flat. This avoids the need for long legs (much material, unfavourable force effect with levers too long), which would have to raise the 'keel' from the ground. Moreover, on sloping ground a tortoise with a rather convexly shaped underside would roll on to its back more easily and perish helplessly. This would give us sufficiently sensible explanations for the flatness of the underside.

Fig. 145. The shell of the tortoise. **A** Advantages of a flat underside; **B** advantages of a highly rounded back; **C** drawing of the sawn section through the shell of a Greek tortoise

We shall now assess the correct convex curvature of the upper side of the tortoise in a similarly qualitative way. If a larger mammal steps on to the tortoise or if its shell is crushed by other vertical loads, there is the danger of shell-buckling. Without any calculation we can easily imagine that a shell which is more convex above will collapse downward less easily than a shell which is almost plate-like and only very shallowly curved (Fig. 145B). Greatly simplified, this can be explained by the greater difference between the breadth of the shell and the length of the arc of dorsal shell above it. Because of its greater arc length, the convex shell is simply more difficult to press down between the two lateral 'bearings', i.e. supports formed by the edge of the ventral shell. A shallow curvature of the dorsal shell is only slightly longer than the distance between the supports, and therefore collapses downward more easily. The convexity of the dorsal shell thus protects the internal organs of the tortoise, and increases its stability against shell-buckling. If the tortoise does fall on to its back, despite all the helplessness of the situation, a dorsal shell that is highly convex is still the best suited for helping its struggling movements to succeed by rolling sideways (perhaps on a slope). As speed levers, the tortoise's short legs are naturally unsuitable for rapid running, but by their very shortness they do confer on the four-legged armoured car quite an incredible propulsion even in difficult terrain.

Figure 145C shows a sawn section through the shell of a dead tortoise. Here too the local variations in wall thickness, controlled by the axiom of uniform stress, must have developed the optimum thickness distribution by evolution. That means that the greatest thicknesses are found at the places of high loadings, thus again ensuring the spatial uniformity of stress which was merely postulated here (supported by experience with the horny claw of the tiger) and not proven by computer.

Clemens Kunisch and Frank Walther devoted much more computer work to the study of the nut-shell of *Mezzettia leptopoda*. (We thank Dr. Peter Lucas of Singapore for setting the task, and also for the nut samples.) However different the nuts may be from tortoises, they do have in common the fact that their destruction by external pressure acts against the preservation of the species. Nuts must also bring forth their contents sometime when germinating, because shoot and roots must be formed.

Figure 146 shows the stress distribution in the longitudinal section of such a nut which is resisting mechanical destruction under external pressure. The nut is very well adapted to this load situation by local wall thickenings, and the four stress values in the region of greatest bending moments are about equal in magnitude. With loading by internal pressure (Fig. 147) the pointed corner on the right acts as a point of potential fracture. In addition there is the plug-like insertion which is placed immediately at the edge of the stress maximum and facilitates fracture by internal pressure. Accordingly, this first approximate two-dimensional analysis proves that this nut facilitates failure by internal pressure but tries to avoid failure by external pressure, as the four stress maxima are about equal in

magnitude. In the context of the plane model, a completely uniform stress cannot be expected.

Fig. 146. Stress distribution in the longitudinal section through a nut of *Mezzettia leptopoda* when loaded by external pressure

Fig. 147. Stress distribution in the longitudinal section through the same nut when loaded by internal pressure

Bracing: Ultra-Light but Highly Specialized

The Advantages of Bracing and Its Sensitivity to Loading Inappropriate to the Design

One might criticize the author for introducing this stage of biological light-weight construction with an observation that smacks of a truism. It is, however, necessary to make things digestible for the reader who is less familiar with the theory of the stability of kinking rods.

Let us consider a rod set into the ground (Fig. 148), which in one case (Fig. 148B) is anchored on both sides with guy-ropes and tent-pegs. Now, if this is loaded from one side, e.g. by wind, then the rope on the windward side is under tensile stresses, and the one on the leeward side will slacken and sag somewhat. It suffers no damage when it slackens. As it can transmit no pressure, there is no danger of buckling in this mechanical component which is highly specialized for transmitting tension alone.

Unfortunately things are different in another case (Fig. 148A), where the vertical rod is held by a sloping support-rod installed on one side. Now if the sloping support-rod is installed on the windward side, it acts rather like the guy-rope. This applies especially if it is pivoted above and below and thus cannot be loaded in bending. But if this heavyweight supporting member is on the leeward side then it must (in contrast to the rope) support the vertical rod, as it is loaded under compression. It is deprived of the blessing of being able to slacken, and of being relieved by the opposite guy-rope. The stiff support-rod cannot slacken, but it may very well fail in an unstable way by kinking when the kinking load is reached. To prevent this, it must either be made as short as possible, which is inappropriate here because of the desired height of attachment, or it must be made thick enough for the prescribed length. With the rope we only had to consider the maximum tensile load. When placed on the windward side the lateral support-rod must also withstand only tearing, but on the leeward side it must also withstand kinking failure. Thus it is no longer a proper light-weight element, for a thin wire will usually suffice to take the tension load on the windward side. On the leeward side, however, that thin wire becomes a hopeless element, failing at the first breath of wind. Then it must be given the dimensions of a respectable tube or solid cylinder in order to exclude kinking failure. But this costs material and therefore money. If, moreover, it is a part that is moved about in service, then lugging this heavy-

weight around will cost additional energy and under certain circumstances will also cause avoidable environmental damage.

With all the destructive criticism of our poor sloping support, we should still remember that it does represent one step in the light-weight direction, as against the over-dimensioned vertical pole without ropes or sloping supports. Because of our focus on external aid structures, we have dispensed here with a detailed optimization of the vertical pole itself, e.g. as a hollow cylinder with variable wall thickness and radius. With CAO this would be a trivial routine problem.

Now after seeing that the combination of the vertical upright with lateral bracings corresponds best to the light-weight principle, we can state with some self-satisfaction that our own skeletal system is just such a light-weight construction, consisting of the bony skeleton bearing the compression and bending and the musculature bearing only tension. The muscles are also braces which actively contract and can thus move the bony skeleton. This again puts us in the happy position of putting a full spoon to our mouth when our favourite dish is steaming on the table, or pedalling like a madman through the country on a mountain bike. In short, much of what makes our life pleasant through movement is due to the wonderful interplay of this skeletal system consisting of compression supports and contractible braces acting both with and against one another. Moreover, we also save energy with it, for as a biological design we are – most of us at least! – light-weight and shape-optimized.

Fig. 148. B The saving on material with two-sided bracing of a pole, as against **A**, the tension-compression rod on one side

Naturally there is also a snag in all this. The ropes are only light-weight because they can only take tension, and no kinking stiffness is required from them. If our pole were fixed with only one guy-rope on the leeward side, this rope would be loaded in compression and ineffective. Optimization of the component also means sensitization by specialization to a particular load situation. The less optimized vertical pole without any attachment will cheerfully take bending loads from all directions, but never to the extent that the optimized system would in the direction of the bracing. The risk of loading inappropriate to the design must therefore also be remembered in designing, and avoided by taking all conceivable load situations into account. If loads opposed to one another are possible, these must be appropriately captured by opposite bracings.

From our own skeletal system we know the interplay of bending and stretching muscles which act against another external loading. We do not wish to investigate this anatomically and kinematically complex system, but rather we wish to present bracing as a general design variant, as found by functional demand in a multitude of plant and animal structures. From this diversity we shall merely compare here the human hip-joint and a tree-stone friendship on a steep slope.

Bracing at the Hip-Joint and in Trees on Eroding Sites: A Functional Identity

Figure 149A shows the loads in the pelvis-leg skeleton when standing on one leg, greatly simplified and based on Pauwels [29]. The foot must be below the body's centre of gravity, otherwise we'll topple over. Moreover, because of the articulated connection of the trunk on the upper thigh bone (femur), tipping over of the trunk in the direction of the raised leg must be prevented. This is achieved by a group of muscles, the abductors, which connect a protuberance of the femur (the trochanter major) with the outer edge of the pelvis, as the detail in Fig. 149A shows. These braces then run further along the outer side of the femur. One can easily feel them by placing one's hand on the outer side of the femur, and raising the other leg. Then one clearly feels the tightening of the braces which, incidentally, the anatomists call the tractus iliotibialis. We have already encountered these bracings of the abductors in the earlier section on the design of the femur, where we saw that they are also responsible for the upper concavity of the femur (Fig. 129).

However much the functional anatomists may frown, examination of Fig. 149 will remove any doubt: from the mechanical standpoint the tree-stone contact illustrated is very similar in design to the hip-joint. The round stone corresponds to the head of the femur, the tree's prop enveloping the stone corresponds to the hip socket, and the buttress root pulling upslope corresponds to the abductor muscles.

Fig. 149. Two bracings from nature. **A** The bracing of the abductor muscle group prevents the tipping of the trunk over the hip-joint; **B** the bracing of the buttress root prevents the tipping of the tree over the stone

How else could it be, if one needs to find a light-weight solution to limit a lateral tip-over movement? The optimum solutions must at least look similar. This uniformity of design with all the diversity of individuals and individual constructions will be discussed in detail in the final part of this book as an important piece of knowledge with all its consequences. Close examination of Fig. 149 will, however, reveal one significant difference, which will be discussed below.

Buttress Roots from the Standpoint of Bracing

While the muscles of the abductor group are genuine ropes, still capable of contraction and which pre-stress themselves, the buttress roots are just a board, of which only the upper edge is highly loaded and the zone near the stem is rather relieved of load and carries nothing. The way in which the buttress roots develop from a horizontal root explains this. It was computer-simulated with CAO by Manfred Prinz at the Karlsruhe Research Centre.

Before considering the results of these calculations, we want to elucidate the formation of the buttress roots and their prerequisites qualitatively. At first, buttress roots can develop by vertical ovalization, as the upper side of a horizontal root grows preferentially. This has been known for a long time and proven by sawn sections [37]. Figure 150A shows a shallow-rooter which has placed the sinker roots running vertically from the horizontal roots in the middle under the stem. In this case it is not reasonable for the force flow to lose itself into the horizontal root ends to the outside; rather, it leaves the stem via the sinker roots into the soil directly beneath. Things are different in Fig. 150B, where the sinker roots are largely arranged far from the stem. The whole force flow is now driven through the full length of the horizontal roots which are thus stimulated into vigorous growth. However, this only applies for the windward side, where the tension side of the bending coincides with the upper side of the root. The root is loaded in axial tension as well as in bending, which intensifies the tensile stresses

from bending in the upper side of the root, but drastically reduces its compressive stresses in the lower side. With this combination of bending and tension loads in the horizontal root (Fig. 150C) we have all the explanations for the formation of the buttress root (Fig. 150D).

As in all the previous examples, here too there exists the mechanical preference of the mammalian skeleton for the avoidance of superfluous material. The buttress has a zone largely relieved of load in the inner part of the root (Fig. 150D). As wood does not shrink, this is inevitable and moreover is caused by the gradual development of the buttress from a rather circular horizontal root.

So far we have not yet established why the buttress roots form only on the windward side, as can be very clearly observed on Lombardy poplars in nature. Figure 150B explains this. While the horizontal root on the windward side is raised somewhat from the ground, the horizontal root on the leeward side presses firmly on to the soil near the stem if it is not lying clear. The sinker roots at its end are unnecessary for dissipating the downwards pressure. The force flow leaves the horizontal roots here near the stem, as in (Fig. 150A), which also forms no buttress root. On the windward side, however, the horizontal root will be raised up somewhat from the ground near the stem, and only the sinkers far from the stem are anchoring it in the soil. Here, the force flow must go through the full length of the root and stimulates its growth into the vertical oval. These complex mechanisms have been clearly confirmed by the author in numerous field studies by root excavations on indigenous and tropical trees.

Fig. 150. Qualitative explanation of the development of buttress roots. **A** No buttress root formation with the sinker roots arranged near the stem; **B** good chances for buttress root formation on the windward side where the force flow goes through the full length of the horizontal root. On the leeward side the force flow leaves the horizontal root near the stem through its intimate contact with the soil; **C** the buttress roots act like guy-ropes and stiffen the horizontal root; **D** completed buttress root: the non-loaded zone is **hatched**

The effects of buttress root formation on the stress state, and thus the advantages of bracing, are presented in Figs. 151-153. Moreover, these CAO simulations also prove the prerequisites for buttress root formation, which have only been postulated qualitatively up to now. In Fig. 151, a tree stem with one individual horizontal root fixed over the whole lower side was used in the FEM structure. Thus an arrangement of sinker roots is simulated along the whole horizontal root, i.e. also under the stem as in Fig. 150A. As an initial design we assumed a circular transition from stem to root, which causes high notch stresses at the root spur. When the CAO method is applied this unnatural engineering design grows into a condition of uniform stress without forming a buttress root. The tree is thus satisfied with its design even without a buttress root.

The actual buttress-root formation occurs in Fig. 152, while the individual stages of root formation are shown in chronological sequence in Fig. 153. Here, the horizontal root is fixed only at its outermost end. In fact, the tree ends its adaptive growth only after the state of stress uniformity was created by the formation of a buttress root. The tremendous reduction in the notch stresses to about 1/40 of the initial value is also interesting. Conversely, this means that the optimized tree with buttress root withstands loads 40 times higher than the disadvantageous engineering design proposal with a quarter-circle notch at the root spur. The relieved zone in the interior of the buttress area is also clearly visible; in a bone this would have been broken down. Thus the prerequisites for buttress-root formation postulated in Fig. 150 would actually be proven, though critical readers could still ask what about the growth on the underside of the root.

In the context of the considerations presented in Fig. 152, growth was in fact prohibited on the underside of the root. In a later CAO simulation, growth was permitted on both the upper and also the lower side of the root. With the same initial model as in Fig. 152, Fig. 153 shows the formation of a similar buttress root, the underside of which also grows a little. Thus an anchor-like root form is formed, which is quite often seen in nature, e.g. in spruce.

All this reveals the following rules for the formation of buttress roots:

1. Buttress roots are formed by trees with shallow roots.

2. The horizontal root should not exhibit any, or any significant, supporting vertical sinker roots near the stem.

3. Buttress roots form on the leeward side only if the horizontal root has no ground contact near the stem, i.e. it is lying clear of the ground.

The buttress root generally improves the stability of the tree tremendously, by fixing it like a guy-rope does the tent-pole. The only disadvantageous thing is the presence of buttress parts which are less loaded, but these can be explained from the history of their development. The buttress is, so to speak, the 'record of growth' of the upper edge of the root, which represents the actual guy-rope, as the highly loaded zone in Figs. 152 and 153 also shows.

No Buttress-Root Formation with Sinkers Near the Stem

deformation plot

Mises stress along contour s

Mises stress

non-optimized

optimized

high

low

FEM: Manfred Prinz

Fig. 151. No buttress root formation, with sinker roots arranged everywhere on the underside of the horizontal root. Initial design with high notch stresses at the circular notch; optimized design with uniform stress along the notch contour which is no longer circular

Fig. 152. Formation of a buttress root with the horizontal root fixed only far from the stem. Initial design is a circular notch shape with high notch stresses. Optimized buttress root design has uniform stresses on the upper edge of the root and up the stem

Formation of Anchor-Shaped Buttress Roots

Mises stress

σ_{max}/σ_0
37.1
15.9
7.9
3.2
2.7
1.6
1.4
1.1
1.0

FEM: Manfred Prinz

Fig. 153. Step-wise formation of a buttress root with growth on the upper and lower side of the root

To present all the bracings of nature even briefly would fill several books. We shall leave it with these very different and yet functionally similar examples (hip-joint, tree-stone contact on a slope, buttress root), as they have already been used in technology. In the following sections the computer methods like SKO and CAO, deduced from the axiom of uniform stress, will be applied to technical components in order to improve their light-weight quality and durability in accordance with biological design rules.

Shape Optimization by Growth in Engineering Design

Light-weight construction can be practised to only a limited extent in technical components, as reliable damage avoidance is usually desired for each product, in contrast to nature. For example, if human life is involved, then we cannot approvingly accept the fracture of some motorcycles in order that this model gets by using less fuel. As already mentioned, nature does not know this scruple. Some of the following examples are industrial commissions and have mostly been built and successfully tested.

Plane or Rotationally Symmetrical Models

The Orthopaedic Screw

The orthopaedic screw optimized here is exposed to considerable loads in service. It is used to fix implants to bone, and generally bridges over broken regions of bone. The treatment of a vertebra fracture is shown in Fig. 154. The vertebra, collapsed by shell-buckling, is relieved and bridged by applying the rear plates. We have already reported on the high loading of the spinal column due to unfavourable lever relationships in the section on the optimum shape of the vertebral arch. The plate must now cope with this loading and conduct it into the bone again above and below the bone fracture via the screws. A screw thread is, however, nothing more than a helically coiled ring notch, and the first thread in particular is usually the whipping-boy of the construction. It was precisely here that the screws shown in Fig. 154 broke, and their fragments must have been very difficult to remove again. Incidentally, orthopaedic surgeons also call these screws pedicle screws. Figure 155 shows the success of the CAO application in a presentation already familiar to us. The non-optimized thread design is formed by circular arcs at the base of the thread. As so often before, we pay for this deficiency in the initial design with high notch stresses.

After a few growth steps with the CAO method, carried out by Dagmar Gräbe, these notch stresses were completely removed. The thread is now a notch without notch stresses, i.e. a shape-optimized notch. The screw was then manufactured by our industrial partner and tested in a repetitive bending test by my colleague Dr. Klaus Bethge. The optimized screw withstood 20 times as many load cycles as the

non-optimized screw, and exhibited no visible crack formation even after this incredibly longer life. The danger of implant fractures is thus reduced to the absolute minimum.

One could still ask: why not simply take a thicker screw with the old thread and dispense with the costs for the optimization? Unfortunately, this is not possible because the pedicle screws have to be introduced through the pedicle, a thin piece of bone. This pedicle should not be weakened by drilling too large a hole, or it will fracture itself. In this case the CAO method seems in fact to be not only the more elegant but also the only way out, at least unless one wishes to abandon the screw/plate construction completely.

The next example is of historical importance because it was first tackled by Baud [1].

Fig. 154. Treatment of a vertebra fracture and breakage of the bone screws which remain clearly visible in the bone after implant removal

Orthopaedic Screw

Fig. 155. Optimization of the thread of an orthopaedic screw

Beam Shoulder Loaded in Bending

Fig. 156. Shape optimization of a beam shoulder loaded in bending

Beam Shoulders

The abrupt change in diameter of a shaft is called a shaft shoulder. Analogously we shall call a local reduction in the width of a transverse beam a beam shoulder; both of them seem similar to our own neck-shoulder transition. Such shaft shoulders are made in rotationally symmetrical form with the desired changes in diameter, as needed e.g. for installing a bearing, wheel, etc. Both in round form as a shaft shoulder and also in plane form as a beam shoulder, a notch in the shape of a quadrant (Fig. 156) causes a dangerous notch stress [30]. The notch stresses can be very quickly removed completely with a simple routine application of the CAO method, which was carried out at Karlsruhe Research Center by Dagmar Gräbe. The optimized curve agrees excellently with that found by Baud [1] by filing down a strip of plexiglass. The stress concentration factor $F = \sigma_{max}/\sigma_0$ was drastically reduced from 1.85 to 1.07. This results in a massive increase in durability, which was proven in a repetitive bending test by Dr. Klaus Bethge. Figure 157 shows the non-optimized structure and the CAO-optimized component manufactured by CAM (Computer-Aided Manufacturing). Although the design differences do not appear very drastic to the naked eye, the shape-optimized component survived 36 times as many load cycles as the non-optimized component without crack formation. Even after this enormously higher number of load cycles, there was not even the tiniest crack in the optimized component. The test was then terminated in order not to occupy for too long the expensive hydraulic pulse machine with which these repetitive bending tests were run.

Fig. 157. Photo of the non-optimized component with crack, and of the optimized component which still exhibits no crack after a service life 36 times longer

So far, we have shape-optimized machine components that are plane or rotationally symmetrical. One special advantage of the CAO method is that it can also crack three-dimensional nuts without needing great problem-specific modifications. The following example will show this computationally and by experimental proof.

Shape Optimization of Three-Dimensional Components

Shaft with Rectangular Aperture

This component (Fig. 158), like the orthopaedic screw, was given to us by industry with the request for shape-optimization. The reason was occasional fatigue fractures in the corners of the rectangular aperture. This was not in the least surprising because the component, loaded preferentially in bending, has circular notches in the corners, exhibiting those proud notch stresses already well known to us from earlier circular-notched components as component-killers. Component optimization carried out by Dagmar Gräbe also led to success in this case without any problem, as shown by the complete removal of notch stress and the profile of the stresses along the aperture contour in Fig. 158.

This example reveals further advantages of the CAO method. For functional reasons the basic shape of the shaft could not be altered. It had to remain round, and the length and breadth of the milled out aperture could not be altered. Accordingly, only the aperture edge could be allowed to grow. Even worse: so that manufacturing was still feasible at reasonable expense, the edge had to be plane in the sense that both aperture edges can be made with a single milling operation. This was achieved by 'ordering' the maximum calculated increment at each place of the edges at all points over the thickness of the edge.

These additional manipulation possibilities also make the CAO method interesting for those designers who have to place special value on cost-effective manufacturing. With cast components this is of less importance than with machined components (turned or milled). Once the necessarily expensive mould has been made, series manufacture of the cast items is less of a problem. It is different with series manufacture by machining, where the expense is the same with each component. However, because of the constantly improving CAM methods, a massive trend towards shape-optimization is expected here too, which is also a welcome trend towards ecodesign.

In the repetitive bending test the shape-optimized shaft had a life 40 times longer without crack formation than the form previously used in industry. In this case too, the perfectly satisfactory test was terminated without any visible cracks having appeared in the optimized component (Fig. 159).

Shape Optimization of Three-Dimensional Components 215

Shaft with Rectangular Aperture

Fig. 158. Three-dimensional component optimization of a shaft with rectangular aperture

Failure after 200 000 cycles

No Failure after 8000000 cycles

Fig. 159. Non-optimized component, and optimized component having a life over 40 times longer

The author knows of no other method for shape-optimization which can improve complex three-dimensional components with such ease as the CAO method by biological growth. This potential for success is revealed in the three-dimensional shape optimization for the simulation of buttress-root growth. We shall leave it here with these 2D and 3D examples from technology. Readers interested in further applications will find a number of new examples at the end of the book.

As already mentioned when presenting the 'Kill Option' developed by Andreas Baumgartner at the Karlsruhe Research Centre, the CAO method cannot by itself produce any holes in a component. CAO shapes pre-existing holes optimally. The placing of these holes must be done with the SKO method (Soft Kill Option), which is best suited for the design of shape-optimized frameworks. The reader should remember that SKO, like CAO, is a tool for shaping components in accordance with the axiom of uniform stress.

Frameworks

The desire for light-weight construction, as achieved in nature in trabecular bone micro-frameworks or in the artfully welded aerial-root frameworks, lies at the very basis of framework thinking. We have already seen with the cantilever beam (Fig. 26) that the completely useless expenditure of material in the zone of the unloaded neutral fibres in loading by bending can be sensibly limited by a framework design. The trusses of technical frameworks cannot adopt a placing appropriate to the force flow by drifting and rotating like trabecular bone struts, because they are arranged more or less expertly and immovably by human hand. This placement is practically uncorrectable subsequently, and must therefore be well thought out and optimally determined before assembly. This can be easily done with the SKO method, as the following examples will show.

Figures 160–162 are largely self-explanatory. In all three cases we proceed from a homogeneous transverse beam. The more highly loaded zones are strengthened in accordance with the SKO principle, and the less loaded zones are made softer. With this now non-homogeneous structure having a locally variable modulus of elasticity, a further computation is made and the E-moduli are corrected again. After a few iterations there is a clear separation between the non-loadbearing shirkers and the industriously load-bearing parts of the components. The latter remain as a framework or better in the first draft, which in many cases could never have been devised so perfectly even by a marvel of fantasy. This automatic creation of the design proposal makes the SKO method so interesting for the practical engineer. A subsequent CAO optimization would then remove any notch stresses still existing. SKO does place the notches (empty spaces between the members of the framework) in the right place, but precise shaping of the holes is not possible purely because of the coarseness of the FEM network, and so this is left to the CAO. The examples in Figs. 160–162 show the influence of the lateral clamping conditions and of the introduction of the load on the final light-weight design proposal, which would now be trimmed to completely uniform stress distribution with CAO. The trusses are strictly divided between tension and compression members. In the latter, kinking failure must still be excluded later on, but this can be easily regulated via the desired value of the state of uniform stress. In order to make this division of work comprehensible, Fig. 163 again shows the framework obtained with SKO from Fig. 162, the tension members being drawn as ropes and the compression members as beams.

FEM: W. Albrecht, A. Baumgartner

Fig. 160. Transverse beam, supported at both ends, with a concentrated central load. **A** Initial beam of homogeneous material with modulus of elasticity the same everywhere; **B** distribution of the modulus of elasticity after application of SKO; **C** final design proposal for the framework

FEM: W. Albrecht, A. Baumgartner

Fig. 161. Transverse beam, supported at both ends, with a concentrated load pulling from below. **A** Initial beam of homogeneous material with modulus of elasticity the same everywhere; **B** distribution of the modulus of elasticity after application of SKO; **C** final design proposal for the framework

Frameworks 219

FEM: W. Albrecht, A. Baumgartner

Fig. 162. Transverse beam, clamped at both ends, with a concentrated load. **A** Initial beam of homogeneous material with modulus of elasticity the same everywhere; **B** distribution of the modulus of elasticity after application of SKO; **C** final design proposal for the framework

Fig. 163. Ropes and compression rods should clarify the division of work of the elements in the framework which ideally, like bony trabeculae, are loaded preferentially in tension or compression. **A** Rope; **B** compression strut; **C** spacer

The calculations for Figs. 160-162 were carried out at the Karlsruhe Research Centre by Wolfgang Albrecht and Andreas Baumgartner. They impressively show the efficiency of the SKO method which, like CAO, gets by without complicated, expensive and actually superfluous mathematical theory, and is therefore a reliable method, offering the best guarantee of success for the practitioner. Like CAO, the method is also directly applicable to spatial problems. The potential of the SKO method in designing cannot be over-estimated. Just think of the infinite wonderland opening up in exterior and interior architecture, furniture design, bridges, cranes, etc. which will allow fantasy to roam free. The land opening up before us is the borderland between art and construction, between nature and technology, between aesthetics and functionality. This land is called Industrial Design. It was hitherto the playground of the designer, and should remain so. A game played with engineers using the multi-coloured balls of SKO and CAO would be fine and full of promise. A scientifically based ecodesign having the natural beauty of biological components is already feasible, as the few cases presented here show.

The axiom of uniform stress has been proven on selected biological components, effective SKO and CAO methods have been developed for implementing this axiom in component design, and their success has been demonstrated in the shape-optimization of technical components and proven by repetitive stress tests. Accordingly, the methodological and pragmatic part of this book is finished. But in order not to drown in the multitude of examples, let us once more examine their common features and work out the generally valid laws.

Unity in Diversity: Design Target and Realization

The aim of improving the chances of survival of a plant or animal species by minimizing the energy requirement is recognizable in all the preceding individual cases examined. The demand for light-weight design with adequate strength is automatically implied. In plants, which do not break down the less heavily loaded zones of the component, the gain is probably only a more economical use of building material. Animals which move about often have the additional possibility of actively breaking down unneeded ballast. In nature, the light-weight principle goes relentlessly on, to the extent that some individuals are readily sacrificed for it. Safety factors in design are kept so low by natural competition that a few of the biological load-bearing structures will fail mechanically under unaccustomed loads. This is, however, sensible in order to be able to preserve the whole species more cheaply. Our own bones fracture occasionally. They are just as underbuilt for a leap from the 6th floor as a tree in a dense stand is for a wind force 12 which it never experiences. A tree with excessive safety factors would forfeit height and therefore light absorption, just as the overweight mammal would experience competitive disadvantages by increasing immobility. Our technical constructions are an exception in the context of these energy-saving emergency sacrifices. We humans want to avoid any sensibly conceivable damage in the normal operation of a component. The idea of accepting a certain in-service damage rate and hence accident rate with a motor vehicle, in order to reduce the fuel consumption of the totality of motor vehicles by more riskily light-weight construction, is foreign to us. This profoundly human social behaviour is unnatural, when measured only against the merciless criteria of biological design targets. We must wait and see whether this increased safety of the individual based on over-dimensioning will have to be paid for by more rapid destruction of the environment and thus the destruction of the species as a whole.

One useful way out would at least be the possibility demonstrated in this book of achieving biological light-weight design in technology too. The SKO and CAO methods are the practical tools for this, already available here and now. But even with these tools, the higher safety factor necessary to guarantee the security of every human individual will, in the final analysis, keep us from achieving biological light-weight quality in technology. Our morals restrain us (fortunately!) from accepting the loss of some of our fellow humans in accidents as a 'natural damage rate' analogous to the wind breakage of trees. Therefore, we do not need to throw away all our lovely new SKO and CAO methods. Many of the technical components still used today are afflicted with dangerous notches and, so that they do not

break, are hopelessly overweight. The removal of these notch stresses and the associated saving in material and weight is in itself an incredible potential for saved energy. Let us concentrate on shape optimization as a first step in saving energy.

After these general considerations, which explain an adequately strong light-weight structure as the design target, we must once more rehearse the realization of this target.

The axiom of uniform stress has proved to be a prescription with which the biological form in best agreement with nature can be predicted on the basis of numerous individual biological examples. The range of examples extends from the annual ring of trees to the tiger's claw, from the branch junction to the healing of bone fractures, from the buttress root to the vertebra, and from the trabeculae of spongiform bone to the frameworks of aerial-rooters. Tree-welding and stone-enveloping are just as predictable as wound healing in trees. Apart from these diverse examples, which are united by the common feature of a uniform stress state on average over time on the surface of the component, the rule of stress uniformity is also eminently reasonable. It means both avoidance of potential fracture places and non-loadbearing ballast. In other words, both overloading and underloading are avoided, which in the final analysis convincingly causes the uniformity of stress. The transfer of this knowledge to technical components with the simple and efficient SKO and CAO methods was actually an obvious step.

Although CAO optimizations have also been successfully carried out already for dynamic loads (harmonic stimuli), the methods are limited at least at present to static or quasi-static loads. These are processes in which the inertia forces can be ignored. However, we can easily live with this restriction, for genuine dynamic processes are a tough nut, even in the context of simple stress calculations without optimization, because of the possibility of wave reflections etc. The demarcation of very rapid load reversal also does not worry us much, because of its small technical importance in comparison with slow applications of load.

A quite different and much more delicate problem is, however, associated with any component optimization which involves a certain potential for danger if carried out carelessly.

Critique on Optimum Shape: Sensitization by Specialization

Shape-optimization means an adaptation of the component's shape to a quite special load and bearing situation. The optimum design is advantageous only for these external circumstances. So far, so good. However, in many cases this specialization is associated with a poorer suitability of the design with respect to other cases of load inappropriate to it, against which the component is thus sensitized. We have seen a simple example in the spiral grain of trees. It means an adaptation of the course of the grain to a particular direction of rotation comparable to the strands of a rope, which press on to one another wonderfully with the lay in one direction and strengthen it. By reversing the twist of the rope, its strands loosen from each other and the rope loses its good properties (Fig. 106). In contrast, a co-axially parallel bundle of fibres without any twist would be equally poor in both directions of rotation or equally good, just as you wish. It is not optimized, i.e. it is not specialized to one direction of rotation and thus is not sensitized as regards the other direction of rotation. For the designer, this means that before optimizing the component must be considered all possible cases of load. If combined loadings can occur, the designer must assume the worst possible combination and optimize with respect to this. Then the component is the optimal light-weight structure only for this combination. Admittedly, the component is still strength-optimized for some loads out of the array, but it is no longer lightweight. It is overweight to the extent that the complete array of loads was trimmed down. All this must be remembered if the blessing of CAO is not to turn into the curse of fracture mechanics. This warning should not deter us from progressing along the road to the biologically shaped technical component with the new and promising SKO and CAO methods. But this must be done alertly, for thoughtless optimization is sabotage with loading inappropriate to the design.

Outlook: Ecodesign and Close-to-Nature Computer Empiricism

We should have succeeded in making the axiom of uniform stress credible as a biological and technical design prescription of fundamental significance. The SKO and CAO design methods derive directly from this tenet as tools for the practitioner. The combination of SKO and CAO is a complete method for automatic component layout, and we can hope for wide application in the field of industrial design. The acceptance of the CAO method in industry so far confirms this. The enterprises which have purchased CAO come from all fields where fatigue fractures of components must be avoided, e.g. construction of chemical plants, the motor industry and deliverers, electrical machinery manufacture, general machine-building, manufacture of products such as electric razors and washing machines, monitoring organizations, biomechanics, turbine manufacture etc. The diversity of interest alone indicates the rigorous universality of the method, which is naturally expected to cover just as great a diversity of forms in the technical field as does its natural counterpart, adaptive growth, in nature. It is to be expected that these very practical methods will spread increasingly in the future. Thus, in their mechanical design quality, technical components could approach the biological components evolved by brutal natural selection. A machine component grown like the skeleton of an animal or like a tree – an entity of technology and nature: the ecodesign! Success justifies this apparently crazy idea, and increasingly encourages other structural mechanical engineers to try the very promising combination of observation of nature and modern computer methods.

It really does seem as though there is still great potential for success in the region where biology and technology overlap. We are surrounded by an enormous diversity of optimum constructions which can scarcely be improved upon and which have evolved in merciless competition. There is nothing more appropriate than to study the laws of these biological components and to make use of them for ourselves.

The constantly improving numerical possibilities of modern computer methods allow us to gain this knowledge in a time-effective way. Anyone who can simulate growth does not need to wait a couple of years first, until the plant or the trusting experimental animal has grown.

In this book we have shown that a multi-disciplinary and rigorously unconventional style of work, which does not eschew the risk of a spectacular and painful

flop, can lead to heartening successes, which will probably also ensure the increasing importance of close-to-nature computer empiricism in the future.

New Examples of Application in Self-Explanatory Illustrations

The following examples should illustrate the diversity of kinds of optimized structures, but also make clear their sensitivity to service loading.

Fig. 164. From a rectangular design area, clamped on the left and loaded on the right with a concentrated force (cantilever), the SKO method determines an appropriately filigreed framework in accordance with the choice of reference stress. The CAO method applied subsequently then rounds out the corners and reduces notch stresses. (FEM: Andreas Baumgartner)

Supporting of a Hangar Roof

Fig. 165. A bridging framework derives from a design having a circular inner contour. The latter is responsible for the residual stress peaks in the lower region of the pillars, and these can be reduced by further CAO growth. Note also the two narrow elements in the upper-arch region, where the bending moment has a zero passage. (FEM: Gerd-Ulrich Kappler)

Fig. 166. A bicycle frame is devised from a rectangular design area. Note that the extremely complex and varying loading in service has been greatly simplified here. (FEM: Raimund Kraus)

'Tree-House'

loading and boundary conditions

σ_{ref}

$2\sigma_{ref}$

$4\sigma_{ref}$

FEM: Frank Walther

Fig. 167. Here, different reference stresses, i.e. stresses in service, lead by means of the SKO method to variants of a 'tree-house'. (FEM: Frank Walther)

Structural Optimization of a Loaded Plate

design area with loading conditions

σ_{ref} $1.5\sigma_{ref}$ $2\sigma_{ref}$

$2.5\sigma_{ref}$ $5\sigma_{ref}$ $10\sigma_{ref}$

FEM: Andreas Baumgartner

Fig. 168. Here, in accordance with the reference stress, the SKO method finds different tension areas from a rectangle pulled at the corners. (FEM: Andreas Baumgartner)

Angle-Piece under Tension Loading

loading and boundary conditions

Finite-element mesh

SKO-structure proposal

Mises stress

high low

FEM: Matthias Teschner

Fig. 169. SKO makes a tension-loaded angle-piece out of a rectangle. (FEM: Matthias Teschner)

Frameworks 233

Angle-Piece under Shear Loading

loading and boundary conditions

Finite-element mesh

SKO-structure proposal

Mises stress

high low

FEM: Matthias Teschner

Fig. 170. SKO makes an optimum design for shear loading out of a rectangle. (FEM: Matthias Teschner)

Angle-Piece under Loading by Twisting Moment

loading and boundary conditions

Finite-element mesh

SKO-structure proposal

Mises stress

high low

FEM: Matthias Teschner

Fig. 171. SKO makes an optimum design for loading by a twisting moment out of a rectangle. (FEM: Matthias Teschner)

Angle-Piece under Transverse-Force Loading

loading and boundary conditions

Finite-element mesh

SKO-structure proposal

Mises stress

high low

FEM: Matthias Teschner

Fig. 172. SKO makes an optimum design for loading by a transverse force out of a rectangle. (FEM: Matthias Teschner)

Angle-Piece under Transverse-Force Loading

loading and boundary conditions

Finite-element mesh

SKO-structure proposal

Mises stress

high low

FEM: Matthias Teschner

Fig. 173. SKO makes an optimum design for loading by a transverse force out of a rectangle. The bearings on the right-hand side can take no moments in this example, in contrast to Fig. 172. (FEM: Matthias Teschner)

Optimum Plane Load-Bearing Structure

initial model with loading

SKO structure proposal

Mises stress

FEM: Matthias Teschner

Fig. 174. SKO makes three connecting rods out of a triangle pulled at the corners. (FEM: Matthias Teschner)

Three-Legged Stool (3D SKO Optimization)

FEM: Wolfgang Albrecht

Fig. 175. SKO makes a three-legged stool out of a cylindrical design space. (FEM: Wolfgang Albrecht)

Fig. 176. SKO and CAO determine the optimum form for the tension loading of a connecting rod. The residual notch stresses still present as a result of bearing can be reduced by growth out of the plane of the illustration. (FEM: Frank Walther)

Lever Arm under Loading in Tension and Bending

Fig. 177. SKO makes a toggle lever loaded in tension and bending, and still with a rather uneven surface, out of a rectangular design area. (FEM: Matthias Teschner)

CAO Optimization of a Lever Arm

SKO structure proposal

CAO optimization of the SKO structure proposal

FEM: Matthias Teschner

Fig. 178. Here the CAO method smooths the surface and creates a uniform stress distribution on it. The high stresses near the hole can be reduced by further growth out of the plane of the illustration. (FEM: Matthias Teschner)

Lever Arm under Tension Loading

SKO structure proposal

Mises stress

FEM: Matthias Teschner

Fig. 179. SKO makes a tension strap out of a rectangle. The right-left asymmetry of the design is explained by the concentrated load acting at the edge of the hole on the right, and the rigid fixing of the edge of the hole on the left. (FEM: Matthias Teschner)

Stiffening of a Shell-Structure

SKO

Design area

CAO

Fig. 180. The tube with the profile of a tortoise's shell (half structure!) must have inner stiffenings under external pressure from all sides. In a still rather uneven version, SKO finds a horizontal rope which prevents cross-sectional flattening and a slanting compression support which stiffens the lower shell. CAO smooths the contours. (FEM: Frank Walther)

Form Optimization of SMA Actor Components

Finite-element mesh

axis of symmetry

Mises stress distribution for the non-optimized form

high

low

Mises stress distribution for the optimized form

manufactured actor component (laser cutting)

FEM: Dagmar Gräbe, Matthias Teschner

Fig. 181. After application of CAO this spring from a memory material not only has a uniform stress distribution and no more notch stresses but also its memory capability is more uniform. (FEM: Dagmar Gräbe and Matthias Teschner)

Rotating Disk of Uniform Strength

Fig. 182. The attachment of a turbine blade: CAO-optimized component loaded by centrifugal forces. (FEM: Matthias Teschner)

Laval Disk of Uniform Strength

initial model

$r_a = 1$ m; $r_s = 1.2$ m; $m_s = 100$ Kg; $\omega = 300$ 1/s; $\rho = 4500$ Kg/m^3

optimization of the cross-section

— uniform thickness — analytical solution
— CAO-optimized

radial stress

FEM: Matthias Teschner

Fig. 183. Good agreement between the analytical solution and the CAO result for a Laval disk of uniform strength. The initial model was a disk of uniform thickness. (FEM: Matthias Teschner)

Cylindrical Pressure-Vessel with Convex Ends

$t/d_i = 0.05$ $r_i/d_i = 0.175$ $R_i/d_i = 0.75$ $L/d_i = 2.7$

Mises stress

non-optimized ······ axis of symmetry optimized

Mises stress along internal and external contour

FEM: Matthias Teschner

Fig. 184. For this pressure vessel, CAO calculates the optimum shape and wall-thickness distribution in order to achieve a uniform stress pattern on the inside and outside of the tank. (FEM: Matthias Teschner)

Optimization of a Mounting Screw in Restorative Dentistry

failure-triggering stress concentration

CAO

screw 1.7 x 6 mm, screw pitch 1.0 mm

moment amplitude, Nmm

● optimized
○ non-optimized

load cycles to fracture

FEM: A. Baumgartner

Fig. 185. Optimization of a mounting screw for restorative dentistry. CAO removes the failure-triggering stress concentrations, which is seen in the test by a clear increase in the number of load cycles to fracture. (FEM: Andreas Baumgartner)

Beam with Central Hole

$a/w = 0.7 \quad t/w = 0.1 \quad L/w = 1.8$

Mises stress

non-optimized

optimized

optimized contour

Mises stress along contour s_1 and s_2

$\sigma_{nom} = 6M/tw^2$

non-optimized
optimized

FEM: Matthias Teschner

Fig. 186. A beam with a central hole, stressed in bending, exhibits notch stresses in the region of the hole. CAO renders the excessive stresses safe by putting on material in the plane. (FEM: Matthias Teschner)

Beam with Central Hole

a/w = 0.7 t/w = 0.1 L/w = 1.8

Mises stress

non-optimized optimized

Mises stress along contour s_1 and s_2

$\sigma_{nom} = 6M/tw^2$

non-optimized
optimized

FEM: Matthias Teschner

Fig. 187. In this beam the notch stresses are eliminated by growth out of the plane. This procedure is also possible with CAO without any problem. (FEM: Matthias Teschner)

Pipe Joint under Internal Pressure

Fig. 188. Excessive stresses occurring at the transition between two pipes of different diameter can be removed by optimization of wall thickness with CAO. (FEM: Matthias Teschner)

Plate with a Hole under Tension

L/D=5 a/D=1.25 t/D=0.05 h/D=2

Mises stress

non-optimized optimized

Mises stress along contour s

FEM: Matthias Teschner

Fig. 189. In a plate of uniform thickness with a central hole, tension loading causes notch stresses in the region of the hole. For CAO optimization, only a change in plate thickness is permitted. This causes thickening of the plate in the region of the hole, and clear reduction of the notch stresses. (FEM: Matthias Teschner)

Circular Hole in a Pipe under Tension

$R_a/t = 100 \quad r/t = 38$

Mises stress

non-optimized

high

low

optimized

Mises stress along contour s

σ_{Mises}/σ

s/R_a

non-optimized
optimized

FEM: Matthias Teschner

Fig. 190. Similarly to Fig. 189, a circular hole in a pipe under tension loading leads to notch stresses in the region of the hole. CAO increases the wall thickness locally at these places. In places with less loading, the wall thickness can be reduced by CAO to save material. (FEM: Matthias Teschner)

Circular Hole in a Pipe under Internal Pressure

$R_a/t = 100$ $r/t = 38$

Mises stress

non-optimized

optimized

$\sigma_t = p_i(R_a-t)/t$

Mises stress along contour s

σ_{Mises}/σ_t

— non-optimized
— optimized

FEM: Matthias Teschner

Fig. 191. In this example the tension loading of Fig. 190 is replaced by internal pressure, thus altering the wall-thickness distribution required for a uniform stress pattern at the edge of the hole. (FEM: Matthias Teschner)

Circular Hole in a Pipe under Torsion

$R_a/t = 100$ $r/t = 38$

Mises stress

non-optimized

optimized

$$\tau_{edge} = \frac{2 M_t R_a}{\Pi (R_a^4 - R_i^4)}$$

Mises stress along contour s

— non-optimized
— optimized

FEM: Matthias Teschner

Fig. 192. Torsional loading of the pipe leads to a more uniform increase of the wall thickness in the region of the hole with CAO. (FEM: Matthias Teschner)

Fig. 193. CAIO calculates the optimum fibre pattern (appropriate to the force flow) for a tension strap made of a fibre composite material with differing fibre orientation over the cross-section. (FEM: Matthias Teschner)

Optimized Fibre Pattern for a Fork Fitting

fibre pattern in the design area

non-optimized optimized

shear stress between the fibres

non-optimized optimized

reduction of maximum shear stress by 80%

FEM: Matthias Teschner

Fig. 194. In the fork fitting, as in Fig. 193, the force is introduced into the component via a rigid bolt at an angle of 35° to the horizontal. CAIO shows what the optimum fibre arrangement must be like to minimize the shear stresses between the fibres. (FEM: Matthias Teschner)

Optimum Fibre Pattern for a Fork Fitting

F
60°
bolt
design area

fibre pattern in the design area

non-optimized

optimized

shear stress between the fibres

high

low

non-optimized

optimized

reduction of maximum shear stress by 95%

FEM: Matthias Teschner

Fig. 195. The optimum arrangement of the strengthening fibres for a fork fitting depends greatly on the direction of loading, as this example shows. In contrast to Fig. 194 the pulling is done at an angle of $60°$ to the horizontal, which leads to the bolt winding round. (FEM: Matthias Teschner)

Optimum Fibre Pattern for a Fork Fitting

fibre pattern in the design area

non-optimized optimized

shear stress between the fibres

non-optimized optimized

reduction of maximum shear stress by 96%

FEM: Matthias Teschner

Fig. 196. The dependence of the optimum fibre orientation on the load direction is also seen in this example, where the pulling was at an angle of 28°. (FEM: Matthias Teschner)

Optimum Fibre Pattern for a Bolted Plate with a Hole under Tension

L/D=10
a/D=2.5
t/D=0.125
h/D=3

fibre orientation in the cross-section

- design area
- $\alpha=0°$
- $\alpha=+45°$
- $\alpha=90°$
- $\alpha=-45°$

fibre pattern in the design area (yellow)

non-optimized | optimized

shear stress between the fibres

non-optimized | optimized

high ▮▮▮▮▮▮ low

reduction of maximum shear stress by 95%

FEM: Matthias Teschner

Fig. 197. In this example of a plate with a hole, the bolt serves as bearing. CAIO modifies the originally uniaxial fibre pattern so that the shear between the fibres is converted into tension in the fibre direction by the looping around the bolt. (FEM: Matthias Teschner)

	WHAT CAN EACH METHOD DO ?	
C A O	causes a uniformly distributed stress on the component's surface by growth at overloaded areas and shrinking at underloaded areas.	
S K O	removes the non-load-bearing parts of the component, taking design limits into account. Thus the components become lighter with identical strenght.	
C A I O	lays the fibres of a fibre composite along the force flow. Thus the shear between the fibres is minimized.	
V T A	assigns symptoms to tree defects, surveys them and evaluates them with failure criteria.	

Fig. 198. Our instructors, trees and bones, have given us four methods: CAO, SKO, CAIO and VTA. This illustration shows what they can do

CAO Method Specialized for Corrugated Sheet of Uniform Thickness Appropriate to Load

Elastic FEM run with service loading

Stress-controlled displacement of the surface

$$\vec{u}_i = A \cdot d_i \cdot \vec{n}_i \quad ; \quad \{\vec{u}_i = 0 \text{ if } d_i < 0\}$$

$$d_i = Max(\sigma_i^b, \sigma_i^t) - \sigma_{ref}$$

u=displacement, i=node, A=scaling factor, σ=stress, σ$_{ref}$=reference stress, b=bottom, t=top, n=positive normal direction (normalized)

Addition of the displacements to the nodal-point co-ordinates

FEM: Matthias Teschner

Fig. 199. Corrugated sheets can be optimally adapted to their service loading with a modification of the CAO method

Optimized Corrugation for a Sheet under Area Load

initial model with boundary conditions

optimized form and distribution of corrugation

non-optimized — top side — optimized

high / low

maximum stress reduction 43%

bottom side

maximum stress reduction 49%

FEM: Matthias Teschner

Fig. 200. In a sheet with area load, optimization produces a reduction in maximum stress. (FEM: Matthias Teschner)

Fig. 201. With identical maximum stress, the optimized design needs less material than the flat sheet. (FEM: Matthias Teschner)

Fig. 202. In a sheet with a central area load, optimization brings reduction in maximum stress. (FEM: Matthias Teschner)

Fig. 203. With identical maximum stress the optimized design needs less material than the flat sheet. (FEM: Matthias Teschner)

Optimized Corrugation for a Sheet under Line Load

initial model with boundary conditions

optimized form and distribution of corrugation

non-optimized | top side | optimized
high
low

maximum stress reduction 52%

bottom side

maximum stress reduction 67%

FEM: Matthias Teschner

Fig. 204. In a sheet with line load, optimization brings reduction in maximum stress. (FEM: Matthias Teschner)

Fig. 205. With identical maximum stress the optimized design needs less material than the flat sheet. (FEM: Matthias Teschner)

For more Unity

of

Technology

and

Nature

References

1. Baud R (1934) Beiträge zur Kenntnis der Spannungsverteilung in prismatischen und keilförmigen Konstruktionselementen mit Querschnittsübergängen. Verband für Materialprüfung in der Technik 29, Zürich (Schweiz)
2. Baumgartner A, Burkhardt S, Mattheck C (1991) The Kill Option: a powerful method to prepare engineering low-weight design proposals. Pro Int Conf Materials 6 (ICM6), Kyoto, Japan, 28 July - 2 Aug
3. Braun H (1988) Bau und Leben der Bäume. Rombach Verlag, Freiburg
4. Breloer H (1996) Verkehrssicherungspflicht bei Bäumen aus rechtlicher und fachlicher Sicht. Thalacker Verlag, Braunschweig
5. Curry J (1988) The mechanical adaptation of bone. Princeton University Press, Princeton
6. D'Arcy Thompson (1917) On growth and form. (New edition 1966) Cambridge University Press, Cambridge
7. Gerhardt H, Mattheck C (1991) FEM-Analyse der Biomechanik des Windbruchs. Interner Bericht des Forschungszentrums Karlsruhe
8. Klein L (1908) Die Physiognomie der mitteleuropäischen Waldbäume. Jahraus-Verlag, Karlsruhe
9. Knothe K, Wessels H (1991) Finite Elemente. Springer, Berlin Heidelberg New York
10. König E (1958) Fehler des Holzes. Holzzentralblattsverlagsgesellschaft, Stuttgart
11. Kübler H (1987) Growth stresses in trees and related wood properties. For Abstr 48:131-189
12. Kübler H (1983) Mechanisms of frost crack formation in trees – a review and synthesis. For Sci 29:559-568
13. Kübler H (1991) Function of spiral grain in trees. Trees Struct Funct 5:125-135
14. Mattheck C, Korseska G (1989) Wound healing in a plane (*Platanus acerifolia* [AIT. Willd.]) – an experimental proof of its mechanical stimulation. Arboricult J 13:211-218
15. Mattheck C, Prinz M, Soldner E (1989) Biomechanisch begründete Wege zum dauerfesten Hüftgelenksersatz. Bericht Nr 4722 des Forschungszentrums Karlsruhe
16. Mattheck C, Ziegler J (1989) Implantate zur Versorgung gelenknaher Frakturen. VDI-Forschungsberichte
17. Mattheck C (1990) Engineering components grow like trees. Materialwiss Werkstofftech 21:143-168
18. Mattheck C, Bethge K (1990) Wind breakage of trees initiated by root delamination. Trees 4:225-227
19. Mattheck C, Burkhardt S (1990) A new method of structural shape optimization based on biological growth. Int J Fatigue 12:185-190
20. Mattheck C (1992) Die Baumgestalt als Autobiographie – Einführung in die Mechanik der Bäume und ihrer Körpersprache. Thalacker, Braunschweig
21. Mattheck C (1991) Trees – the mechanical design. Springer, Heidelberg Berlin New York
22. Mattheck C, Breloer H (1991) Wie bricht ein Baum? Gartenamt 40:746-748

23. Mattheck C, Breloer H (1994) Handbuch der Schadenskunde von Bäumen. Rombach Verlag, Freiburg
24. Mattheck C, Burkhardt S (1991) Der Unglücksbalken. Allg Forst- und Jagdzeit 162:170-174
25. Mattheck C, Reuss S (1991) The tiger claw – an assessment of its shape optimization. J Theor Biol 150:323-328
26. Mattheck C, Vorberg U (1991) The biomechanics of tree fork design. Bot Acta 104:399-404
27. Mayer-Wegelin H (1936) Ästung. Schaper-Verlag, Hannover
28. Metzger K (1893) Der Wind als maßgeblicher Faktor für das Wachstum der Bäume. Mündener Forstliche Hefte. Springer, Berlin
29. Pauwels F (1965) Gesammelte Abhandlungen zur funktionellen Anatomie des Bewegungsapparates. Springer, Berlin Heidelberg New York
30. Peterson (1970) Stress concentration factors. John Wiley & Sons, New York
31. Schröder K (1991) Baumschadensdiagnose und Verkehrssicherungspflicht. Landschaftsarchitektur 1:26-28
32. Schröder K (1990) Doppelgurt für Bäume. Ein neues Kronensicherungssystem. Dtsch Gartenbau 31
33. Shigo A (1986) The new tree biology. Shigo and Trees, Associates Durham
34. Szabo J (1972) Höhere Technische Mechanik. Springer, Berlin Heidelberg New York
35. Troll W (1959) Allgemeine Botanik. Enke-Verlag, Stuttgart
36. Vincent J (1990) Structural biomaterials. Princeton University Press, Princeton
37. Wilson F (1988) The growing tree. University of Massachusetts Press, Amherst
38. Zimmermann M, Wardrop A, Tomlinson B (1968) Tension wood in the aerial roots of *Ficus benjamina* L. Wood Sci Tech 2:95-104
39. Zimmermann M, Brown C (1980) Trees – structure and function. Springer, Berlin Heidelberg New York

Subject Index

annual ring 115, 118
apical dominance 43-45, 48, 50-51

beam 5-6, 39-40, 54, 99, 148-149, 153-158, 161, 212- 213, 217-219, 249-250
 – bending 5
 – hazard 148-150, 153-158
 – I- 6, 99
beam shoulder 212-213
bone VII-VIII, 1, 6, 25-26, 39-41, 163-165, 167-174, 177-179, 182-184, 209-210, 217, 222
 – cortical 167
 – spongiform 167, 222
 – trabecular 167, 169, 174, 177-178, 183, 217
bone design 167
bone mineralization 40- 41
boundary condition 21
bracing 199, 201-202
branch junction 58-60
buckling 144-147, 191-193, 196
 – shell 144-145, 191-192

CAIO method 130-133, 256-257, 260-261
callus 85, 89, 92-93
CAM 131, 188, 213-214
cambium 32, 113, 148, 155
CAO method VII-VIII, 1, 32-35, 37-41, 220-223, 225-228, 239, 241, 243-253, 255, 261-262
claw 26, 184-187
cohesion 73-75
collar 59-60, 89-93, 123-124, 163, 174
 – branch-shedding 58, 60, 89, 91, 93, 123-124, 163
 – prosthetic 174
component killers 14
contact 64, 79-81, 96-106, 114-115, 117, 119, 121, 124-127, 195, 201, 208
 – mechanical 64, 79-81, 91, 96, 100-101, 104, 114, 121

 – tree-stone 64
 – tree-tree 100
contact area 64, 79-80, 94, 96, 100, 105, 114-115, 124-127, 195
controlling mechanism 43
crack VII, 19-20, 22, 119, 121-122, 154, 156-158
 – fatigue 20, 22, 36
 – frost 118-119
 – longitudinal 118, 154, 156
 – secondary 154
 – unstable 20, 22
crack propagation 20

Devil's ear 147-148
displacement 11

ecodesign 41, 131, 225
expansion 11-12, 21, 32, 44
 – coefficient of thermal 11-12
 – thermal 11-12, 21, 32, 44

factor 10, 15, 22, 29, 32, 213, 221
 – proportionality 10, 54
 – safety 221
 – stress concentration 15, 22, 29, 213
 – thermal expansion 32
FEM IX, 12, 14
femur 167, 170, 172
fibre 90-91, 106, 129-134, 142, 159-161, 182, 256-260
 – neutral 25, 217
 – tension 154
 – wood 59, 91, 106, 123, 126, 129, 135, 138, 149, 154, 157
flare 127, 129
flattening 143-147, 192- 193, 243
force 3-4, 7-11, 14-15, 22-23
 – axial 3, 7, 29, 177-178, 188
 – contact 96
 – reaction 21, 159
 – tensile 4, 135

Subject Index

force flow 9-10, 14-15, 20, 22-23, 29, 31, 57-60, 84-91, 123, 126-127, 129-131, 134-135, 137, 172-174, 177, 179, 217
fork 56, 61-67, 257-258
– compression 62, 64-67, 79, 105
– tension 62, 66-67, 105
– tree 61
Fractometer 149, 151-152, 162
fracture 141-144, 147, 157-164, 169-172, 209-210, 221-223
– fatigue 23, 214, 225
– femur 170
– march 169
– transverse 141
framework 105-109, 112-114, 182-184, 217, 219
– bony 169, 183
– micro- 39, 167, 174, 177, 182, 217
– trabecular 184
– tree 107, 183
– welded 183

geotropism 44-51, 68, 138
– negative 44, 48, 68
grain 10, 84, 127-137, 223
– helical 116, 134-137
– spiral 134, 223
gravity 3-4, 44-45, 47, 49-50
growth VII-VIII, 9-12, 31-35, 37, 39, 41-44, 50-51, 209
– adaptive VII, 26, 31-32, 39, 41, 172, 225
– biological 10-11, 41-42, 216
– computer-simulated 1, 175
– crack 20, 22
growth regulator 43, 49, 114

hazard beam 148-158
height-diameter ratio 53
Hooke's law 10-11
hydrotropism 68

internal architecture 177
isotropy 129

kinking 142, 160-162, 199
– fibre 142, 160-161

lateral 170
load 3-8, 12-15, 21-22, 35-36, 53, 61, 146, 187, 199
– area 13-14, 263, 265

– axial 178
– bending 6-7, 47, 49-50, 56, 79, 177, 179
– concentrated 13-14, 218-219, 242
– crown 7
– cyclic 22
– dynamic 222
– external 3, 10, 21, 41, 81, 138, 149
– line 13-14, 21, 267
– mechanical 2, 12, 14, 33, 58
logarithmic spiral 185-188

meandering 46, 116-117
mechanics of trees 43
medial 174
Mises stress 19, 21, 32, 83, 188
Mohr-Coulomb's law 68-69
moment 4-8
– bending 3-7, 21, 53, 59-61, 99, 141-143, 178-179, 228, 234
– torsional 3, 8, 21, 135
moment of inertia 5-6

network 32-33, 35, 37, 179, 217
notch 14-16, 22-25, 29-31, 62-63, 65, 80, 85, 91, 100, 118, 123-125, 154, 163, 168-169, 175, 188, 193, 204-206, 209, 213-214, 217, 222, 227, 239, 244, 249-250, 252-253
– circular 14, 19-20, 82, 85, 111, 175, 187, 205-206, 214
– internal 22
– longitudinal 15
– ring 60, 123, 163, 209
– triangular 85, 88
nut 195-196

optimization VII, 22, 29, 33, 35, 53, 78, 99, 106, 131, 135, 164, 187-188, 191, 222-223
– internal 150
– mathematical 40
– self- 54, 134, 188
– shape VII, 29, 31, 54, 107, 154, 175, 177, 187, 192, 209, 212, 214, 220, 222-223
orthopaedic screw 209
orthotropy 84, 131
osteoblast 165, 169
osteoclast 165, 178

phototropism 43, 48-49, 68

Poisson's ratio 21
pruning 60, 88-91, 92, 163-164
 – artificial 88
 – green 89
 – natural 60, 88, 91, 163-164
 – stub 91-92

redwood 116
Resistograph 162
rib 119-122
 – frost 118-119, 121
root 67-81, 134, 153, 157-160, 175, 188, 202-208, 216-217, 222
 – air- 56, 112-113, 183-184
 – buttress 159, 202-208, 222
 – hanging 112
 – heart 159
 – horizontal 67, 157-160, 202-206
 – shallow 67, 204
 – sinker 67, 157-158, 202-205

shell 144-147, 191-196, 209, 243
 – biological 144, 191, 195
 – curved 191, 193, 195
shrinking 41, 163-165
 – active 164-165
 – passive 164
SKO method 35-41, 70, 131, 216-223, 225, 227, 230-240, 242-243, 261
 – stress-increment-controlled 37, 39
splitting 66, 135, 144, 149-150, 154, 157-158, 192
 – axial 144, 154, 158, 192
 – longitudinal 144, 154
 – root 157
strangler fig 112
strength VII, 59, 64, 142, 149-150, 160, 162-163, 221, 246
 – bending 149, 151-152
 – compressive 142, 160, 165
 – shear 69
 – tensile 144, 148, 160, 165, 185
 – transverse 143, 149-150, 154
stress VII, 4-15, 21, 29-33, 37, 39, 138, 142, 148, 150, 188, 217, 222
 – applied 15, 29
 – axial 9, 155
 – axiom of uniform VII-VIII, 25-27, 29-30, 41, 50, 53-54, 57, 59, 62, 64, 70, 79-80, 89, 91, 104, 115, 121, 137, 155, 164, 169-170, 173, 178-179, 182-183, 187-188, 196, 208, 220, 222, 225

 – bending 4-8, 25, 53, 83, 141, 142, 167, 173, 177-179, 187
 – compressive 4-5, 7-9, 25, 117-118, 147, 157-158, 177-178, 203
 – contact 64, 94-99, 102-106, 114, 195
 – growth 83, 117-118, 121
 – internal 3
 – Mises 19, 21, 32, 83, 188
 – notch 14-16, 19-20, 22-23, 25, 29, 32-33, 36-37, 41, 58-59, 62, 80-83, 85-88, 107, 112, 124, 154, 169, 188, 193, 204-206, 209, 213-214, 217, 222, 227, 239, 244, 249-250, 252-253
 – principle normal 37, 131
 – reference 9-10, 21-22, 32, 37, 39, 227, 230-231
 – shear 8-9, 70, 90, 118, 122, 129, 131, 137, 257
 – tensile 4-5, 25, 117-119, 147-149, 152, 154, 157, 199
 – thermal 2-3, 11, 21, 33
 – transverse 10, 148, 154-155
 – uniform 27, 29, 39, 53-54, 81, 83, 96, 98-99, 125, 131, 145-146, 170, 173, 177-178, 197, 204, 217, 220, 241
stress peak 15, 22, 91, 121, 173, 228
stress tensor 9

thorn 185
tortoise 195
trabecular drifting 178-180
tractus iliotibialis 201
tree
 – body language of 162
 – host 112-113, 183
 – sabre 47, 152
trochanter major 201

VTA method 162, 261

welding 64, 80, 105-106, 112, 126
 – axial 64, 104-106
 – cross 106
 – tree 64, 100, 102, 104-107, 114
wind breakage 54, 157-158, 170, 221
windthrow 159-160
wood
 – compression 26, 44, 46, 116-117
 – green 10
 – growing 83, 100
 – reaction 44, 46, 48, 50, 64, 66, 116-117, 137

– tension 44, 64, 116
wound healing 60, 81-90, 117, 222

wound spindle 83, 85-88

Printing: Druckhaus Beltz, Hemsbach
Binding: Buchbinderei Schäffer, Grünstadt